PAINTING FOR THE MUGHAL EMPEROR

PAINTING FOR THE MUGHAL EMPEROR

THE ART OF THE BOOK 1560–1660

SUSAN STRONGE

V&A PUBLICATIONS

FOR ALEXANDER AND KARIM

First published by V&A Publications, 2002

V&A Publications
160 Brompton Road
London
SW3 1HW

Susan Stronge asserts her moral right
to be identified as author of this book

ISBN 1 85177 358 4

A copyright record for this book
is available in the British Library

Designed by Harry Green
Photography by Dominic Naish
and V&A Photography Studio
Map designed by Technical Art Services

Origination by Colorlito, Milan
Printed in Hong Kong

JACKET ILLUSTRATIONS

FRONT: detail from 'The sons of Shah Jahan',
by Balchand, c. 1635 (PL. 117)

BACK: detail from 'The submission of the rebel brothers
Ali Quli and Bahadur Khan', by Kesav the Elder
with Chetar, c. 1590–95 (PL. 30)

FRONTISPIECE: detail from 'Akbar's triumphal entry into
Surat in 1572', by Farrokh Beg, c. 1590–95 (PL. 37)

CONTENTS

ACKNOWLEDGEMENTS

This book concentrates almost exclusively on the V&A collection, which cannot be seen in isolation. It is therefore a pleasure to express my thanks to curators and directors for access to their collections, records and for many kindnesses: Ashmolean Museum, Oxford: Andrew Topsfield; Bodleian Library, Oxford: A. D. S. Roberts and Doris Nicholson; British Library, London: Jeremiah P. Losty and Pat Kattenhorn; British Museum: Robert Knox and Sheila Canby; Brooklyn Museum of Art, New York: Amy Poster and Layla Diba; Calouste Gulbenkian Foundation, Lisbon: Nuno Vassallo e Silva; Chester Beatty Library, Dublin: Michael Ryan; Fogg Art Museum, Harvard University: Rochelle Kessler; Freer Gallery of Art/Arthur M. Sackler Gallery, Washington, DC: Milo Cleveland Beach; Lahore Museum: Anjum Rehmani; Los Angeles County Museum of Art: Stephen Markel and John Listopad; Metropolitan Museum of Art, New York: Daniel Walker, Marie Lukens Swietochowski and Stefano Carboni; National Museum of India, New Delhi: Naseen Akhtar; San Diego Museum of Art: Caron Smith; Staatsbibliothek zu Berlin: Hartmut-Ortwin Feistel; Vienna, Museum für Angewandte Kunst: Rainald Franz.

The final stages of writing the book were greatly enriched by my having taken part in the international workshop convened in the Golestan Palace, Tehran, to study and discuss the pages of Jahangir's Golshan, or Rose Garden, Album. Organized under the auspices of Iran's Cultural Heritage Organization and Syed Mohammad Beheshti, this remarkable project was the brainchild of Milo Cleveland Beach and Chahryar Adle, supported by Ali Reza Anisi. Apart from having the immense privilege of studying the most important royal Mughal album of paintings and calligraphies by master practitioners, I was also able to discuss the many problems of album borders with Ada Adamova, whom I thank enormously, and general points with Asok Kumar Das, who later, in London, kindly identified the portrait of Abdu'l Hadi (pl.121) and advised on the transliteration of Hindu artists' names.

Robert Skelton's advice and suggestions were of crucial importance in enabling me to conclude the last chapter and, with typical generosity, he lent photographs from his famous personal archive to show the relationship between architectural motifs and Jahangiri album borders (reproduced pls 133 and 134). He also commented constructively on parts of the text, correcting some significant errors. Catherine Asher provided instant expert advice over architectural problems, putting me in touch with U. S. Moorti and R. Sharma of the American Institute of Indian Studies, who speedily sent research photographs. B. N. Goswamy provided invaluable comments and corrections for the first chapter; Farhad Hakimzadeh guided me through the literature on published datable Iranian textiles that I wished to compare with Mughal decorative motifs; Catherine Glynn Benkaim was extremely generous in sending me a copy of *Biblical Stories in Islamic Painting*; and Steve Bromberg gave advice on Western printed editions of maps. I am greatly indebted to all these friends and colleagues for their generosity. Most of all, I thank my husband, A. S. Melikian-Chirvani, for tolerating constant discussion of the book's content, providing wise counsel, and supplying a new translation of Qandahari's important passage on the *Hamzanama*.

Within the V&A, the meticulous recording of technical data on paintings by my former colleague Betty Tyers was of great assistance, as were her notes of opinions expressed by Robert Skelton and visiting scholars: where used, these are fully acknowledged. I would like to thank Dominic Naish for his new photography, and his colleagues in Photo Studio for earlier transparencies; Divia Patel; Graham Parlett; Nicholas Barnard; Jennifer Wearden; Steve Woodhouse; Frances Rankine; Richard Loveday; Nick Frayling; and particularly Pauline Webber, Mike Wheeler and Anna Hillcoat-Imanishi. The book could not have been written without periods of research leave and I therefore owe a great debt to Charles Saumarez Smith for approving my initial transfer to the Research Department in 1993, to Paul Greenhalgh, Malcolm Baker and Carolyn Sargentson for later transfers, and to Deborah Swallow for her warm support of my applications throughout for research leave. Above all, in producing the book I thank Mary Butler and Harry Green for their enthusiasm and consummate professionalism; Michael Bird for his careful scrutiny of the text and many helpful comments, John Noble for the index, and Rosemary Amos and Ariane Bankes for seeing the book through the final stages.

I WOULD LIKE TO RECORD MY IMMENSE GRATITUDE TO BENJAMIN ZUCKER for his generosity in establishing an annual lecture on Mughal art at the V&A in 1993. This has allowed us to invite to London leading international specialists in painting, architecture, jewellery and other decorative arts, all of whom have attracted large audiences for their presentations and ensured that the museum remains at the forefront of Mughal studies. Coincidentally, this book has been written, very sporadically, over the same period and the lectures have therefore provided a stimulating and thought-provoking background.

PREFACE

◆

Akbar said: 'Kingdoms are divided from each other by rivers, mountains, deserts or languages.'[1] The Mughal emperor's kingdom, encompassing by the end of the reign a vast territory covering parts of present-day Pakistan and Afghanistan, Kashmir and the whole of northern India, was called Hindustan.[2] The land was a conquered one; its unifying language, Persian, imposed. In 1526 Akbar's grandfather Babur, a prince from the great dynasty of Timur, had marched on Delhi from his stronghold in Kabul to defeat the Muslim ruler of the Delhi sultanate, Ibrahim Lodi. His tenuous hold on a kingdom covering little more than the Delhi hinterland nevertheless laid the foundations for one of the greatest dynasties of the Indian subcontinent. It was to last, if only in name, until 1858, when the British took over all the former Mughal territories and Hindustan became part of the British Empire.

The great age of the Mughals, artistically as well as politically, covered the reigns of three emperors: Akbar (r.1556–1605), Jahangir (r.1605–27) and Shah Jahan (r.1628–58). This book describes the paintings in the collection of the Victoria and Albert Museum (V&A) produced during this period. The majority were once illustrations to books; many of the rest belonged to albums. Now detached from their bindings or from colophons stating when the books were completed, they yield frustratingly incomplete information. Yet a surprising number of the V&A's paintings and decorated pages of calligraphy have a direct connection with the emperors, or to major themes of artistic production in the court milieu.

The focus of the book is narrowly on the V&A collection for two reasons. Firstly, despite their renown, there has never been a Museum monograph on either of the largest groups of paintings: the illustrations to a large section of the *Akbarnama*, or 'Book of Akbar', the history of Akbar's reign illustrated by artists from his own atelier (pl. 1), or the pages from albums of Akbar's grandson

THE UZBEK
KHANATE

KASHGHAR

• Khotan

Balkh ■ • Qunduz

BADAKHSHAN

BALKH

Boundary of the Mughal empire

Boundary of the provinces (*subas*)
of the Mughal empire

Boundary of the Deccan sultanates
(Ahmadnagar, Golconda, Bijapur, Bidar)

■ Capitals of *subas* and other states

• Herat

THE SAFAVID EMPIRE

• Kabul

KABUL

• Ghazni

Srinagar

KASHMIR

LAHORE

Qandahar ■

Lahore ■

■ Lhasa

QANDAHAR

MULTAN

• Multan

D E L H I

T I B E T

Panipat •

• Delhi

AWADH

THATTA

AJMER

Fathpur
Ajmer •

Ranthambhor

AGRA

Agra ■

Awadh
■

Allahabad

Banaras

Patna
■

Tanda
■

Thatta ■

• Chitor

ALLAHABAD

BIHAR

BENGAL

Dacca
■

Ahmadabad ■

GUJARAT

Ujjain
■

Cambay •

Surat •

MALWA

Gondwana

ORISSA

INDEPENDENT AND
TRIBUTARY CHIEFS

Diu
(Port.)

Daman
(Portuguese)

Burhanpur
KHANDESH

Ellichpur
•

Cuttack
■

Portuguese

Daulatabad
•

BERAR

A R A B I A N

Ahmadnagar
■

AHMADNAGAR

Bidar
•
BIDAR

Golconda
•

GOLCONDA

Bijapur
•

S E A

BIJAPUR

Goa
(Portuguese)

Vijayanagar
•

Masulipatam
•

B A Y

O F

Penukonda
•

VIJAYANAGAR

B E N G A L

Calicut
•

Jaffna
(Portug. Protect.)

SRI
LANKA

Colombo
•

Kandy
■ Kandy

Kotte
(Portuguese)

0 150 miles

0 200 km

OPPOSITE: The Mughal Empire in 1601.
Source: Irfan Habib, *An Atlas of the Mughal Empire*,
OUP, Delhi, 1982

Shah Jahan, with their calligraphy and pictures surrounded by exquisitely decorated borders. In the vast body of writing on Mughal painting, the V&A's collection has featured prolifically, but often in an oddly tangential way. It has been used to illustrate general points, or to provide comparisons with paintings in other collections, or to give a signed example of the work of a particular artist.[3] Many of the images may therefore be familiar, but crucial information about them has often been omitted; others are almost completely unknown. This book puts the collection at centre stage.

The other reason for the narrowness of the focus is practical. Facts concerning Mughal artists are extremely sparse. Basawan, for example, one of the greatest artists of Akbar's reign, has rightly attracted considerable critical attention.[4] Mentioned by the court chronicler, Abu'l Fazl, in his famous list of leading artists of the late sixteenth century, Basawan's signed works attest to the range and quality of his skills. Many more are attributed to him, sometimes on doubtful grounds. He was a senior artist involved in the production of the *Akbarnama*, collaborating with, and presumably training, juniors who were to become leaders of the atelier in the early seventeenth century. He contributed paintings to manuscripts whose dates are known,[5] but not a single date is associated with events in his life, not least his birth and death. The only other detail known about him, apart from his being a Hindu as indicated by his name, is that he was the father of Manohar, who also became a leading court artist.[6]

There is a similar dearth of information for most of the artists working in Mughal India, whether for the emperors and their immediate family or for the most important nobles of the court. Defining the characteristics of their personal style may sometimes be possible, but it is problematic, due to a widespread reluctance of scholars to differentiate, when writing about these widely scattered works, between authentic signatures, contemporary ascriptions, later attributions by informed individuals, and wishful thinking on the part of later owners (or vendors).

This book introduces the V&A collection, closely analysing particular works, and including where possible indications as to the reliability of their inscriptions. Due to the relatively large number of works directly linked to the royal circle, the arrangement of the book is regnal.

1

PAINTING AT
THE COURT OF AKBAR

PLATE 2 Abd ur-Rahim, the young son of
Bayram Khan, is presented at court in 1561
following the assassination of his father.
By Anant
Illustration to the *Akbarnama*, *c*.1590–95
31.7 × 18.5 cm
IS 2-1896 7/117

The future emperor Akbar was born in 1542 at a time when it
seemed that Mughal rule would not endure in Hindustan. His
father, Humayun, had been chased out in 1540 by the Afghan
Sher Shah and fled to Iran in a desperate attempt to gain the support of
Shah Tahmasp (r.1525–76). He was forced to leave his pregnant wife behind
at Amarkot in Sind, where Akbar was born, though the infant and his
mother were soon taken to the safety of Kabul by Humayun's brothers. The
deposed emperor returned with Iranian forces to take Qandahar and Kabul
in 1545, where the family remained for the next ten years until he was able
to regain Delhi and his lost territories.[1]

Once again ruler of Hindustan, Humayun quickly took control of the
political administration and divided his subjects into three classes according
to specific governing principles. One of these, the *ahl-i murad* ('those who
aspire'), included 'architects, painters, musicians and singers', 'because they
were the delight of all the world'.[2] Among the artists were two Iranian mas-
ters, *Mir* Sayyed Ali and *Khwaja* Abdu's Samad, who had joined Humayun in
Kabul in the month of Shawwal, AH 959 (20 September–18 October 1552),
and were to play a crucial role in the future development of painting under
the Mughals.[3]

Before the *ahl-i murad* could delight the empire, however, Humayun died,
only six months after returning to Delhi. Climbing at night down a dark flight
of steep, stone steps from the flat roof of a building known as the Sher Mandel,
he tripped and fell. His death was not announced for 17 days to allow Akbar's
supporters time to bring the boy safely to the capital from the Panjab.[4]

On 14 February 1556 the 13-year-old was enthroned and spent the next
years expanding his kingdom and suppressing rebellions under the expert
guidance of Humayun's friend and general, Bayram Khan. In the very first
year, they had to deal with Humayun's old foe Hemu, who seized Agra and

Delhi, and declared himself the independent Raja Bikramajit. The Mughal army defeated his forces in 1556 on the historic battlefield of Panipat, where 30 years earlier Babur had defeated Ibrahim Lodi to found the empire.

The relationship between the strong-willed young ruler and Bayram Khan, whom the court chronicler described as having 'taken into his skilful hands the bridle of the administration of the empire',[5] soon deteriorated. In 1560, at Akbar's suggestion, Bayram Khan chose a tactical pilgrimage to Mecca rather than be removed from office,[6] but was assassinated on the way to the port of Surat, in Gujarat. His widow and four-year-old son were taken back to the court, where they were received into the royal household (pl. 2).[7] Akbar was now free to rule independently and to organize the empire as he wished.

His influence on the arts was to be spectacular. The growing kingdom was full of skilled artists, craftsmen and architects; he inherited his father's master practitioners; and foreign artists of all kinds joined the royal ateliers, notably from Iran. All this, combined with Akbar's enthusiasm and wealth, and the increasing political stability, led to an artistic florescence almost unparalleled in the history of the Indian subcontinent.

His cultivation of the arts of the book was to transform painting in India. Despite Akbar's inability to read or write, he had a detailed knowledge of the literary, scientific and philosophical works that were held in his magnificent library and were read aloud to him.[8] He composed poetry, and collected illustrated manuscripts, commissioning his own from about the 1560s.[9]

Painting, always regarded as inferior to calligraphy,[10] was nevertheless a great passion. Akbar's friend Abu'l Fazl makes repeated references in his history of the reign to the emperor's interest in painting, notably in a famous passage on 'The Art of Painting', where he writes: 'His Majesty, from his earliest youth, has shown a great predilection for this art, and gives it every encouragement.'[11] He is said to have examined the work of all his artists every week. By the 1590s more than a hundred painters, predominantly Hindus, were said to be 'famous masters', with many others 'approaching perfection'.[12]

Akbar's comments on an art that might be criticized in ultra-orthodox Muslim quarters were also recorded:

There are many that hate painting; but such men I dislike. It appears
to me as if a painter had a quite peculiar means of recognizing God;
for a painter in sketching anything that has life, and in devising its limbs,
one after the other, must come to feel that he cannot bestow individuality
upon his work, and is thus forced to think of God, the giver of life, and
will thus increase in knowledge.[13]

Abu'l Fazl's insistence on Akbar's encouragement of painting is generally accepted without question, although it has been suggested that this is an example of a phenomenon whereby the emperor was automatically given

credit for any innovation, and that all such claims should thus be dismissed as eulogistic conceits.[14] There is little doubt, however, that he was closely involved in the daily work of his artists, as well as in many other kinds of artistic practice, from architectural projects to improving the manufacture of textiles and weapons, and had a keen desire to stimulate new technology generally.[15] Akbar's love of painting is demonstrated by the number of illustrated manuscripts he commissioned, the plethora of detached pages of the period of very high quality, and the abundant traces of pictorial decoration on royal monuments, notably those of his new capital of Fathpur. His own training made him an informed patron: his teachers, *Mir* Sayyed Ali and Abdu's Samad, were the greatest masters of the royal atelier. Their closeness to the royal family is vividly apparent in a painting by Abdu's Samad in the Golestan Palace Library's Golshan Album (*Moraqqa'e Golshan*) that depicts Akbar as a boy, presenting to Humayun portraits of them both by the artist.[16]

The memoirs of his son Jahangir include an incident recounted by Akbar himself that underlines Abdu's Samad's role in his early education:

> His Majesty used to relate: 'In Kabul one day I was learning to paint
> under the care of *Khwaja* Abdu's Samad Shirin Qalam ['Sweet Pen'],
> when my brush painted a form, whose parts were all separated from each
> other and scattered. One of those near asked "Whose picture is this?"
> I said, "It is Hemu's." '[17]

Abu'l Fazl describes the same episode with slightly different details, including the fact that both Abdu's Samad and *Mir* Sayyed Ali were Akbar's teachers.[18]

Regardless of any talent Akbar may have had as an artist, his early training must have given him a thorough understanding of the techniques, problems and possibilities of painting, as well as an an intimate knowledge of the men who were to direct the first major work of the painting studio when he became emperor, the production of multiple volumes of the *Hamzanama* ('Book of Hamza').[19]

THE MAKING OF THE *HAMZANAMA*

At some time in the early 1560s, Akbar gave orders for the romance of Amir Hamza to be written down and illustrated. This Persian cycle of stories, thought to have originated in Iran in the eleventh century,[20] describes the fantastic adventures of a historical character, Hamza ibn Abd al-Muttalib, the paternal uncle of the Prophet.[21] These stories seem to have been overlaid with the colourful exploits of another Hamza, a ninth-century revolutionary leader from Sistan,[22] in the extraordinary tales of a hero fighting against various kinds of unbelievers for the cause of Islam. The romance was immensely popular and was traditionally disseminated by professional story-tellers in Iran, though it was periodically written down or translated into other languages.[23]

PLATE 3 Hamza is approached by fairies imploring his help to kill the dragon said to be troubling his kinsmen, the Genii.
Painting on cotton
Illustration to the *Hamzanama*, c.1562–77
66.8 × 51.3 cm
IS 1505-1883

PLATE 4 Akbar taming wild elephants in the forests of Narwar in 1564.
By Mohesh and Kesav the Younger
Illustration to the *Akbarnama*, c.1590–95
33 × 20.5 cm
IS 2-1896 40/117

It reached those areas of the Indian subcontinent suffused by Iranian cultural influence, and could have been heard at the court of Mahmud of Ghazni in the early eleventh century, though the earliest extant written (and illustrated) version dates from the late fifteenth century.[24] Nothing had ever been seen, however, on the scale of Akbar's *Hamzanama*.

It is not difficult to understand the appeal that the swashbuckling tales of Hamza must have had for the young emperor, with their underlying theme of good versus evil. During the early years of the reign, Akbar struggled to keep control of territories where rebellions constantly broke out, forcing him to dash all over the empire to subdue them. In the romance, Hamza and his band of heroes repeatedly set forth to combat enemies, including unbelievers, demons, dragons (pl. 3), monsters and magical forces. They engage in exploits where sorceresses beguile by assuming the form of beautiful young girls, magicians ride mythical beasts, and characters may be plucked out of the landscape by a hand reaching down from the clouds.

A passing reference in the *Akbarnama* demonstrates the role the stories played in court entertainments. After a strenuous and successful day in 1564 spent capturing wild elephants, one of Akbar's favourite pastimes, the royal entourage halted in the forests near Narwar (pl. 4). Next morning, when Akbar rose, 'for the sake of delight and pleasure he listened for some time to Darbar Khan's recital of the story of Amir Hamza'.[25]

The sheer number of paintings in the *Hamzanama* volumes meant that they were the primary task of the new Mughal atelier for many years.[26] It is impossible, however, to establish precisely which years these were. The details given by contemporary and later authors are frustratingly sketchy, vary slightly, are occasionally irreconcilable and never mention dates. The usually meticulous Abu'l Fazl wrote: 'the "Story of Amir Hamza" [*Qissa-ye Amir Hamza*] was represented in twelve volumes, and clever painters made the most astonishing illustrations for no less than one thousand and four hundred passages of the story.'[27] Different authors mention 12, 14 or even 17 volumes, but the total of 1,400 illustrations is a more consistent figure.[28] Slightly more than one-tenth of this total has survived, the largest group, of 61 folios, being in the Museum für Angewandte Kunst, Vienna.[29] The second largest, consisting of 24 pages and 3 fragments, is in the Victoria and Albert Museum (V&A).[30]

An important reference to the making of the *Hamzanama* was noted by

Pramod Chandra in his analysis of the evidence. *Hajji* Muhammad Arif Qandahari, in his contemporary history of Akbar's reign, the *Tarikh-i Akbari*, wrote:

> Another point is magnificent painting. The instruction was issued that each story in the *Narrative of Amir Hamza*, which contains 360 stories, be illustrated with scenes, and that 100 peerless figural painters, illuminators, designers and bookbinders work at that; the format of that book being one and a half legal *gaz* ['cubits'] and that its multiple papers having been bound, and their margins gilt [*hall-kari*], and a *chowtar* fabric sheet having been inserted between two sheets of paper that it be made very strong, all its pages are to be illustrated and illuminated. A royal edict has been issued that writers with a rare gift of exposition, having sung this narrative like sweet-tongued parrots [*tuti* is the bird speaking the language of esotericism] in every one of its stories give that narrative balance and rhythm [i.e. write it in ornate prose], and that calligraphers with a golden pen and the signature of Mercury [the scribe planet], make it all into a book. Despite all that [only] one volume is prepared every two years and it is estimated that for every volume up to ten lakh [10,000] black coins needs to be spent.[31]

Another contemporary source, *Mir* Ala ad-Dowla Qazvini, an Iranian scholar and poet who came to Mughal India in the 1560s (and witnessed the Mughal siege of Chitor in 1567–68), names *Khwaja* Ata'ullah Munshi Qazvini as the author of the new version of the stories, though he may not have been the only one.[32]

Attempts to attach the production of the *Hamzanama* volumes to precise years depend on the details mentioned in passing by two contemporary sources. Badaoni, the disgruntled secret historian of Akbar's reign, referred to the project having taken 15 years to complete, and *Mir* Ala ad-Dowla Qazvini noted *Mir* Sayyed Ali's imminent departure for Mecca after seven years as director, and his replacement by Abdu's Samad, who clearly speeded up production.[33] It is not certain, however, exactly when *Mir* Ala ad-Dowla finished his own book, making it impossible to ascertain when 'seven years previously' may have been.[34]

Although some authors have suggested that work on the *Hamzanama* began under Humayun, this idea is now widely rejected, and most authors follow Pramod Chandra's estimate of *c.*1562–77, or modify it slightly.[35] Given the fragmentary nature of the pages that have survived, and conflicting interpretations of the evidence they supply, greater precision may be difficult to achieve; dating based solely on stylistic considerations is also unreliable. Nevertheless, there are a few specific details that can date certain pages approximately. For example, a page in the V&A depicts the shadowy forms of Portuguese soldiers, whose precise costume details were extremely

PLATE 5 Hamza receives an envoy
in a mountain pass.
Painting on cotton
Illustration to the *Hamzanama*, *c.*1562–77
67.6 × 51.1 cm
IS 2516-1883

unlikely to have been seen by Mughal artists until after 1572, when Akbar's forces conquered Surat, the residence of many Portuguese soldiers (pl. 5).[36] Some architectural features, moreover, are similar to those in Akbar's new city at Fathpur, founded in 1571. One of the Vienna pages shows a pillar similar to the column in the Diwan-i Khas (Hall of Private Audience) at Fathpur, which is broadly datable to the 1570s and also reflects the emperor's western conquests. Its unusual circular, overhanging upper tiers of deeply cut sinuous brackets represent a distinctively Gujarati form.[37] Gujarati motifs were introduced into Mughal architecture following the conquest of Gujarat in 1572, and their appearance in the paintings could reflect direct knowledge brought to court by a Gujarati artist seeking a new patron. Equally, they could have been copied from monuments in the royal city of Fathpur itself, where the atelier would have been located in the later years of the *Hamzanama*'s production.

I.M 4-1921.

PLATE 6 Hamza is killed in battle at
Mount Uhud and is beheaded and mutilated
by Pur Hind.
Painting on cotton
Illustration to the *Hamzanama*, c.1562–77
67.8 × 51.5 cm
IM 4-1921
Given by Lt-Col. Sir Raleigh Egerton, KCB, KCIE

As so few of the *Hamzanama* folios have survived, and there is no extant manuscript of the complete text, any comments on the relation of text and image are necessarily limited. *Mir* Ala ad-Dowla's text mentioned that, in the volumes finished by the time he wrote (i.e. the first four), the pages were so arranged that the text was opposite the relevant picture.[38]

The most detailed summary of the stories remains that of Heinrich Glück, who as long ago as 1925 attempted to arrange all the illustrations then known in their correct sequence. He created his framework by reference to surviving texts of different periods and in different languages, a method that is clearly defective but which at least allowed him to propose identifications for the subjects of most of the paintings and to arrange them in sequence.[39] According to Glück, the sequence begins with the adventures of the king of ancient Iran, Anushirvan, and the hero, Hamza, who sets out on expeditions to Spain and North Africa, 'Rum' (Turkey) and Ceylon (Sri Lanka). As he travels, he and his band of heroes battle against unbelievers, first the Franks and then the Iranian fire and sun worshippers, until a new enemy, the giant Zumurrod Shah, appears with an army of sorcerers. The romance ends with the battle of Uhud, in which Hamza meets a gory death (pl. 6).

THE *HAMZANAMA* PAGES IN THE VICTORIA AND ALBERT MUSEUM

In 1881 Caspar Purdon Clarke, the first Keeper of the South Kensington Museum's Indian Department, was sent to India to buy contemporary 'industrial arts'. According to Caspar Stanley Clarke, his son and successor as Keeper, while he was in Srinagar, Kashmir, Purdon Clarke entered 'one of the picturesque wooden huts on the Hawa Kadal Bridge spanning the River Jhelum'. Here he saw some large paintings, which he immediately bought: 'several of the badly damaged specimens were rescued from the lattice-windows of the humble curiosity-shop, over which they had been plastered by the vendor during the previous frosty season.'[40] They arrived in London the following year to delight the Arts and Crafts designer William Morris, who 'extolled the treatment of the trees, foliage, and flowering plants, recommending them as excellent studies for tapestry and wall-paper design.'[41]

The pages are all of similar size, with a complex structure that seems to accord with Qandahari's contemporary description. Each picture is painted on cotton backed with thin paper, and the text on the reverse of each folio is written on thicker, white paper backed with cotton. Text and picture were pasted together, and a woven cotton border added, over which decorated paper strips were pasted.[42] Most of the borders on the V&A pages are missing, with only remnants of faded marbled paper remaining. The text, usually written in 19 lines of black *nasta'liq* on white paper flecked with gold leaf,

PLATE 7 The murder of Qubad
in his pavilion.
Painting on cotton
Illustration to the *Hamzanama*, c. 1562–77
69.3 × 50.2 cm
IS 1508-1883

PLATE 8 Detail of plate 7.
Illustration to the *Hamzanama*, c. 1562–77
IS 1508-1883

has various corrections and annotations in red and black, a feature also seen on the Vienna folios. A few folios have fragments of text written in the margin beneath the painting, some with page numbers, and there is a page number written on the text side, usually between the penultimate and last lines, where this part of the page has survived. On one of the paintings are two numbers, 7 and 32, probably indicating the volume and page numbers respectively (see pl. 12).[43]

Given their history, it is not surprising that most of the V&A pages have extensive areas of water damage, tearing or scorching. In addition, many of them at some point suffered the attentions of religious iconoclasts, who smeared brown paint over the faces of all the living beings – humans, demons, animals, birds and fish – or rubbed off the paint with such ferocity that the weave of the cotton support is visible. Some faces have been repainted, either carefully but in a jarringly different style or, in a few instances, with crude thick black lines. Painstaking conservation treatment in some cases has removed the brown paint, revealing the underdrawing (pl. 7 and details pl. 8). But even where dark smudges remain on the same page, they do not entirely conceal the quality of the detail (notably on the top layer of the tent in pl. 7).[44]

Despite all these disadvantages, an immense vigour still emanates from the pages, and much of the decorative detail has survived. The quality is uneven: whereas a few pages must originally have been very fine, others are poorly composed and have crude details. Nevertheless, the V&A paintings contribute a great deal to the study of manuscript production at court in the early part of Akbar's reign, and illustrate the appearance in the subcontinent of an exciting new style.

THE SOURCES OF THE *HAMZANAMA* STYLE

The various conventions used to portray humans, landscape and architecture in the *Hamzanama* paintings, often on the same page, demonstrate that more than one artist worked on each of them, and that they worked within radically different traditions.[45] The defining characteristics of the pictures are Iranian: the vertical format, high viewpoint and lack of recession; such motifs as Chinese clouds; and certain gestures, such as the forefinger pressed against the lips to indicate wonder or awe (pl. 9). These are all the logical result of the direction of *Mir* Sayyed Ali and Abdu's Samad.

But the paintings are also suffused with concepts, motifs and specific characteristics – notably the enlargement of detail and broad panels of saturated colour – as well as certain recognizable conventions that are clearly from Hindustani traditions. Together, these elements create a style never seen before in Iran or Hindustan, while occasionally providing glimpses of contemporary life in even the most fantastic settings.

PLATE 9 Hamza kills the demoness Qamir while Amr looks on.
Painting on cotton
Illustration to the *Hamzanama*, *c*.1562–77
67.5 × 50.5 cm
IS 1513-1883

PLATE 10 Hamza's sons, Hashem and Haris, come as veiled knights to deliver Hamza's camp from the unbelievers.
Painting on cotton
Illustration to the *Hamzanama*, *c*.1562–77
68.1 × 51.8 cm
IS 1511-1883

The raw energy of many of the illustrations springs from the abandon with which the paint has been applied. The lines are often loose and sometimes barely controlled, though on the same page there may be sophisticated decoration that could have been lifted from Iranian book illumination or carefully copied from gold overlaid decoration on steel weapons (pl. 10). The overall liveliness is reinforced by tiny details suggesting a working atmosphere not always characterized by quiet contemplation. Dabs of red paint found their way on to a white sheet before the calligrapher wrote his text, but he ignored the stains and wrote it regardless. A small eye has been doodled on the frame of one picture;[46] and an artist began to decorate the text with blue scrolls bearing palmettes and flowers but broke off before it was finished and forgot to return.[47]

A surreal quality in some of the *Hamzanama* pictures is the result of the

PLATE 11 Hamza kills a tiger.

Painting on cotton

Illustration to the *Hamzanama*, c. 1562–77

65 × 51.2 cm

IM 5-1921

Given by Lt-Col. Sir Raleigh Egerton, KCB, KCIE

PLATE 12 Hamza's spy, Badawi, surprises an enemy agent, Namadpush, who he beheads and buries. He recovers a document from the body revealing the enemy's plans and then tries to gain admission to the castle.

Painting on cotton

Illustration to the *Hamzanama*, c. 1562–77

68.1 × 51.6 cm

IS 1520-1883

complicated intermingling of Iranian influences with Indian Sultanate styles from the fifteenth century, together with the absorption of specific characteristics from Shiraz. In indigenous Indian book painting, the frame of a scene does not interfere significantly with the integrity of the figures it encloses. The frame may be provided by an architectural structure, perhaps of irregular shape and with certain features, such as a dome or projecting eave, intruding into the border. The clothes or limbs of the characters may float outside the structure, but the frame would not cut across the figures, and would certainly never cause parts of them to disappear. The *Hamzanama* pages incorporate a Shirazi mannerism, whereby characters in the scene are altered by elements in the composition: heads and shoulders peep out from behind rocks, the rest of their bodies invisible, figures walk out of the frame of the picture, frozen in the moment of disappearing. The effect is sometimes bizarre, as in the page where Hamza kills a tiger, and half a horse gallops out of the picture, away from a severed body in the foreground (pl. 11).[48]

Other, less obvious features are also drawn from Iranian sources. Figures depicted with their back to the viewer almost never appear in Indian book painting before the Mughal period. Though not common in Iranian painting, this view of the human body does occur as early as the fourteenth century, as in the *Shah Nama* broken up by the Paris dealer Demotte, which probably dates from the 1330s.[49] It also occurs in the work of the great masters of the court of Shah Tahmasp, notably Behzad, whose paintings were valued highly at the Mughal court and copied by artists of the royal atelier.[50] Some of these seated or crouching figures have a vertical line running down the back, continuing the curve of one of the shoulders, the neck and head awkwardly positioned above.[51] *Mir* Sayyed Ali and Abdu's Samad, who began their careers at the court of Shah Tahmasp under Behzad's strong influence if not his direct tutelage, must have carried this idiosyncratic feature to Mughal India, where it appears in the pages of the *Hamzanama*, on at least one occasion so bizarrely that it is tempting to assume it is by the hand of a Hindustani painter trying to assimilate an exotic new technique (see pl. 3).

Another hint of *Mir* Sayyed Ali's influence may be seen in the painting depicting the story of Hamza's spy, Badawi (pl. 12). Badawi has just crept up on an enemy agent, Namadpush, and cut off his head (bottom left). Namadpush had been carrying a document revealing the plans of Hamza's foes, which Badawi now reads. Badawi's posture, and his turban, strongly recall *Mir* Sayyed Ali's self-portrait probably done in Lahore between 1555 and 1556.[52]

PLATE 13 The witch Ankarut, in the upper branches of a tree, offers to free Hamza's
enemy, Iraj, who is bound to the branches of a tree nearby, if he becomes her lover.
Painting on cotton. Illustration to the *Hamzanama*, c.1562–77. 67.2 × 51.4 cm IS 1512-1883

PLATE 14 Hamza's son, Rostam, questions a slave girl who has betrayed him (left),
while the princess Mehr Afruz prepares their wedding feast (right).
Painting on cotton Illustration to the *Hamzanama*, *c.*1562-77. 69.6 × 57.6 cm IS 1519-1883

Despite the range of Iranian forms and motifs, most of the artists in the Mughal atelier must have been Hindus, whose training took place in very different, if now largely elusive, schools. It is their contribution that gives the *Hamzanama* its unique quality.[53] Certain pages must have been painted under the close direction of one of the Iranian masters, who was probably responsible for the original drawing, some of which is now visible, and for much of the detail. Nevertheless, the overall effect is radically different from Safavid book painting.

Because so little has survived from the centuries immediately preceding the Mughal period in Hindustan, and the manuscript illustrations that do survive are in such bewilderingly different styles, it is impossible now to determine which elements continue well-established idioms, or even where they may have originated.[54] Although some may have been deeply embedded, reflecting the prescriptions of ancient Sanskrit treatises on painting, others seem to be innovations.

The lush treatment of landscape is particularly distinctive. Some of the *Hamzanama* illustrations have a sense of magical fantasy, with rocks seeming to float upwards like clouds, imparting an otherworldliness to the scene, with its inhabitants positioned in an abundance of greenery (pl. 13). A page that must originally have been one of the most beautiful in the entire series fills the landscape with wildlife (pl. 14). Hamza's son, Rostam, questions a servant girl who has betrayed his love affair with Mehr Afruz in the foreground, but the eye is drawn into the scene along the oscillating rhythms of the line of blue and red screens (*qanats*) towards the greeny-blue forest behind them, where the trees are filled with flamingos, cranes and other birds. Mehr Afruz's attendants prepare her for the wedding and themselves wear wedding jewellery of a kind that still survived in south India as late as the nineteenth and twentieth centuries.[55] The pages simultaneously incorporate long-standing conventions of Indian (and Iranian) painting, such as that used for water.[56] The 'basket-weave' pattern suggesting rippling streams is used to great effect to suggest the excitement and turbulence at the time of the birth of the Prophet, when pagan idols reportedly fell down and aquatic creatures and fish expressed their satisfaction at the marvellous event (pl. 15).

Similarly, ancient concepts combine with the avant-garde in the illustration of an episode where Badawi has killed Namadpush. The story continues on the same page (see pl. 12), Badawi stealing towards the castle, calling quietly to a confederate inside to open the gates. The stillness of the night is emphasized by the goatherds in the foreground, who are fast asleep, oblivious to Namadpush's murder beyond the wicker screen that encloses their dozing or grazing goats. Only a dog pricks up its ears, trying unsuccessfully to alert his master. The scene curiously echoes a principle laid down in a Sanskrit text on the 'Rules of Painting', the *Chitrasutra*, part of the much

PLATE 15 Miraculous incidents at the birth
of the Prophet.
Painting on cotton
Illustration to the *Hamzanama, c.* 1562–77
66.9 × 51.2 cm
IS 1509-1883

larger *Vishnudharmottara*, which predates the eighth century AD, though the
conventions it represents may be discerned in Indian painting up to the
nineteenth century.[57] The instructions for depicting the nocturnal atmos-
phere seem to resonate across the *Hamzanama* page: 'The portrayal of night
is by showing the moon, stars and planets, people asleep, or engaged in noc-
turnal amours and thieves prowling about.'[58] The diagonals of the path lead-
ing between the goatherds draw the eye towards the drawbridge of the
castle, the line emphasized further by the curve of Badawi's arms. Inside the
castle are more sleeping figures, some of whom begin to stir. The two figures
at top right, one of them enthroned, gesture towards a sleeping man, whose
servant gently tries to wake him. The calmness of the scene is reinforced by
the reclining woman near by, who breastfeeds her baby. Incidental details of
the minutiae of daily life also appear in Iranian book painting, for instance in
the famous illustration of Layla and Majnun in the British Library's *Khamsa*

ABOVE LEFT: PLATE 16 Detail from a *Hamzanama* page in the V&A.
*c.*1562–77
67 × 51.5 cm
IS 1514-1883

ABOVE CENTRE: PLATE 17 Detail from the scene depicting Hamza's death (pl. 6).

ABOVE RIGHT: PLATE 19 Detail of the doorkeeper in plate 18.

of Nizami dated 1539–42, painted by *Mir* Sayyed Ali before he entered Humayun's service.[59]

Throughout the pages of the *Hamzanama*, the human face is represented using a much wider range of conventions than has survived in the limited body of paintings produced in the century or so before the Mughal period, or outside the empire in its early years. This is only partly attributable to the influence of the Iranian directors of the studio. Other conventions seem to derive ultimately from the kind of varied prescriptions found in the *Chitrasutra*, suggesting that the *Hamzanama* preserves the memory of schools of painting now lost to art history.[60]

The *Chitrasutra* detailed the many conventions to be used for the human eye. These depend on whether, for example, the person is a holy man, a lover, a yogi, or an ordinary person; for each, the eye has its correct proportions and relation to the tilt of the face.[61] This wide range persisted across the centuries, and is apparent in the *Hamzanama*, demonstrating the presence of artists trained in very different schools.[62]

In the 'Western Indian style' of Jain manuscript painting that also influenced Hindu book illustration before the establishment of the Mughal atelier, the face is often turned almost imperceptibly towards the viewer to include the merest suggestion of the far side of the forehead and the second eyebrow, as well as the other eye which floats, bizarrely independent, above the nose.[63] The appearance of this dramatically projecting eye in the *Hamzanama* (pl. 16, figure at left edge) is often singled out as evidence for the employment of artists trained in this tradition in the Mughal studio, but it is comparatively rare in the V&A pages. Other artists may have come from different Indian traditions: there are several examples of eyes seen frontally in a face turned slightly to one side, the whites starkly contrasted against dark skin, and with black pupils like small pin-pricks touching the upper lid but with a white space below (pl. 17). These are characteristic of painting styles much further to the south, seen for example the sixteenth-century wall paintings of Lepakshi.[64]

Such details are often found on the same page as other conventions for depicting the eye that may be traced directly to Iran. A much less exaggerated

OPPOSITE: PLATE 18 Tayyir the spy steals into a fort to release Fayzlan Shah.
Painting on cotton
Illustration to the *Hamzanama*, *c.*1562–77
65 × 49 cm
IS 1518-1883

version of the projecting eye than that derived from the Western Indian style must have been brought to India by the Iranian masters of the new Mughal studio, and is often represented in their own work as in that of the great artists of Shah Tahmasp's court.[65] In the *Hamzanama* illustration depicting the spy Tayyir stealing into a fort to release the captive Fayzlan Shah (pl. 18), both the man behind the door (detail, pl. 19) and Tayyir (seen striding towards the left in the upper half of the painting) exemplify this characteristic, while the youth closest to the women at right has the joined eyebrows and oval face that epitomize the idealized 'moon-faced' beauty of Persian poetry as depicted in Iranian and pre-Mughal illustrations to Persian texts in India. As would be expected, this standard literary image is found in the *Hamzanama* text.[66]

The artists of the new royal studio may have been used to painting in more than one style. A page from a Jain manuscript predating the Mughal period (pl. 20), for example, depicts on a miniature scale a king receiving the petitions of 'Shahi' figures. The similarity of their hands and feet suggests that they are all the work of a single artist. The king, however, is shown according to the conventions of the Western Indian style, while the faces of his petitioners derive from Iranian art and would fit equally comfortably, if seen independently, into the small body of work associated with Indian Muslim court patrons and often labelled 'Sultanate'. In the Mughal atelier, conventions from many parts of the subcontinent would have been brought together, the artists probably copying and influencing one another while working under the guidance and direction of Iranian masters.

A notable characteristic of the *Hamzanama* illustrations is the charm with which animals are depicted, as they had been in painting and sculpture from ancient times in the subcontinent. The bears frolicking incongruously on the edge of the violent scene of gardeners beating Hamza's enemy, the giant Zumurrod Shah (pl. 21), compare closely with those in the contemporary Mughal *Anwar-i Suhayli* of AH 978 (1571).[67] The elephants are as convincing and appealing as in the pages of the *Akbarnama*, and many of the *Hamzanama* compositions include animals and birds darting through trees or foliage, contributing to the overall sense of vitality.

Some of the innovative motifs of the *Hamzanama* were to continue in use to the end of the sixteenth century. The composition of Hamza slashing with his sword a tiger leaping out from behind tall grass is close to that of Akbar similarly thrusting with his sword from a prancing horse, cutting deep into the neck of a tigress that also springs from behind grass at centre left in Basawan's painting in the *Akbarnama* (see pl. 41). In both paintings, a red-turbaned figure looks on, pressing his finger to his lips in silent wonder. In the same way, archetypal models of celebrated events, or images by artists of the highest stature, would be copied and reinterpreted in court painting throughout the Mughal period.

PLATE 20 The monk Kalaka in conversation with two Shahis.
Detail from a folio of a Jain *Kalpasutra* and *Kalakacharyakatha* manuscript
Western India, *c.*1400
Prince of Wales Museum of Western India, Bombay
Folio 12.7 × 30.5 cm

OPPOSITE: PLATE 21 Gardeners beating the giant Zumurrod Shah, who is trapped in a well.
Painting on cotton
Illustration to the *Hamzanama*, *c.*1562–77
68.5 × 51 cm
IS 1516-1883

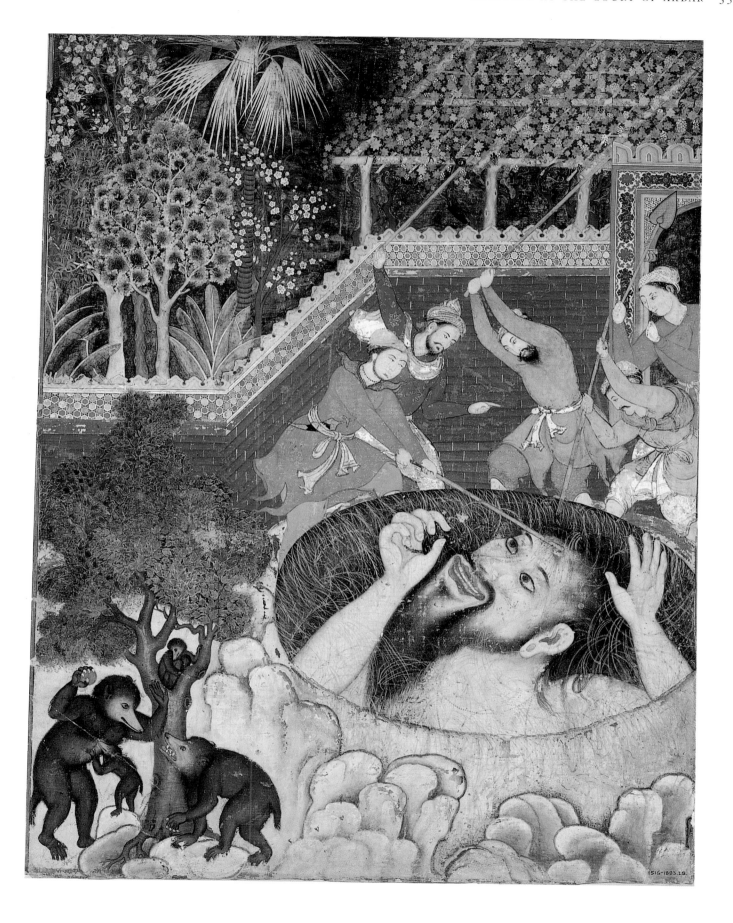

2

THE MAKING OF
A ROYAL MANUSCRIPT

✦

PLATE 22 Akbar directs the attack against
Ranthambhor fort in 1569.
One of the illustrations to the *Akbarnama*
By Khem Karan, *c.*1590–95
32.9 × 20.9 cm
IS 2-1896 73/117

In May 1895 a disintegrating manuscript written in Persian, its 273 folios (including 116 illustrations and an illuminated frontispiece) loosely held between lacquered covers, was brought into the Museum (pl. 22). 'One Book of Indian Drawings to the A'in-Akbari by Abu'l Fazl (very much damaged) with cover and box' was entered in the records as having been left on approval by a Mrs Clarke. Frances Clarke was the widow of Major-General John Clarke, who had bought the manuscript in Oudh while serving there as commissioner between 1858 and 1862.[1] She suggested a purchase price of £300; the Museum authorities offered £100, and this was accepted in a letter of 10 February 1896.[2] The Museum took charge of the manuscript and separated the miniatures so that they could be framed and displayed in the large Indian galleries of the Imperial Institute on Exhibition Road.

No further consideration seems to have been given to this acquisition until chance brought Henry Beveridge into the Museum early in 1905. For many years, the retired Indian Civil Servant had worked on a translation into English of the Persian-language history of Akbar's reign, the *Akbarnama*, written by Abu'l Fazl.[3] When his sister-in-law had mentioned the display, he rushed to the Museum and immediately realized that the paintings were not illustrations to the *A'in-i Akbari*, the third book of the *Akbarnama* that listed the institutions and administration of the court, but depicted historical events from the first two volumes. Moreover, they were ascribed to many of the artists Abu'l Fazl named in the text as being the finest of Akbar's court (pl. 23).[4] Even more excitingly, a holograph inscription on the first folio showed that the manuscript had once belonged to the emperor Jahangir (pl. 24).

There was, however, no colophon and no date on the incomplete manuscript. Beveridge hurriedly typed out a report on his discoveries, including summary descriptions of each painting, transliterations of the artists' names,

PLATE 23 Akbar receiving the Iranian
ambassador, Sayyed Beg, in 1562.
Double-page composition by La'l with
Ibrahim Kahar (left) and Nand, son of Ram
Das (right), c.1590–95
LEFT 31.1 × 19.2 cm IS 2-1896 28/117
RIGHT 30.8 × 19.1 cm IS 2-1896 27/117

and references to the Persian text of the Asiatic Society of Bengal edition.[5]
For convenience, he followed the Museum's numbering of the paintings,
which is not entirely accurate in relation to the original Persian numbering
and has caused confusion ever since. He mentioned that the text covered the
fifth to the twenty-second years of Akbar's reign, but was primarily con-
cerned with establishing the authenticity of the work and the importance of
its miniatures, recording his intention to publish more later.[6]

He also mentioned 'two boards covered over with lacquer paintings', and
concluded that these were of a later date, as a man smoking a *huqqa* could be
seen among the group of figures hunting in a landscape. Smoking was
unknown in Mughal India until 1604, when Akbar's ambassador to the
Deccan returned to the court with tobacco and a jewelled water pipe, intro-
ducing a habit that quickly spread.[7] The covers disappeared from the
Museum some time in the first half of the twentieth century and are now
known only from a black-and-white illustration.[8]

Beveridge was the first to evaluate the great importance of the paintings

and, since his discovery, most general publications on Mughal art, and almost all those dealing specifically with sixteenth-century Mughal painting, have included miniatures from the V&A *Akbarnama*. Surprisingly, however, codicological aspects were ignored for more than 70 years after the acquisition of the *Akbarnama*. The first monograph on the *Akbarnama* did not appear until 1984, and the extensive preparations made for the writing of the text, well known to historians and historiographers, have not been fully taken into account by many art historians when publishing the V&A pages.[9]

THE WRITING OF THE *AKBARNAMA*

On 4 March 1589, in his thirty-third year as emperor, Akbar ordered his friend the polymath Abu'l Fazl to write the history of his reign, confirming it in a second order on 19 May 1589.[10] The task was formidable, not least because Abu'l Fazl's rigorous approach meant that a huge mass of material had to be carefully sifted and considered.

A primary source was the official court records of the Record Office (*qanun-e waqi'a-nevis*) established in AH 982 (1574).[11] The regulation (*A'in*) for this department of the royal household shows the wealth of information available to Abu'l Fazl when writing the *A'in-i Akbari*.[12] The daily activities of the emperor were recorded in formidable detail, ranging from his official duties, which included issuing edicts, bestowing rank or promotion on particular individuals, receiving distinguished visitors at court (pl. 25) and ceremoniously dismissing them when their stay had come to an end, to personal information such as the food and drink he consumed, how long he slept, and the titles of books read out to him. Of major importance to the historian would have been the 'obituaries of well-known persons', 'battles, victories and peace', and 'the reports on events' from the different parts of the empire. The Record Office gathered this into a clearly written report for the emperor's approval, after which the permanent record was signed and sealed.

The material would have provided Abu'l Fazl's framework for the later part of his history. The author's privileged position at court meant that he was familiar with many of the events of which he wrote but, recognizing that his own perspective might be biased, he went to extraordinary lengths to produce an objective account: 'For each event I took the written testimony of more than twenty intelligent and cautious persons.'[13] Astonished by the discrepancies in their accounts of such relatively recent history, he diplomatically made the emperor the final arbiter.[14] Akbar, meanwhile, had made other preparations to assist the historian, as is known from the preface to Bayazid Bayat's volume of personal reminiscences, *Tazkira-ye Humayun va Akbar* ('A Memoir of Humayun and Akbar').[15] Bayazid Bayat had spent his early life in Tabriz and met Humayun during the emperor's exile in Iran, entering Mughal service in 1544. Later, in the entourage of Mun'im Khan,

PLATE 24 The first folio of the V&A *Akbarnama* text with royal inscriptions and seals of later owners.

36.5 × 22.5 cm

IS 2-1896 1/117

PLATE 25 Akbar greeting Rajput rulers and
other nobles at court, probably in 1577.
By Miskina, Sarwan and portraits by
Madhav, c.1590–95
32.9 × 19.8 cm
IS 2-1896 114/117

the *khan-i khanan*, he was to witness some of the most important events of
Akbar's reign, including Akbar's expedition to Kabul in 1585.[16] His appoint-
ment to high office in 1587 was suddenly interrupted by a stroke, and he
moved with the court to Lahore, where he built a house and commissioned
other architectural projects. As the paralysis caused by his stroke prevented
him from writing down his own account, Abu'l Fazl appointed a writer to
whom the events of 1542 to 1590 were dictated. Bayazid Bayat's preface
mentions Akbar's command to all court servants to record their recollections
of major events of his reign and that of Humayun.[17]

This may have been what prompted Jowhar, Humayun's *aftabachi* (ewer-
bearer) in AH 995 (1566–67) to begin writing the account of his life in
imperial service. This included the flight from India with Humayun across
Sind to Iran, and the conquests of Qandahar and Kabul, and ended with the
recapturing of India, Humayun's death and Akbar's accession. On completion
of the text, Jowhar gave it to Ilahdad Fayzi Sarhindi to be rewritten in ornate
prose, before being presented to Akbar at Lahore on 24 September 1589.[18]

Although Jowhar was probably encouraged to write his memoirs by Akbar,
he does not specifically say so. Babur's daughter, Gulbadan Begum, on the
other hand, states in the first line that she wrote her memoir, the *Humayun
Nama* ('Book of Humayun'), in response to Akbar's order (*hukm*).[19]

As well as books written primarily for Abu'l Fazl's use, earlier histories were
available. The original intention of the historian Arif Qandahari had been to
dedicate his book to his patron, Muzaffar Khan Turbati, under the title *Muzaffar
Nama*. However, when Muzaffar Khan inconveniently died in 1580, the author
offered it to Akbar with the new title, *Tarikh-i Akbari* ('The Akbarian History'),
completed in August 1581.[20] His sources seem to have included the papers
of high-ranking individuals,[21] and Abu'l Fazl must have had access to similar
collections. The richly-stocked royal library would have supplied a wide range
of histories in a variety of languages from the Islamic and Christian world, and
some of those dealing specifically with Hindustan included biographies of the
nobles of the court from the time of Humayun onwards.[22]

Babur's memoirs were an extremely important source, having recently
been translated from the original Chaghatai Turkish into Persian at Akbar's
command. Abu'l Fazl drew heavily on the new translation, entitled the
Baburnama, for his first volume outlining Akbar's genealogy and the history
of the Timurid dynasty up to Akbar's accession.[23]

ABU'L FAZL'S VERSIONS OF THE *AKBARNAMA*

Of great significance in the light of ensuing disagreement over the dating of
the V&A *Akbarnama* illustrations is the fact that Abu'l Fazl wrote five ver-
sions of his text.[24] The first stage was completed when the author, having
taken written testimonies and gained the emperor's approval, was satisfied

that he had written the most accurate version possible. At this point, 'no minute regard to details had taken place, and their chronological sequence had not been satisfactorily adjusted.'[25] He reworded the text, therefore, to take into account the Divine ('Ilahi') Era, the Iranian solar calendar introduced by Akbar at the beginning of the twenty-ninth year of his reign (10 March 1584), to replace the conventional lunar *hijri* calendar.[26]

Abu'l Fazl at first intended to divide the history into volumes that would each cover 30 years of the emperor's life.[27] When he had written his account up to the middle of the seventeenth regnal year (towards the end of 1572), however, he was forced to rearrange the text because Akbar ordered that the second volume should begin with his own birth.[28] When this was done, the book seems to have been circulated, as Abu'l Fazl records: 'Numerous expressions of satisfaction were felicitously evoked.'[29] It was still far from completion, however.

The text covering the first ten years of Akbar's reign was revised by Abu'l Fazl's brother, the great poet Fayzi, to give it a more literary turn, but he died in October 1594.[30] His death interrupted Abu'l Fazl's work, as the historian succumbed to grief that seems to have been accompanied by an intense anguish and crisis of confidence in what he could achieve without the guidance of his brother.[31]

By this time, three complete drafts had been written, but as Abu'l Fazl emerged from his mourning, he began a fourth, 'to remove any superfluous repetitions and give continuity to the easy flow of my exposition'.[32] This may be the version he notes having quickly finished after he returned to his work on 11 November 1595, despite his mental condition.[33] His dissatisfaction, and his apparent sudden release from despair concerning his writing, then inspired him to revise the entire text from the beginning.[34] This final, fifth version was finished on 16 April 1596.[35] The second volume had been intended to run from the seventeenth regnal year to the middle of the forty-seventh, but Abu'l Fazl presented it incomplete to Akbar in the forty-second year of the reign, AH 1006 (1598).[36]

THE DATING OF THE ILLUSTRATIONS

Various suggestions have been made as to when the undated illustrations may have been painted. When the 'Clarke manuscript' was first published, most authors dated them to about 1600,[37] a logical conclusion if the artists were thought to have been given the text only after its final completion in 1598. By 1969, advances in the study of Mughal painting made this seem stylistically too late, and a revised dating of about 1590 was generally accepted.[38]

Then, however, a theory evolved that the illustrations had been intended for another biography of Akbar, now lost, that had been superseded by Abu'l Fazl's definitive work, and that the paintings were simply recycled for the *Akbarnama*.[39]

ABOVE: PLATE 26 Detail of the court
assembly receiving Sayyed Beg (pl. 23),
showing replacement text panel.
IS 2-1896 27/117

RIGHT: PLATE 27 Akbar receiving his sons
at Fathpur in 1573 after the victorious
campaign in Gujarat.
By Kesav the Elder and Nar Singh,
c.1590–95
31.5 × 18.4 cm IS 2-1896 110/117

This seemed to be supported by certain characteristics of the painted pages,
unremarked until John Seyller drew attention to them, such as their unusual
thickness and the fact that their original text panels have almost all been replaced
by new text pasted on top (pl. 26).[40] He noted that only one page retains a frag-
ment of original text, written directly on to the paper (pl. 27), but was unable to
find the precise phrase in the published text of the *Akbarnama*.

The argument for the V&A paintings having been done for another, unknown
history of the reign may be dismissed, however. The events to be illustrated

PLATE 28 A meeting between the rebel
Bahadur Khan and the Mughal emissary,
Mir Mu'izz al-Mulk in 1565.
By Farrokh Beg, *c.*1590–95
27.1 × 17.1 cm
IS 2–1896 96/117

could have been decided upon as long as four years before Abu'l Fazl finally completed his work, as a version of the text was in circulation as early as AH 1001 (1592–93); Nezam ad-Din Ahmad, in his preface to the history of India from the tenth century onwards (*Tabaqat-i Akbari*), completed in that year, acknowledges Abu'l Fazl's *Akbarnama* as his most important source for Akbar's reign.[41]

Although there is certainly a diminishing of the close relation of the paintings to Abu'l Fazl's text towards the end of the manuscript, as will be seen, and at least one page may have been recycled from another work (pl. 28), the paintings accord closely with the detailed description of events

in Abu'l Fazl's text. The majority illustrate the particular incidents given significance of various kinds in the narrative; in the single instance where the original text can be read because it has been covered by gold paint rather than paper (pl. 30), it is apparent that Abu'l Fazl's text has simply been slightly rearranged.[42] The paintings were prepared for one version of the text, but their exact position was moved for the next one.

John Seyller's discovery of a date on one of the folios of the V&A text suggests that it may have been completed two years before the final version (pl. 29). Although the inscription is difficult to decipher, he noted that it clearly includes the month of Deymah and the regnal year 40, corresponding to December 1595–January 1596.[43]

However, a crucial omission from the text, so far overlooked, clearly demonstrates that the V&A recension predates the final version. Abu'l Fazl interrupts the events of the seventeenth regnal year in September 1572 to record his joy and relief at completing the first volume of his work, that is the history of the first 30 years of Akbar's life. This took place on 16 April 1596 (27 Sha'ban 1004), and the event is marked by a long peroration on his task. These pages are in the Bibliotheca Indica Persian edition of the *Akbarnama* used by Beveridge for his English translation, but are entirely missing from the V&A text.[44] This is not a question of pages having disappeared, since the V&A text continues without a break from the events of September 1572 to those immediately following. Abu'l Fazl's long preface to the beginning of the second volume is similarly missing.[45] The work of illustrating the text could have begun as early as 1590, shortly after Abu'l Fazl started his work, and was probably fully under-

PLATE 29 The inscription dated to the month of Deymah, fortieth regnal year, written on the back of an illustration to the *Akbarnama*.

IS 2-1896 84/117

way by 1592, when a usable draft was in general circulation. The paintings must have been finished by the end of 1595, the date on the text; this conclusion is supported by a brief reference in Abu'l Fazl's description of the *tasvir khana* (studio). He recorded that, at the time of writing, various books had already been illustrated by the royal artists, including 'this book', meaning the *Akbarnama*, 'His Majesty himself having indicated the scenes to be painted'.[46] Thus, in 1596, the long process of work was over, and the evidence for the emperor's own involvement in the choice of passages to be illustrated is compelling.

PLATE 30 The submission
of the rebel brothers Ali
Quli and Bahadur Khan.
By Kesav the Elder with
Chetar (right) and
Madhav the Elder (left),
c.1590–95
LEFT 32.7 × 18.4 cm
IS 2–1896 20/117
RIGHT 32.7 × 18.2 cm
IS 2–1896 19/117

THE VICTORIA AND ALBERT *AKBARNAMA*

The period of Akbar's life covered by the V&A text is extraordinarily inter-esting. It begins with the emperor's journey from the Panjab to the capital, Agra, in AH 968 (1560) and ends abruptly in the middle of 1577 with a description of a comet seen during a march from Ajmer, again to the Panjab.[47] During these years, the young ruler emerged from the controlling influence of Bayram Khan and, subsequently, the court faction led by the powerful Maham Anaga, Akbar's foster-mother, and her son Adham Khan.

PLATE 31 An attempt on Akbar's life in 1564.
By Jagan with Bhawani the Elder and faces by Madhav, *c.* 1590–95
33.8 × 19.4 cm
IS 2–1896 33/117

PLATE 32 Akbar's entry into the fort of Ranthambhor after the submission of Rai Sarjan Hada in 1568.
By La'l and Shankar, *c.* 1590–95
33.4 × 20 cm
IS 2–1896 76/117

PLATE 34 Rejoicings
at Fathpur on the birth
of Akbar's second son,
Murad, in 1570.
By Bhura with faces
by Basawan, c.1590–95
33.2 × 19.5 cm
IS 2-1896 80/117

PLATE 35 Akbar watching a
fight between two bands of
Hindu devotees at Thaneswar,
Panjab.
By Basawan with Tara the
Elder (right), and Asi, brother
of Miskina (left), c. 1590–95
LEFT 32.9 × 18.8 cm
IS 2-1896 62/117
RIGHT 32.9 × 18.7 cm
IS 2-1896 61/117

PLATE 36 The Battle of Sarnal,
Gujarat, in 1572.
By La'l with Sanwala (left)
and Babu Naqqash (right), c. 1590–95
LEFT 30.6 × 19.7 cm IS 2-1896 107/117
RIGHT 31.8 × 18.8 cm IS 2-1896 106/117

There was an assassination attempt on Akbar (pl. 31), and epic battles such as
the sieges of Ranthambhor (pl. 32) and Chitor in Rajasthan took place, both
illustrated in the V&A manuscript. The strategic and military experience
gained by his army, combined with his own bravery and daring, enabled the
emperor to extend his territory into western and eastern India. He rebuilt
the citadel of Agra and later founded a new city nearby called Fathpur (pl. 33),
following the births of his all-important male heirs there (pl. 34).[48] The
arrival of embassies from powerful neighbours meant that his own position
was acknowledged, and he met Europeans for the first time.

The significance of the V&A manuscript to the Mughal rulers is shown by
the collection of seal impressions and notes by successive owners on the first
and last folios (see pl. 24). Jahangir's alacrity in putting his mark on the book so
soon after his accession – it entered his library on 5 Azar in the first year of his

reign, AH 1014 (1605) – implies that it was one of the most important of his new acquisitions. It remained in royal ownership until the reign of Aurangzeb (1558–1707), as shown by a seal dated AH 1075 (1664), but by AH 1208 (1793) it had come into the possession of Raushan ad-daula Ghaleb Jang Munir al-Mulk, Ahmed Ali Khan Bahadur, whose seal is dated.[49]

The annotations by a contemporary librarian to most of the paintings on the lower border provide the names of their artists. In most cases, there are two names: the senior artist, responsible for the '*tarh*', usually taken to mean the overall design and direction of the work; and the junior artist responsible for the '*amal*', or 'work' (usually taken to be the painting).[50] In a few instances, the portraits of important characters in the scene are ascribed to their author, who is either a third artist, or the senior artist for that particular painting. From these notations alone, a considerable amount of information may be gleaned about the elusive artists of the Mughal court.

As Beveridge was the first to point out, in 1905, several were listed by Abu'l Fazl in his famous commentary on painting at court. Four were given particular prominence in his list: the first two were the Iranian masters *Mir* Sayyed Ali and *Khwaja* Abdu's Samad, who had by the 1590s probably long retired; the third, Daswanth, was certainly dead. The fourth was Basawan: 'In backgrounding, drawing of features, distribution of colours, portrait painting, and several other branches, he is most excellent, so much so that many critics prefer him to Daswanth.'[51] The V&A *Akbarnama* includes three double compositions and four single pages ascribed to Basawan, who was the portraitist on two other pictures (e.g. pl. 35).[52] Abu'l Fazl then lists 13 artists who 'have likewise attained fame', 12 of whom contributed either compositions or portraits to the V&A *Akbarnama*. La'l and Miskina, at the top, stand out as senior artists, La'l being responsible for the composition of nine single and five double-page compositions (e.g. pl. 36), and Miskina for ten single and four double-page compositions.[53]

Family relations are revealed in the attributions. Asi, for instance, the junior artist on a single painting, was the brother of the great artist Miskina;[54] Nand, or Nandi, was the son of Ram Das,[55] who may be the 'Ram' on Abu'l Fazl's list. The artists' names show them to be predominantly Hindu, with family ties in Gujarat[56] and Gwalior.[57]

Three contributions to the *Akbarnama* by another artist on the list, Farrokh Beg, stand out for their distinctive Iranian style and because, uniquely, they are by him alone rather than being a collaboration between two or more artists. One of these (see pl. 28) may have been intended for another manuscript, as its carefully erased calligraphy differs from that on all other pages in being contained within 'cloud' outlines rather than a rectangular frame. Another painting depicts Akbar's triumphant entry into Surat in 1572 and reveals certain aspects of the range of skills the artist must have brought with him in 1585, when he arrived at the Mughal court from Kabul (pl. 37).[58] The painting is

۱۲ فرّخ بیگ ۱۵۳

ABOVE: PLATE 38 Akbar hunting at Palam
near Delhi in 1568.
By Mukund with Manohar (right) and
Narayan (left), *c.* 1590–95
LEFT 33.1 × 20.3 cm IS 2-1896 70/117
RIGHT 34.6 × 20 cm IS 2-1896 71/117

OPPOSITE: PLATE 37 Akbar's triumphal entry
into Surat in 1572.
By Farrokh Beg, *c.* 1590–95
31.9 × 19.1 cm
IS 2-1896 117/117

executed with minute delicacy and a marked attention to architectural deco-
ration that is also seen in a painting in the Golshan Album in the Golestan
Palace.[59] In both works, inscriptions that are part of the architectural decoration
testify to the artist's skill as a calligrapher, and it is therefore likely that Farrokh
Beg was involved in designing this kind of ornamentation at the Mughal
court. The Golshan Album page includes a fine passage of gold illumination
demonstrating another talent so far unremarked by art historians.

A few junior artists who appear only fleetingly in the *Akbarnama* illustra-
tions, notably Mansur and Manohar (pl. 38),[60] continued to work in Jahangir's
atelier, where they would become leading masters with their own highly
distinctive styles.

3

ILLUSTRATING THE
AKBARNAMA

Abu'l Fazl's historical accuracy means that the *Akbarnama* is a primary source for all later historians, even when the character of Abu'l Fazl's prose is intensely disliked, and the V&A pages are often used as illustrations to their work.[1] Major political events are presented in a straightforward chronological and vividly descriptive fashion, and the dates and factual content of the work are generally accepted.

The appeal of the V&A *Akbarnama* paintings, with their vibrant colours and myriad details, is so strong that they have often been reproduced as individual works of art, their role as text illustrations largely ignored. When they are considered in relation to the text they so clearly illustrate, however, there is no rhythm and seemingly little logic to their placement. There is a heavy concentration of illustrations in the first half of the book, including three paintings in the first three folios alone, while the last 140 pages, covering equally dramatic and important events, have only five pictures. Some years lack any illustration at all, and particular incidents seem to be given a significance beyond their immediate context by virtue of being illustrated. This rather bewildering arrangement is more easily explicable, however, if the illustrations are considered in close relation to the events described in the *Akbarnama* to the end of the fifteenth regnal year, AH 977 (1571).

As has been seen, all the events are as historically accurate as Abu'l Fazl could make them, but they are presented from a very particular perspective. The historian's intention is clear, as indicated by his concluding remarks to the entire work: 'This history is intended to serve as a lesson-book of political science for the instruction of mankind and as a moral treatise for the practical teaching of subjects in the right conduct of life.'[2]

Abu'l Fazl elaborates on his approach several times in the *Akbarnama*, notably in the preface to Akbar's accession: 'The chain of arrangements in

Creation's work-shop, which is a truth-showing exhibition of evidences, and an illustration of self-existent power, needs to be linked to the sway of a lofty soul.'[3] The close examination of a reign through a ruler such as Akbar thus reveals the splendour of God, and Abu'l Fazl explains this further in a long passage at the end of the *Ain-i Akbari*, where his guiding principles are put forward. Akbar's unrivalled greatness as a ruler rests on two foundations: the first is his ability to 'secure the benediction of God', which is the means to eternal life; the second, his good reputation in the material world, achieved through virtue and sincerity of intention.[4] When these two are found together, as in the person of Akbar, 'the primordial intelligence of nature itself stands amazed and the wonder-working heavens are confounded.'[5]

The explanation of Akbar's ability to move metaphorically between the two dominions, the material and the spiritual, in order to enlighten the world, is the guiding principle behind the historian's approach. Events are often seen as illuminating particular principles, and the pictures reinforce this. To a great extent, his approach explains why certain incidents are selected, whereas others, seemingly worthy of inclusion, are not. This is apparent from the beginning of the V&A series.

THE ROYAL HUNT

The opening illustration depicts Akbar hunting, in what seems to be simply a standard royal image (pl. 39). The text makes it clear, however, that the event was particularly significant in the emperor's life, and followed arguably the most important occurrence of his reign to date.

The preceding chapters had charted the deterioration of the relationship between Akbar and Bayram Khan, the Chief Minister or *khan-i khanan*, and *de facto* ruler of the empire.[6] His ambitions led him towards rebellion, and by March 1560 Akbar was forced to act. Leaving Agra on the pretext of setting out on a hunting expedition, Akbar moved to Delhi, the seat of government, without alerting Bayram Khan, and from there declared that Bayram Khan's authority as *khan-i khanan* had been withdrawn.[7] The group supporting Akbar included one of his closest and most trusted servants, Maham Anaga, who had been his wetnurse and now effectively became *vakil* (the most influential position at court).[8] When Bayram Khan seemed to be on the point of moving to the Panjab, from where he would have been able to attack the capital, Akbar himself led a force to block the route.

In the end, Bayram Khan avoided ignominy by relinquishing the emblems of his office and taking the escape route suggested by Akbar of leaving for Mecca.[9] On the way to the Gujarati pilgrimage port of Surat, he was assassinated, and his son and wife were taken under Akbar's protection (pl. 40), though these events are not mentioned (or illustrated) until later in the text,

PLATE 40 The young Abd ur-Rahim is taken
into royal protection after the assassination
of his father, Bayram Khan, on his way to
Mecca in 1561.
By Mukund, c.1590–95
32.1 × 18.9 cm
IS 2–1896 6/117

when the news actually reached the court.[10] With Bayram Khan out of the
way, and the affairs of the Panjab set in order, the 18-year-old Akbar must
have felt an exhilarating sense of freedom in taking control for the first time.
It is at this point that the V&A text begins.[11]

Akbar and his entourage left the Panjab for Delhi, taking a detour to Hisar
Firuza in order to hunt. Although, as one of the stock images of Iranian art
and literature, the royal hunter is a fitting opening to the chapter marking his
independence from Bayram Khan, this subject is portrayed in an unusual

PLATE 41 Akbar kills a tigress defending her
offspring near the fort of Narwar in 1561.
By Basawan (including portraits) with
Sarwan (left) and Tara the Elder (right),
c.1590–95

LEFT 31.7 × 19.2 cm IS 2-1896 18/117
RIGHT 31.5 × 19.1 cm IS 2-1896 17/117

way. The event had another nuance, highlighting Akbar's skill as a hunter.
The chronicler notes that the capture of cheetahs was the most remarkable
of all the arts of the hunt in Hindustan: the animals had to be lured into
specially dug pits. This occasion was the first time that Akbar himself had
ever caught one.[12] The artist emphasizes the emperor's intimate involvement
with the scene by showing him crouching down to attach a collar to the
cheetah's neck, and by placing him on the ground among his entourage
rather than slightly elevated and separate from them.

Similarly, other hunting scenes are more than general records of Akbar's
favourite pastime. Two dramatic paintings on the same opening by Basawan
depict sequential scenes from a journey made by the emperor and his
entourage in 1561, returning to Agra and hunting as they progressed (pl. 41
above). Hunting was not simply an amusement; it was also a very shrewd
stratagem. The royal cavalcade was a fighting force, and hunting expeditions
were often the best means of moving troops freely round an area to monitor

PLATE 42 Akbar hunts near Lahore in 1567, while Hamid Bakari is punished by having his head shaved and being made to ride an ass backwards.
By Miskina with Mansur (left) and Sarwan (right), c.1590–95
LEFT 32.1 × 18.6 cm IS 2-1896 56/117
RIGHT 32.3 × 18.9 cm IS 2-1896 55/117

possible sedition without provoking alarm.[13] During the hunt, a fierce tigress suddenly sprang out from the forest and, wild with rage, lashed out to protect her five cubs. Abu'l Fazl records that Akbar's companions froze in terror, the hairs on their bodies standing on end, but the emperor reacted instantly, killing the tigress with one stroke of his sword.[14] Her five offspring were then killed by Akbar's companions. The tigress was the first beast of prey killed by Akbar in an incident where his bravery was notable.

The finest hunting scene in the V&A pages is the double page composition designed by Miskina (pl. 42). At the beginning of the twelfth regnal year, Akbar was encamped in the royal city of Lahore where, on 11 March 1567 (29 Sha'ban AH 974) the Nowruz (New Year) celebrations were held.[15] The emperor decided to hold a *qamargah*, a spectacular hunt in the style of the Timurids. A ten-mile circular area was marked out, and all the game within it was driven towards the centre from the outer edges. As the circumference was drawn in like a noose, the trapped animals were hunted down.

حال حدذ ساخه رمین مجن بری حالی سرعبذ دولت شد و نوارش سیعاپے قخاوت

والحضرت خالدین ابالحا است ان حصن حصین گذ اشته

۱۳ آمدن حاکم قلعه کاران بلا ارت ۹٤ حضرت دکلید دلعه اوردن و نوارش یافتن

PLATE 43 The governor of Gagraun fort
surrenders the keys to Akbar in 1561.
By Madhav the Elder, c.1590–95
31.8 × 18.2 cm
IS 2-1896 14/117

For five successive days, during the day or by torchlight at night, the nobles of the court and the emperor killed them, the servants then being allowed to take their share.

According to one source,[16] the hunt was the greatest ever held; as such, the reasons for its illustration seem obvious. The fact that it re-enacted a Timurid ceremonial made it even more significant. The regulations of Chinghiz Khan, promulgated in 1206 and adopted to some extent by the Timurid rulers, emphasized the importance of hunting as a means of keeping the army alert and efficient. This was not by any means exclusive to the Timurids, but the specific regulations of the *Turah-i Chinghizi* seem to have been applied to the organization of the Mughal *qamargah* in 1567.[17] The *qamargah* was the prerogative of the emperor, the princes and nobles being allowed to participate only at his invitation. The right-hand side of the composition shows Akbar hunting alone; on the left side he appears again, accompanied by another hunter, presumably one of his sons, at the edge of the enclosure.

The event is recorded in a stylized way that reduces the vast hunt to a metaphorical area, the swirling movement of the animals brilliantly suggesting the swiftness of the hunt. Also included is a reference to an incident that happened during the *qamargah*, when Hamid Bakari shot at one of Akbar's servants. The emperor ordered Qilij Khan to 'relieve that unruly one of the burden on his neck', but after two attempts to cut off his head failed, Hamid Bakari was deemed to have been saved by destiny. Instead, he was ritually humiliated by having his head shaved and being paraded round the hunting ground sitting backwards on an ass.

THE DEPICTION OF TREACHERY

The early years of this phase of Akbar's life were full of betrayal, even by his most trusted servants such as Mun'im Khan, who replaced Bayram Khan as *khan-i khanan*. Abu'l Fazl claims that Akbar was always aware of duplicity, even if he did not show it. To some extent this was probably true; his position was not yet sufficiently strong to allow him to control all the various factions who wished to depose the young emperor. The behaviour of Maham Anaga's younger son, Adham Khan, for example, was consistently disloyal but, given the need to have the mother's suppport, Akbar must have felt unable to act until Adham Khan's offences could no longer be ignored.

The conquest of Malwa at the beginning of the fifth regnal year, AH 968 (1561),[18] was the first important victory of the Mughal army since Bayram Khan's death. It was a campaign long planned, and Adham Khan had led the Mughal army. As he chased after Baz Bahadur, Malwa's ruler, however, 'the cap of his pride was blown away by the wind of arrogance', and he took for himself such royal prerogatives as distributing alms as thanksgiving, and

OPPOSITE: PLATE 44 Adham Khan pays
homage to Akbar at Sarangpur in 1561.
By Khem Karan, c.1590–95
33.5 × 19.9 cm
IS 2-1896 15/117

PLATE 45 Baz Bahadur's dancers from
Mandu perform for Akbar in 1561.
By Kesav the Elder with Dharmdas,
c.1590–95
32.7 × 18.7 cm
IS 2-1896 16/117

rewarding his leading officers. He also kept the considerable spoils of war, including Baz Bahadur's renowned dancing girls.[19]

The illustration of an apparently insignificant event, when Akbar stopped at the fort of Gagraun and was given the keys by its unnamed governor, should probably be interpreted against this background (pl. 43).[20] The chapter had opened in the way that characterizes Abu'l Fazl's history, whereby historical events are simultaneously seen as examples of general principles. In this case, the principle is that, 'whenever the world-adorning Deity establishes the pillars of an auspicious one He totally subverts his opponents.'[21] Akbar had realized that, after the conquest of Malwa, Adham Khan might harbour more grandiose designs. Leaving Agra in the charge of Mun'im Khan, he took a small army to investigate for himself the state of affairs in the province, and discovered on the way that the strategic fort of Gagraun was still under Baz Bahadur's control. He halted warningly outside the ramparts and, 'when the governor became aware that the Shahinshah was casting the shadow of conquest over the fort', he immediately made over to the emperor the keys to the citadel and kissed the ground before him in submission.[22] The emperor's power was by now such that his mere presence could persuade potential foes to make peace.

From here, Akbar travelled on to confront Adham Khan at Sarangpur, moving with such speed that the would-be rebel and his band were thrown into confusion. Caught unawares, Adham Khan immediately placed 'the face of servitude in the dust of supplication and was exalted by kissing the stirrup' (pl. 44).[23] Abu'l Fazl's stock image of Akbar's 'world-illuminating beauty' is alluded to in the painting by the emperor's isolation against a golden yellow ground. The standard above his head is one of the insignia of royalty.[24]

The following illustration to the text depicts a performance by dancers taken from Baz Bahadur's household but also contains within it the theme of treachery (pl. 45). On one level it is simply a depiction of the celebrations following the defeat of a worthy foe, when Adham Khan had finally handed over the spoils of the Malwa conquest, including dancers, at an entertainment arranged by his mother for the emperor. However, it also implicitly refers to Adham Khan's indefensible behaviour, as the text makes clear. 'Two special beauties from among Baz Bahadur's women who had recently been exhibited to His Majesty' had been abducted by Adham Khan. When this

OPPOSITE: PLATE 46 Adham Khan is flung
to his death from the palace walls at Agra
in 1562.
By Miskina (including portraits) with
Shankar, *c.*1590–95
29.9 × 19.4 cm
IS 2-1896 29/117

was discovered, his mother rashly had the two dancers killed to prevent them
from telling the emperor what had happened (though Abu'l Fazl claims he
was perfectly aware of the facts).[25] In giving such prominence to the two ill-
fated dancers, the painting carries with it the resonance of Adham Khan's
downfall and Maham Anaga's subsequent humiliation.

Adham Khan's long-expected downfall is illustrated later in the manu-
script, in a scene vividly realizing the drama of the text (pl. 46). The event is
described as the occasion when the majesty and justice of the emperor were
unveiled, and Akbar's God-given reason allowed him great powers of under-
standing, coupled with forbearance. To this was added the gift of 'the price-
less jewel of justice, so that he can place the familiar friend and the stranger
in the same balance and can comprehend the affairs of Creation's Workshop
[the world] without being weighted by personal considerations.' The final
episode of Adham Khan's story demonstrates the principle.

On 12 Ramzan AH 969 (16 May 1562), he burst into a gathering of senior
court officials with his companions, one of whom murdered the Ataga
Khan, Mun'im Khan. Adham Khan then rushed towards the *zanana*
(women's quarters), where Akbar was sleeping, but the eunuch guarding the
door locked it to prevent him entering. Woken by the clamour, Akbar came
out of another doorway, sword in hand. As Adham Khan reached for his
weapon, the emperor struck him with his own sword and the rebel fell to
the ground. Clearly, the outrage could not be forgiven and Akbar ordered
Adham Khan to be thrown immediately from a terrace. This failed to kill
him, and he was thrown again on to the stone floor: 'this time they dragged
him up by the hair and in accordance with orders flung him headlong so
that his neck was broken and his brains destroyed.'[26]

SCENES OF PRESTIGE

Between scenes of treachery and their successful outwitting – all illustrations
of general principles – counterbalancing illustrations are inserted that
enhance the emperor's prestige. The appearance at court of the troublesome
brothers Ali Quli Khan-i Zaman and Bahadur Khan to pay homage and
present elephants in 1561 is shown in a double-page composition (see pl. 30),
but a comparable scene occuring at the same time, the arrival of the governor
of the Panjab with his own impressive gifts, is not shown at all. The reason
for this would seem to be that several morals may be drawn from the rela-
tionship between Akbar and the brothers.

Their arrival is prefaced by a commentary on loyalty and nobility of spirit,
contrasting the benefits these sentiments confer when sincerely held with
what happens when they are mere outward display. Khan-i Zaman and
Bahadur Khan illustrate the point perfectly, given their subsequent, sustained
rebellion. They are depicted beneath the feet of the emperor, who sits on an

upper storey of the court building, bowing deeply before Akbar in apparent 'shame and repentance'. The text on the pages, which has been erased from the left half of the composition and recopied on to a new strip for the preceding half, notes the presentation of gifts (*pishkesh*), the secondary focus of the scene. The gifts, including the immensely valuable elephants, which were sufficiently magnificent to have personal names, are recorded by the treasurer in the centre of the left-hand page.

The reception of the ambassador of Shah Tahmasp of Iran in the seventh regnal year was probably included to stress Akbar's increasing dominion after the 1561 Malwa victory (see pl. 23). Sayyed Beg's reception at court was a splendid event in its own right, but also had the immense symbolic importance of demonstrating that Akbar was now seen as a powerful ruler by the outside world.[27] The ambassador conveyed the Shah's formal condolences to Akbar for Humayun's death and congratulated him on his accession.

BATTLES

The period covered by the V&A pages was one in which battles featured heavily as Akbar vigorously expanded his empire. The key battles against opponents such as Baz Bahadur are obvious subjects for illustration, the worthiness of the foe enhancing the prestige of the emperor. The capture of Fort Mirtha is a prime example of how they are presented. As Akbar ruled by divine will, the success of those sharing in 'the blissful abode of loyalty' was necessarily also God-given, and the victory against the valiant Rajput forces defending the impregnable fort was proof of the principle. Success in this instance was deemed to be the inevitable result of the sincere loyalty of the Mughal general, Sharaf ad-Din Husayn Mirza, to Akbar.

Other great battles were treated slightly differently. The account of the campaign against the queen of Gondwana, or Garha Katanga (in present-day Madhya Pradesh), in 1564, for example, covered several pages but was given only one, double-page, composition, as the victory, though important in itself (no Muslim army had ever before been able to conquer the territory), was not considered an illustration of an underlying truth.[28] The victory also yielded rich spoils of war, and the annexation of the kingdom to the empire marked the beginning of a systemic expansionist policy summed up in one of Akbar's sayings: 'A monarch should be ever intent on conquest, otherwise his enemies rise in arms against him.'[29]

The great sieges of the Rajasthani forts of Chitor in 1567–68 and Ranthambhor the following year, and the later campaigns in Gujarat, lack the kind of preface or conclusion Abu'l Fazl often wrote to explain the broader significance of a particular event. Their intrinsic significance is self-evident, and in each the role of the emperor is dominant. They are described in detail, with a series of paintings showing the key events.

The siege of Chitor, in particular, was of huge strategic and symbolic importance. In September 1567, when the campaign began, Akbar had just fought off the threat to his survival by the Uzbeks in the Panjab when another faction, the Timurid princes or Mirzas, also rebelled but were chased off to Gujarat. Success in Rajasthan would not only guarantee the security of the routes to Gujarat and the Deccan, but would also show the emperor to be invincible, if fortresses widely regarded as impregnable could be taken, and other potential rebels might be deterred from acting. The Mewar rulers of Chitor, the 'sky-based fortress', were perfect candidates to emphasize the point. Fiercely independent, they had vowed not even to make matrimonial alliances with the Mughal house.[30]

As the Mughal army pitched camp in October 1567 a wild storm raged, the wind blowing the tents while thunder rolled and lightning filled the skies. Suddenly, the sky cleared and the fortress appeared before them. A poem notes 'the bird of the imagination could not reach it; no one knew its nature and condition.'[31] Over the next month, the fort was reconnoitred and batteries constructed. Hasty direct assaults were made, causing disastrous losses on the Mughal side, including the accidental explosion of a mine, all meticulously recorded in the text, which the illustration follows closely (pl. 47):

> All at once the second mine exploded and the troops who were entering, and also a body of their opponents who were preparing to prevent them, were involved in the catastrophe and their souls severed from their bodies by the fierce storm. Their limbs were blown here and there, and stones were carried for leagues.[32]

About 100 notable men were among them, including 20 known personally to Akbar. A more patient approach was essential if victory was to be won, and covered ways called *sabats* were constructed under the direction of the Rajput Raja Todar Mal and Qasim Khan, the master of ordnance, in order to allow the Mughals to approach the fort. The emperor monitored progress carefully, and early one morning, as he surveyed the ramparts, saw a man wearing a cuirass of a type known as the *hazar mikhi* ('thousand nails'), directing the enemy forces (pl. 48). As this was worn only by men of rank, Akbar fired; the man fell to the ground and was not seen again. Shortly afterwards, Akbar and his companions saw fires breaking out in several places in the fort. It became clear that he had killed the Mewar general, the brave Jaimal,[33] and that the fires were the *jowhar*, the burning of the women that took place when defeat was certain, to avoid them falling into enemy hands. These are the themes of the next two illustrations of the Chitor campaign. The Mughal army killed nearly 30,000 in the massacre that followed, their treatment unusually harsh because the Rajputs had resisted fiercely, rather than surrendering.

PLATE 47 A mine explodes
in 1567 during the siege of
Chitor, killing many of the
Mughal forces.
By Miskina with Bhura (left)
and Sarwan (right), c.1590–95
LEFT 33 × 19.1 cm
IS 2–1896 67/117
RIGHT 33 × 18.8 cm
IS 2–1896 66/117

PLATE 48 Akbar shoots the Rajput hero
Jaimal in 1568 during the siege of Chitor,
after which his followers surrendered.
Artist(s) not identified, *c.*1590–95
32.1 × 19 cm
IS 2-1896 68/117

Illustrations of the other great Rajasthani campaign, the siege of Ranthambhor fort, follow the text equally closely and, again, have no general principles. The importance of such campaigns by a Muslim army – the first to succeed since the time of Ala ad-Din Khalji in 1303 – needed no further gloss. Moreover, it had taken Ala ad-Din a year to defeat Ranthambhor, whereas Akbar succeeded in a month.[34] After these victories, the rest of Rajasthan was easily subdued, and the emperor turned his attention to Gujarat, the third great campaign of the reign.

Here, Akbar's motivation was not simply expansionism, as Abu'l Fazl records that there was no desire to take over kingdoms that were justly ruled. Gujarat, however, was unstable, and pre-emptive action was needed to prevent rebellions spilling over into Mughal territory. In addition, the troublesome Mirzas had taken refuge there, and the safe passage of pilgrims sailing from Surat to Mecca had to be secured, as did the important commercial port of Cambay.[35]

The imperial forces left Fathpur on 4 July 1572,[36] reaching the borders of Gujarat in October.[37] Ahmadabad fell the following month: 'merely by the glance of the Shahinshah, a work which a crowd of men would have regarded as difficult was accomplished with ease.'[38] Cambay followed, and then decisive action was taken against the Mirzas, who continued to cause trouble despite Akbar's presence. With a small band of 200 men he made a daring raid on their army, defeating the 1,000-strong force. Verses celebrated the victory, to which a double-page composition is devoted (see pl. 36), and Abu'l Fazl concluded that 'the account of this great masterpiece is beyond the mould of language.'[39]

Surat surrendered on 26 February 1573 under Raja Todar Mal's expert guidance, and one of the significant events that followed was the meeting with the Portuguese deputation who had been invited to Goa by the Mirzas but who now thought it wise to pay a friendly visit to Akbar instead. This contact is alluded to by the inclusion of a Portuguese figure in the crowd watching Akbar's triumphal procession (see pl. 37) and would lead, eventually, to the first Jesuit mission to the Mughal court in 1582.

THE LIFE OF THE KING

Abu'l Fazl adopted a more reflective approach when describing the personal life of the emperor. The dramatic pace of the grand campaigns and major political events slows down, and incidents are included to illuminate the special qualities of Akbar's nature. In these interludes, even seemingly prosaic characteristics of the emperor's personality are given multiple layers of meaning.

His love of sport is mentioned frequently in the pages of the *Akbarnama*. From the age of 14, he had revelled in riding 'must' elephants (*mast*, a male elephant in a state of frenzy) and was renowned for his bravery and skill in

PLATE 49 Akbar riding the elephant Hawa'i pursuing another elephant across a collapsing bridge of boats in 1561. Artist(s) unidentified on the left side; right side by Basawan and Chetar, c.1590–95

LEFT 34.4 × 21.5 cm

IS 2-1896 22/117

RIGHT 34.4 × 21.3 cm

IS 2-1896 21/117

PLATE 51 Rejoicings at the birth of
Prince Salim at Fathpur in 1569.
By Kesav the Elder with Dharmdas,
c.1590–95
32 × 18.9 cm
IS 2-1896 78/117

OPPOSITE: PLATE 50 Akbar fulfilling his
vow to travel on foot from Agra to Ajmer,
following the birth of his son Salim.
By Basawan with Nand Gwaliari, c.1590–95
33.4 × 19.1 cm
IS 2-1896 77/117

this dangerous pastime.[40] A particular incident in AH 968
(1561–62) stood out, and must have been regularly retold;
Jahangir recalls it years later in his memoirs (pl. 49).[41]
Few of the mahouts were able to ride one of the royal
elephants, Hawa'i, due to its ferocity. Akbar's audacity in
mounting it and goading it to fight an equally terrifying
opponent in one of the court's favourite pastimes was
so insistent and apparently foolhardy that the worried
onlookers called the prime minister, the Ataga Khan, to
try to remonstrate with him. Akbar ordered them to be
silent while he continued his alarming game. The
second elephant fled with Akbar chasing him on
Hawa'i, crossing the River Jumna on a bridge of boats
that rocked under the weight of the 'mountainlike ele-
phants'. As servants flung themselves from the boats into
the water, the emperor finally brought the elephant
under control.[42]

The author explains the broader significance of the
event. Elephant fighting is a means of testing the quali-
ties of men that might be revealed more honestly than
during a hunt. Although the Hawa'i incident might
cause the 'short-sighted ones' (and it is difficult from his
tone not to conclude that Abu'l Fazl was among them)
to imagine the brain of the 'Ruler of Time' was dis-
turbed, Akbar himself told the chronicler why he had
taken such risks: 'If I have knowingly taken a step which is displeasing to
God or have knowingly made an aspiration which was not according to His
pleasure, may that elephant finish us, for we cannot support the burden of
life under God's displeasures.'[43] Even when seemingly engaged in life's
events, the emperor was 'ever regardful of the real, guiding thread and . . . is
outwardly with the creature, and inwardly with the Creator'. This 'guiding
thread' in Akbar's life runs through the pages of Abu'l Fazl's history.

Between the sixth and eighth regnal years Akbar's main preoccupations
were to keep a firm hold on government and to fight off sedition. He also
embarked on spiritual quests, however, seeking out the company of 'jogis,
sanyasis and qalandars and other solitary sitters in the dust, and insouciant
recluses'.[44] He had made the first of a series of visits to the shrine of Mu'in
ad-Din Chishti at Ajmer in 1562 as part of his quest for truth, and his desire
to be with 'travellers on the road of holiness'. Basawan's painting (see pl. 1) of
a subsequent arrival at the shrine is one of the finest of the entire V&A
series. Although the visit itself is described in only a few lines in the text, it is
the general subject of several pages.[45]

Although Akbar regularly returned to Ajmer on pilgrimage until 1579,

PLATE 52 Akbar in a mystical trance while lost in the desert in 1571.
By Mahesh, portraits by Kesav, c.1590–95
33.4 × 20.1 cm
IS 2-1896 84/117

usually after military victories, only one other illustration records it, when he returned to give thanks for the birth of his son Salim, in August 1569. The arrival of a long-awaited son was attributed to the intercession of Shaykh Salim Chishti, after whom the boy was named, and Akbar had vowed to walk from Agra to the shrine of founder of the Chishti order at Ajmer, a distance of about 230 miles, if his desire should be fulfilled (pl. 50).[46] The agitation of the scene of rejoicing following Salim's birth in 1569 vividly suggests the clamour that must have surrounded the bedchamber (pl. 51). The birth of Salim's brother shortly afterwards is also included (see pl. 34); the structures in the painting are probably anachronistically depicted, as the city Akbar built near the saint's dwelling at Sikri was not yet complete. Originally called Fathabad, the city was renamed Fathpur after the Gujarat campaign, and came to be known as Fatehpur Sikri.[47]

The emperor's unusually contemplative and spiritual turn of mind at this period is emphasized in the illustrations. On a journey to the shrine of Farid Shakarganj in the Panjab, when Akbar seemed to be simply hunting, Abu'l Fazl recorded, 'there was in his heart the longing to know God.' Separating from his companions, Akbar became lost and increasingly weak in a hot, barren landscape without water (pl. 52). 'A strange condition supervened, and the weakness from thirst increased to such a degree that he lost the power of speech.' At this point the frantic entourage managed to find him, the chronicler reporting that 'a Divine message impressed itself by a mystic tongue on the heart of His Majesty that he should consider his own holy person and be more careful in guarding it, for in reality that was the ... returning of thanks for Divine favours, and the preserving of the Divine gifts.'[48] Akbar's spiritual condition is expressed in the illustration of this curious incident by his isolation in the composition.

When Akbar had made his first pilgrimage to Ajmer during Nowruz AH 969 (1562), the emperor's fortunes seemed to be entering a new, auspicious phase, and Abu'l Fazl describes the emperor as emerging from behind a 'veil' that had concealed his true thoughts and personality. Imperial justice is now a recurring theme, interwoven with the description of a real event, the construction of Agra fort, the 'principal event' of the tenth regnal year. The accomplishment of each aspect of kingship was deemed to have its proper time, whether it concerned the capture of fortresses to increase safety and to enhance honour and prestige, or the improvement of agricultural practice for the general good. The present period was the time for building a fortress at Agra, to be 'stable like the foundation of the dominion of the sublime family and permanent like the pillars of its fortunes' (pl. 53).[49]

Abu'l Fazl's metaphor of the geometrical perfection of the building echoes a motif used in the previous page, in which the measured progression of other grand projects initiated by Akbar is said to be perceptible to those with mathematical minds. It is, therefore, not surprising that the construction

وازاسباب پیل کگره میکهانی آشیده سرخ آئین مرکی درصفا آئیکه کیسی غا و درزنگ کلکوبه رخسا واقبال توانذ بود د
جنان یا بهم وصل یافت کمرموی را درزان راه نبود و این جصا رعالی کمشال ان مهد سپ خال مبذیه درعس صن

PLATE 53 Akbar
supervising the
construction of
Agra fort.
By Miskina
with Sarwan
(IS 2–1896 45/117) and
Tulsi Khord
(IS 2–1896 46/117),
c.1590–95
LEFT 32.8 × 20.0 cm
IS 2–1896 46/117
RIGHT 32.8 × 19.6 cm
IS 2–1896 45/117

of the Agra fortress should be shown over two pages (both by Miskina and side by side, though not entirely convincing as a double composition). Their wealth of detail demonstrates the verisimilitude Akbar's artists were able to provide from first-hand experience.[50]

Similarly, Akbar's order for the building of Fathpur provides an opportunity for him to be seen as 'architect of the spiritual and physical world' (pl. 54).

PLATE 54 Akbar inspecting the construction of Fathpur in 1571.
By Tulsi the Elder with Bandi, and portraits by Madhav the Younger, c. 1590–95
32.7 × 19.5 cm
IS 2-1896 91/117

As his architects made new foundations for the city, the emperor was 'making strong the foundations of justice' of his empire.[51] Akbar's primacy in this composition emphasizes the role Abu'l Fazl describes.

TEXT AND IMAGE

The association of text with the images of the V&A *Akbarnama* manuscript would seem not to be in doubt, even though the precise arrangement of illustrations in a version that was clearly not the final one underwent changes. Abu'l Fazl was given two significant promotions during the time he wrote the book, presumably marking key stages towards completion of his work: in 1592 he was made up to the rank of commander of 2,000 horsemen,[52] and in 1595 to commander of 2,500 horsemen in the *mansab* system of the Mughal court. The paintings could have been started by 1592, when the text was known to be in circulation (on the evidence of Bayazid Bayat), if not earlier, and were obviously completed by the end of 1595, the date on the V&A text.

As the text was being revised and recopied, the pictures would have been renumbered, and the pages immediately preceding paintings would have had their text adjusted by arranging it in geometrical patterns to spread it out and allow the picture to appear in the correct place.[53] There is, nevertheless, considerable awkwardness in the replacement text on the pictures themselves, with some fragments uncomfortably compressed into the space, and others too thinly spread out (see pl. 27), and some panels prepared but not filled in (pl. 55).

One painting, Farrokh Beg's supposed depiction of an interview between the royal emissary *Mir* Mu'izz al-Mulk and the rebel Bahadur Khan, could depict almost any scene of individuals meeting (see pl. 28). Moreover, the cloud outlines showing where text at top and bottom was subsequently carefully erased are unique in the series; this is an isolated case where it does seem possible that a painting intended for another work has been reused.

In the later part of the manuscript, following the point at which Abu'l Fazl would revise the work to include the long conclusion to the second volume and preface to the third volume found in the final recension, a change in the relation of text and image is discernible. Few of the pictures have text panels, meaning that in one or two cases they cannot be identified with certainty, although most continue to illustrate the history very precisely.

PLATE 55 The burning of the Rajput women following the fall of Chitor in 1568. Artist(s) not identified, c.1590–95
32 × 19.2 cm
IS 2-1896 69/117

Those with panels are the two paintings forming a double composition that has been shown by John Seyller to be original (one half is shown in pl. 27), and another double composition, also with original text but here concealed by gold.[54] It seems possible that Abu'l Fazl's final editing meant that the careful placing of illustrations with their revised text was interrupted and, for reasons that may remain unknown, never finished.

4

THE BABURNAMA
AND BEYOND

PLATE 56 The encampment before Kabul in
1507 before the attack on the rebels holding
the city.
Illustration to the *Baburnama, c.*1590
25.6 × 13.7 cm (page [max.] 26.5 × 16 cm)
IM 271-1913

Although the production of the *Akbarnama* was clearly a major
preoccupation of the royal studio during the 1590s, the royal
artists were also busily occupied on a range of other substan-
tial projects. Major historical manuscripts included the *Tarikh-i Alfi* ('History
of the Millennium'), commissioned by Akbar in 1582 to cover the period
ending with AH 1000 (1591–92) and then illustrated, although few pages have
survived.[1] The *Jami' al-tavarikh* ('History of the World') belonged to a famil-
iar literary genre, and remains almost intact, with 98 paintings and a
colophon dating it to 27 Ramadan AH 1004 (25 May 1596).[2]

Exquisitely illustrated volumes of poems included a *Khamsa* of Nezami
and a *Baharistan* of Jami, both dated to 1595, and important translation pro-
jects led to multiple copies of new texts being produced, which were some-
times illustrated in other courtly workshops, notably that of the *khan-i
khanan* Abd ur-Rahim.[3] Some manuscripts of this period are well known to
scholars; others are either inaccessible,[4] or have long been broken up, the
paintings detached from their bindings and colophons, surviving only as
stray pages scattered across the world and sometimes lacking any text at all.
For these, even determining the subject of the painting may be impossible
and dating becomes highly subjective, making the task of creating a clear
stylistic framework for Mughal painting during these dazzling years all the
more difficult.[5]

One project demonstrates some of these problems. The translation of
Babur's memoirs from their original Turki, or Chaghatay Turkish, the spoken
language of the Timurids, into Persian must have been an undertaking close
to his grandson's heart.[6] Akbar chose Abd ur-Rahim, his *khan-i khanan*, as
translator, and few could have been better qualified. His father, Bayram
Khan, had been in Babur's service, and Abd ur-Rahim himself knew Persian,
Turki and Hindi.[7] Towards the end of November 1589, Abu'l Fazl recorded:

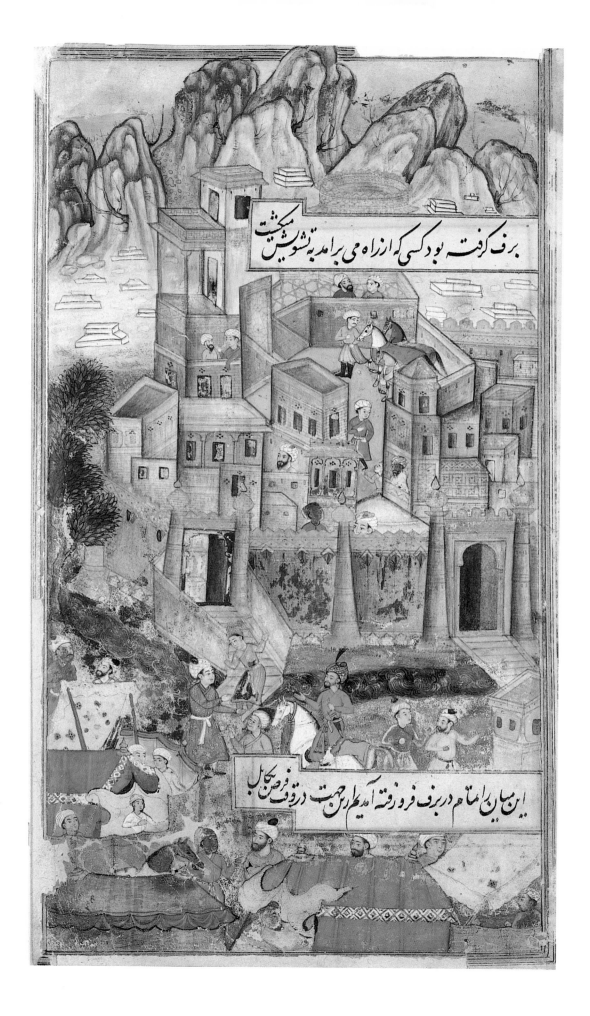

برف گرفته بود کسی که از راه می برآمده تشویش می گشت

این میان راامام در برف فرو رفته آید و جهت در و فرصت بکال

اژ بنج واژ سپیدو اژ بیاہ واژ حت واحبس باحقیا اوثر
فرسودم کر ا ریش من ریلوچہ ان اخشا ژ جح

PLATE 57 Babur receiving envoys in a garden.
By Ram Das
Illustration to the *Baburnama*, c.1590
24.3 × 13.5 cm (page 26.4 × 16.7 cm)
IM 275-1913

'On this day the Khan-i khanan produced before the august Presence the Memoirs of Firdaus Makani [the Dweller in Paradise, i.e. Babur] which he had rendered into Persian out of the Turki and received great praise.' Although the translation process had been much more complicated than this suggests, with several false starts by different scholars over many years,[8] Abd-ur Rahim's version was the definitive one. It was entitled the *Baburnama* ('Book of Babur'), and several illustrated copies were made for Akbar.

The 20 V&A pages came from what is generally regarded as the first illustrated copy.[9] Of these, 19 were bought in London in 1913, when the manuscript, which is estimated to have had 191 illustrations, seems to have been broken up for sale; a final page was bought from a Parisian dealer in 1950.[10] The book details the constant wanderings of the displaced Central Asian prince, whose life was interrupted by battles as he struggled to find, and keep, a throne worthy of his Timurid ancestry. His journeys were often harsh, as when he crossed the mountains in the snowbound depths of winter to confront rebels who had captured Kabul (pl. 56). The memoirs culminate in scenes of magnificence following his final conquest of Delhi in 1526 at the fifth attempt (pl. 57).[11] The warrior was a connoisseur of calligraphy, painting, music and literature, and had a keen eye for observing people and places, even in the midst of the most dramatic events. The descriptions of the lands he saw are evocative and detailed, with many precise and informative observations on the birds, animals (pl. 58), flowers, trees or grasslands of particular regions.[12] He laid out some of his favourite gardens in the province and city of Kabul, where he remained from 1504 until he took Delhi. Here, the court held receptions and entertainments, and often encamped for several days. One of the most beautiful was the Garden of Fidelity (*Bagh-i Vafa*), originally laid out in AH 914 (1508–09) on south-facing land below Kabul overlooking a river, which Babur continued to adorn for many years.[13] Because the double-page illustration (pl. 59) includes a portrait of the emperor, it was finished with greater care than the lightly-washed scenes on most of the other V&A pages. The paint was built up in multiple layers and burnished to produce more saturated colours, and the robes of many of the characters in the scene were embellished with minute gold rosettes and palmettes. Three artists worked on it: Bishndas must have been responsible for the overall design, aided by Isa; Nanha, later to be one of the notable portrait painters

PLATE 58 Birds and animals.
Illustration to the *Baburnama*, c.1590
Page c.26.5 × 15.8 cm
IS 234-1950

of Jahangir's reign, did the faces. The flowering pome-granate and orange trees are delicately rendered, their colours in accordance with those mentioned in the text, and the watercourses of the garden are edged with small multicoloured flowers. The air is cold, as may be inferred from the emperor's fur-lined coat and the fur collar of the gardener. The two halves of the composition are subtly linked by the plumbline stretching from the hand of the gardener on the left page straight across to his colleague on the right.

The image of the emperor as a gardener carried partic-ular resonance and was included in each of the five known Akbar-period copies of the *Baburnama*, whose pictorial scheme is broadly similar.[14] Other versions include a double composition of similar quality to the V&A *Akbarnama* and by three of its artists, now in a Swiss private collection.[15] In contemporary histories, the empire is frequently compared to a garden,[16] and the image of the king as its gardener is specifically elaborated by Abu'l Fazl in his presentation of the theory of punish-ment in the *Akbarnama*.[17] The emperor's motivation in punishing offenders was not retribution, but a desire to promote universal happiness by correcting their behav-iour. The just king manipulates his domain to allow healthy growth to flourish:

> As gardeners adorn gardens with trees and move them from one place to another, and reject many, and irrigate others, and labour to rear them to a proper size, and

extirpate bad trees, and lop off rotten branches and remove trees that are too large, and graft some upon others, and gather their various fruits and flowers, and enjoy their shade when necessary, and do other things which are established in the science of horticulture, so do just and far-seeing kings light the lamp of wisdom by regulation and instructing their servants, and so appear the standard of guidance.[18]

This metaphor does not, however, detract from the fact that Babur had a pro-found love of gardens. His cultural background was nomadic, and the great Mughal cities were yet to be built. Royal encampments in gardens were the setting for his official and private life, as seen in the painting by Ram Das of Babur receiving envoys, enthroned beneath a canopy and surrounded by blossoming trees and flowers (see pl. 57). There are closely observed details in the scene, not least the water stains from the arrow vents in the walls of the fort behind. The time estimated to complete the painting, 50 days, is recorded in a minute note in the margin, at the bottom left of the page.[19]

PLATE 59 Babur supervising
the laying out of the Garden
of Fidelity.
By Bishndas with portraits
by Nanha
Illustration to the *Baburnama*,
*c.*1590
LEFT 22.2 × 13.8 cm
(page 26.6 × 15.4 cm)
RIGHT 21.7 × 14.3 cm
(page 26.5 × 16.8 cm)
IM 276&a–1913

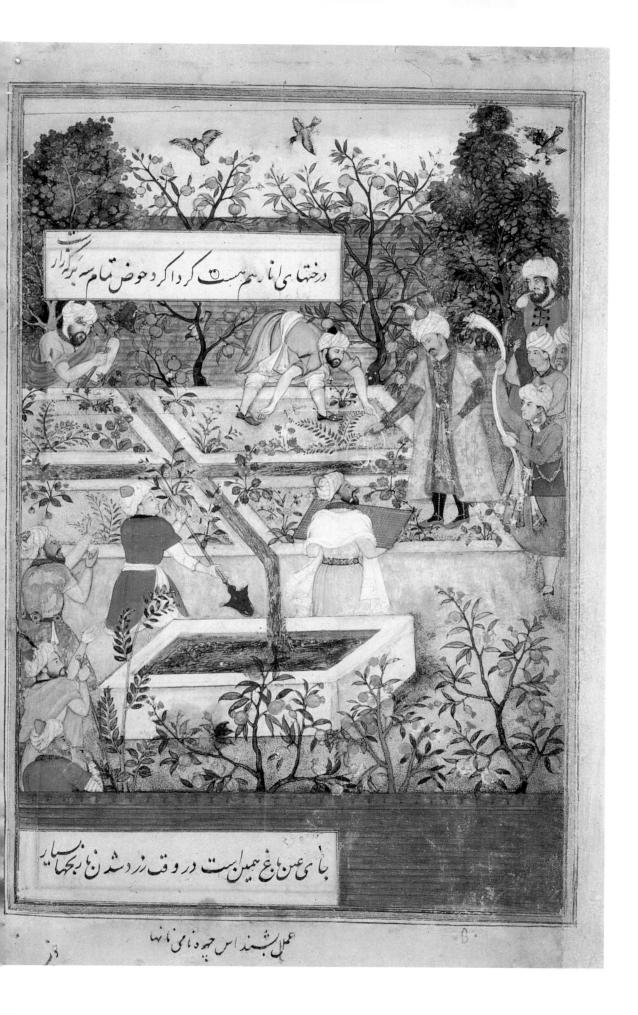

درختهای نار هم هست کردا کرد حوض تمام سه برگزار

جای این باغ همین است در وقت زرد شدن با بهای بسیار

عمل بشند اس چهره نامها

PLATE 60 Duryodhana goes with his brothers to the house of Salya to ask him to be Karna's charioteer when Krishna is Arjuna's charioteer in the great war. Salya and Duryodhana sit together on the same throne.

Illustration to the *Razmnama*, the Persian translation of the *Mahabharata*

By Kamal, son of Khem, 1598

21.9 × 12.7 cm (page 30.4 × 16.9 cm)

Circ.243-1922

OTHER TRANSLATION PROJECTS

The *Baburnama* was one of a series of translations undertaken by Akbar's translation bureau in the 1580s and 1590s, although others had a very different purpose.[20] The emperor's curiosity regarding religion and metaphysics had led him to organize debates with Hindus, Jains, Christians and representatives of the different schools of Islamic thought, famously continued into the night in the House of Worship (*Ibadatkhana*).[21] He was acutely aware of tensions between his Hindu and Muslim subjects, and wanted the seminal texts of each religion to be translated so as to be understood by all. The translation of the *Mahabharata*, the great Sanskrit epic of the Hindus, into Persian was given priority, as this was 'the compendium of the basic and minor beliefs of the brahmans'. Moreover, everyone who read it, including the emperor, would be able to learn from the lessons of history.[22] Akbar assembled a group of linguists who were regarded as free from bigotry, 'to translate the work into a lucid and intelligible language with penetrating insight.'[23] His desire was that, 'those who display hostility may refrain from doing so and may seek after the truth.'[24] The translators' other major projects would include the *Ramayana*, and texts covering a range of subjects such as mathematics and metaphysics.[25] Where appropriate, Akbar's artists added pictures, and other members of the court had the books copied and illustrated by their own artists.[26]

The order for the translation of the *Mahabharata* was given in AH 990 (1582–83),[27] and the work was carried out 'under the superintendence of Naqib Khan,[28] *Mowlana* Abdu'l Qadir Badaoni,[29] and Shaykh Sultan of Thanesar. The book contains nearly one hundred thousand verses: His Majesty calls this ancient history *Razmnama*, the Book of War,' as it detailed the wars between the Pandava and Kaurava clans.[30] Given the emperor's explicit desire to have unbigoted translators, Badaoni's involvement is ironic. His account of the project is written in the characteristically waspish tone he uses when dealing with Hinduism, and it is from him we learn that Akbar first brought together a group of learned Hindus to prepare an explanation of the work and then, for several nights, personally explained the book to Naqib Khan to allow him to prepare a summary in Persian. Afterwards, much to his disgust, Badaoni had to work on the translation, in partnership with Naqib Khan. Four months later, the pious Muslim had finished two of the eighteen sections and consoled himself with the reflection 'what is predestined must come to pass.'[31] Other authors were brought in to complete the task, *Shaykh* Fayzi was ordered to rewrite the rough translation in elegant prose and verse (but finished only two sections), and 'the Amirs had orders to take copies' of the final version, which seems to have been completed in Shaban AH 992 (8 August–5 September 1584).[32] The intact, illustrated presentation volume, with a preface written in 1587, is now in Jaipur.[33]

Other copies were soon made. The six V&A pages are from one that retained most of its text, and 125 miniatures, as late as 1921, when it was sold

94

at Sotheby's (pl. 60).[34] Originally, it may have had as many as 200 illustrations, one of which, now in the British Library, is dated AH 1007 (1598–99),[35] and many of them carry a librarian's ascriptions to artists of the imperial studio. As with most of the V&A *Baburnama* pages, the paintings seem to have been finished quickly, the paint being applied in washes on extremely thin paper, and with little decorative detail.[36] The multiple copies of the *Razmnama* testify to the importance it had at court, and the translation was to reverberate far beyond the reign, and even the territory, of the emperor. The manuscript continued to be copied and illustrated in the seventeenth century. An important page dated AH 1025 (1616–17) in the V&A is also signed by the artist, Abdullah, on the rock at lower right of the picture (pl. 61).[37] The translation travelled as far as the Deccan, where the historian Muhammad Qasem Ferishta used it as his source for an account of the Hindus, and of ancient India, in his *Golshan-i Ibrahimi* ('The Rose Garden of Ibrahim') of AH 1015 (1606–07).[38]

A Persian translation was also made of the *Harivamsa* ('Genealogy of Hari'). This continuation of the *Mahabharata*, composed after the greater part of the original Sanskrit text had been written down, tells the story of the life of Krishna and was translated under the superintendance of Mulla Sheri, a poet born in the Panjab to a family of Sheykhs.[39] Six illustrations bequeathed to the Museum in 1970 by Dame Ada Mcnaghten were taken out of a manuscript whose undated text still survives in the State Museum, Lucknow with nine miniatures, six of which seem to be original.[40] It is thought to have had at least 29 paintings and was almost certainly completed shortly after the Jaipur *Razmnama*, probably about 1590.[41] All the V&A paintings have been cut down and remounted in flamboyant borders in Lucknow style, thereby destroying whatever marginal information there may have been, such as attributions to artists.

Most of the artists in the royal studio at this time were Hindus, so the relationship between artist and text must have had a profundity not experienced when Persian literary texts or historical events were illustrated. Despite this, the style is far removed from Hindu tradition. The illustrations are in the contemporary Mughal idiom, while incorporating some conservative features of Iranian book painting, as in the scene depicting the combat between Krishna and the demon Nikumbha, which took place in a cave where the other heroes of the Yadava race had been imprisoned (pl. 62). The demon is dramatically isolated by the intense black of the cave's interior, a convention borrowed from illustrations to the Iranian national epic, the *Shah Nama* ('Book of Kings').[42]

Another page depicts Krishna's visit to the court of Bhismaka at Kundavipura where he met the king's daughter, Rukmini (pl. 63). Raja Bhismaka and the other princes seeking Rukmini's hand insisted that Krishna had no right to sit among them as he was not crowned, but the two rulers Kratha and Kaishika offered him their own kingdom. Once Krishna

OPPOSITE: PLATE 64 Krishna's combat
with Indra.
Illustration to the *Harivamsa*, *c.*1590
29.5 × 18 cm (page 43.5 × 32.2 cm)
IS 5-1970
Bequeathed by the Hon. Dame Ada Mcnaghten

PLATE 65 Shirin entertaining Khusrow.
Preparatory drawing for a *Khamsa* of
Nezami, *c.*1595–96
15.5 × 12.6 cm
IM 61-1949

was crowned, Raja Bhismaka relented, and the painting depicts Krishna
being honoured by the king as Rukmini extends a garland towards him,
indicating her choice of husband.[43] The finest of the V&A's *Harivamsa* group
depicts the forceful combat between Krishna, swooping across the sky on his
celestial bird Garuda to subdue Indra, the lord of the gods, on his mount, the
white elephant Airavata, as the other gods float above the drama in the clouds
(pl. 64).[44] The conventions of celestial beings hovering in the sky, faces peep-
ing out from clouds at top left and, especially, the vignette of the ship sailing
past a rocky landscape, all clearly derive from European sources.

Akbar commissioned remarkable illustrated versions of the great works of
Persian literature during this period, notably an exquisite a *Khamsa* of
Nezami, completed in AH 1004 (1595–96) and now in the British Library.[45]
A preparatory drawing (pl. 65) touched with gold and pale red washes
depicts Shirin entertaining Khusrow and matches one of the illustrations in
the British Library manuscript, by Farrokh Chela and Dhanraj.[46] Of exactly

similar size, the two differ only in details, the most significant being that in the V&A drawing Khusrow strongly resembles Akbar.

A large number of paintings have survived as detached pages from volumes that have long disappeared; many of these are preserved in albums. Two albums assembled in the eighteenth century and associated with Robert Clive contain a number of late sixteenth and early seventeenth-century works, including two that probably came from a volume describing episodes in the lives of the Prophets. The first depicts the martyrdom of Zakariya, father of Yehya, or John the Baptist (pl. 66). In the Koran, he is included among the Righteous; later legends add the story of his martyrdom. As he fled from his enemies, a tree miraculously opened up for him to hide in, but the hem of his cloak remained outside the tree. When Iblis (Satan) saw this, he showed it to Zakariya's pursuers and suggested that they should saw the tree in half.[47]

PLATE 66 The martyrdom of Zakariya.

c.1600–10

4.1 × 9 cm

IS 133-1964 folio 80

From the Large Clive Album

Another scene may depict an episode from the story of the Judgement of Sulayman, the biblical Solomon (pl. 67). Seen in the Muslim world as the most resplendent of four great world rulers, who also include Iskandar (Alexander the Great), he is regarded as having magical powers as well as great wisdom. The story of his judgement over two women and their babies is familiar. One day, as the women washed their clothes in a river, one of the infants fell in the water and drowned. They took the babies, one dead and one alive, to the village elder for advice and were told to raise the living child together. The continual arguments forced them to go before Sulayman, who ruled that the only solution was to cut the live baby in half, as both women regarded it as their own, and share it. The true mother was the one who implored him to spare the child and give it to the other woman.[48]

THE IMPACT OF EUROPE

One of the great innovations in painting towards the end of Akbar's reign was the introduction of realistic portraiture. According to Abu'l Fazl, the emperor himself 'sat for his likeness, and also ordered to have the likenesses of all the grandees of the realm. An immense album was thus formed: those that have passed away have received a new life, and those who are still alive have immortality promised them.'[49] This seems to have caused a radical change in the way individuals were represented. In the *Akbarnama*, for instance, Akbar is always

PLATE 67 Episode from the story of the
Judgement of Solomon (Sulayman).

*c.*1600–10

20.3 × 10.4 cm

IS 48-1956 folio 50a

From the Small Clive Album

recognizable, but his courtiers are barely distinguishable. As artists began to produce single images of their subjects, usually shown standing against a monochrome ground with their faces in profile, a complex new realism entered Mughal portraits. The figures are small, though considerably larger than in contemporary book illustrations.

Many of these portraits are preserved in the albums of Jahangir and Shah Jahan, often mounted in groups on a single page.[50] The faces, painted with particular care and sensitivity, differ completely from those rendered according to the stylized conventions of traditional northern Indian painting, in which individual personalities are shown not by means of their realistic likeness, but by their *lakshanas*, the characteristic or cognitive attributes of an individual and the role he occupies.[51] Rather than reproducing the outward physical appearance of his subject, the artist follows the prescriptions of texts such as the *Chitralakshana*, showing kingly attributes, for instance, through allusive iconographic qualities.[52]

The new sensibility is apparent in the portrait of Zayn Khan Kuka (pl. 68).[53] His place was at the very centre of court life. His mother, Pica Jan Anaga, had been one of Akbar's wetnurses and her son therefore had the appellation 'Kuka', or foster-brother. His daughter married Akbar's son Salim, and he had a distinguished career, leading the Mughal armies in campaigns against the Afghans and becoming governor of Kabul in AH 1005 (1596–97), before dying in battle in AH 1010 (1601–02).[54] His regular companions included the Iranian poet Talib of Isfahan, a close friend of Abu'l Fazl and *Shaykh* Fayzi,[55] and his talents are described by Badaoni: 'In playing Hindu music, beating the drum and other accomplishments of that sort he is unrivalled in this age. Although he cannot be said to have any other accomplishments, save calligraphy and transcription, yet he sometimes composes a couplet.'[56] Zayn Khan Kuka is dressed simply in a quickly sketched white muslim *jama* with snake-like ties tipped with orange. His orange *shalwar* is lightly shaded with red, but the greatest attention has been paid to his dark-skinned face, shown in profile and given volume by light stippling in black along the jawline. His character is suggested by the determined set of his chin and steady gaze.

The new naturalism in portraiture may also be seen, paradoxically, in an allegorical study of an encounter between two Sufi mystics, the eighth-century Rabi'a of Basra, famed for her asceticism, and the tenth-century Junayd (pl. 69).

PLATE 68 Portrait of Zayn Khan Kuka.

c.1590

10 × 6.6 cm

IS 91–1965

Bought from the executors of the late

Capt. E.G. Spencer-Churchill

Mir Kalan painted two shrunken, ancient characters stooping towards each other in a poignant study of old age that would be repeated in Jahangir's reign by Abu'l Hasan. One is preserved in the St Petersburg Album; it is mounted on a page over a later allegorical painting of Jahangir and Shah Jahan in the company of three saints.[57] The second, depicting Junayd only, is in a private collection in Switzerland.[58] The V&A painting is important for its identification of the figures in an inscription also giving the name of the artist, 'Mir Kalan-i Hindi'.[59] The date, AH 980 (1572–73), may be open to doubt, but a broad time-span of the late sixteenth or early seventeenth century is supported by the very precise representation of the Iranian or Iranian-inspired metal bowl carried by Junayd, its contours familar from extant bowls of the period.[60] The depiction of allegorical meetings of mystics from different epochs and spiritual paths was a major theme of court painting in the first half of the seventeenth century that remains to be explored.

The new portraiture has usually been regarded as the result of European influence. The story of the arrival of European art at the Mughal court, notably with the Jesuit missions from 1580 onwards, has often been told and will not be repeated here.[61] It is striking, however, that when Akbar first studied the paintings of the Virgin in the chapel of the Jesuit Fathers' house at Fathpur, in 1580, his immediate reaction was to bring not only his leading courtiers, but his 'chief painter and other painters' to look at them. Father Francis Henriques recorded that they were 'all wonderstuck and said that there could be no better painting, nor better artists than those who had painted the said pictures'.[62] Their admiration was sincere, as demonstrated by Abu'l Fazl's comment in his famous passage on the *tasvir-khana* (painting studio) that the best Mughal artists could be compared not only to the great Bihzad, but 'may be placed at the side of the wonderful works of the European painters who have attained world-wide fame'.[63] Moreover, the paintings that so impressed the artists at Fathpur were soon copied and incorporated into their own work.[64] The presentation of the seven-volume Polyglot Bible to Akbar by the First Jesuit Mission probably quickly influenced Mughal art.[65] Published in Antwerp between 1567 and 1572 by Christopher Plantin, it was illustrated with fine engravings by such artists as Philips Galle, Jan Wierix and Geeraert van Kampen that may have provided the motif of ships sailing near rocky landscapes studded with buildings seen in several manuscript illustrations of the period, including one of the V&A *Harivamsa* pages, and almost certainly that of deities floating in the sky on clouds (see pl. 64).[66]

The Fathers also presented Akbar with Abraham Ortelius' atlas, *Theatrum*

orbis terrarum (1570),[67] which may have given his artists the inspiration for the tiny 'matchstick men' that had never been seen in Indian painting before their appearance in Akbari commissions of the 1590s – as in the *Baburnama* (see pl. 57) – and continued to scamper across the background of paintings in Jahangir's reign (see pl. 96). In the printed maps of the volume, these small skeletal figures appear against hand-tinted green backgrounds as they do in Mughal painting; the clusters of houses, churches and public monuments, sometimes coloured pink as they are in *Theatrum orbis terrarum*, must also have been a source for the images of exotic architecture that appeared in the 1580s and 1590s (see pl. 64).[68]

By the end of the sixteenth century, Akbar's library contained a considerable number of European printed books, some of them illustrated, and many of them presented by the Fathers of the Third Jesuit Mission in 1595.[69] They lived as intimates of the court in Lahore, and Jerome Xavier travelled with Akbar when he left the northern capital for Agra in 1598. The royal artists in Lahore and Agra incorporated elements from these books into their own work, or copied them so exactly that tracings must have been used.[70] A painting of the Martyrdom of St Cecilia copies an engraving by Jerome Wierix and is ascribed to a female artist, Nini, whose work is otherwise unknown (pls 70 and 71).[71]

Jerome Xavier, the leader of the Third Mission, was fully aware of the need to learn Persian fluently in order to communicate the Jesuits' message to the emperor without the need for intermediaries, and ultimately, to achieve their desire to convert him to Christianity. By 1597, the Father had become proficient enough in Persian to consider providing the translations

PLATE 69 An allegorical encounter between mystics: the eighth-century Rabi'a of Basra and the tenth-century Junayd of Baghdad. Dated AH 980 (1572–73) but perhaps *c.*1590–1600

5.2 × 7.3 cm

IM 254-1921

Given by the executors of Sir Robert Nathan, KCSI, CIE

of Christian texts that the emperor wished to have.[72] He had begun his Persian lessons in Cambay in December 1594, *en route* from Goa to the court at Lahore, and continued them intensively in the royal city. By August 1597 he reported being able to make himself understood to everyone on most subjects, except for the crucial one, religion. From 1600 he produced a series of Persian texts, the earliest being the Life of Christ (*Mir'at ul-Quds*, 'Mirror of Holiness', also called the *Dastan-i Masih*, or 'Story of Christ').[73] An incomplete and badly damaged copy is regarded as the original. Completed at Agra in 1602 and stamped with Akbar's seal, it is preserved in the Lahore Museum.[74] A page from another copy depicting the Virgin, her halo barely visible, sweeping the room of the inn at Bethlehem before the birth of Christ, is signed by the artist Mas'ud Deccani (pl. 72) but bears an inexplicable date of AH 930 (1523–24).[75] The intriguing theory has been put forward that

ABOVE: PLATE 73 An artist decorates
a pavilion in a garden. *c.*1600–10

22 × 10.6 cm (page 35.6 × 24.5 cm)

IS 48-1956 f.56a; from the Small Clive Album

OPPOSITE: PLATE 74 The *simurgh* attacks
a *gaja-simha* carrying off seven elephants.
Tinted drawing. *c.*1600–20

28.1 × 19.2 cm

IM 155-1914. Bought from Mr M.K. Heeramaneck

scenes such as these are charged with such a sense of drama that they must reflect real performances given by the Jesuits and their converts.[76]

ARTISTS, DESIGNERS AND CALLIGRAPHERS

By the end of the sixteenth century, some artists were beginning to emerge as individuals whose style can be recognized. Occasional references are made in Mughal texts to their diverse skills: they were often calligraphers, illuminators, designers of objects and poets. Even their painting was carried out in a broader range of media than is often acknowledged, including wall paintings that have almost entirely disappeared. The Small Clive Album includes a study of a bespectacled artist painting the walls of a pavilion, dressed, as he should be according to the *Chitrasutra*, entirely in white (pl. 73).[77] Little attention has been paid to the range of activities undertaken by individual artists. Farrokh Beg, for instance, must have been a skilled calligrapher, on the evidence of the quality of the writing incorporated into architecture on his paintings (see pl. 37), and some of the architectural decoration is so close to manuscript illumination that he must have excelled at this too, if his sole authorshop of his paintings is to be believed.[78] Mansur's signature always includes the appellation *naqqash*, or 'designer', and the possibility that he played a major role in designing artefacts for the court is suggested by a painting of Jahangir enthroned for which Manohar Das is convincingly credited with providing the portrait and Mansur the elaborate throne.[79] He also provided minutely patterned illumination for manuscripts.[80] The relationship between artists and craftsmen is clearly discernible, though little understood, and very precise depictions of metalwork and textiles on miniatures suggest that the artist responsible probably supplied designs to the royal *karkhanas* (workshops). A bullock and cart on one of the V&A *Akbarnama* pages, for example, is very similar to a motif on the 'Widener Carpet', which also includes the motif of the famous Behzad fighting camels found in the *Akbarnama* that was copied several times by Mughal painters.[81]

A drawing from the end of Akbar's reign depicts a fantastic creature that appears in a number of other media (pl. 74).[82] The half-lion, half-elephant known as *gaja-simha* had such prodigious strength that it could hold in its

PLATE 75 Akbar hawking.

Drawing highlighted with colours and gold

*c.*1600–05

17.3 × 13.2 cm

IS 249-1921

Bequeathed by Sir Robert Nathan, KCSI, CIE

talons seven elephants while simultaneously fighting off the attack of a *simurgh*, the mythological bird of the Persian national epic, the *Shah Nama* or 'Book of Kings'.[83] It was used by ivory inlayers on wood, by carpet weavers, and is found on architecture as well as in painting, but its significance in the Mughal context remains an enigma.[84]

The V&A collection has several drawings in a style known as *nim-qalam*, literally 'half pen', in which artists of consummate skill used to produce exquisite drawings washed with the faintest suggestion of colour in an almost monochrome palette, though touched with gold and sometimes body colour. This minimalist style seems to have been particularly favoured towards the end of Akbar's reign, featuring in several manuscripts dated between 1600 and 1605.[85] A drawing in the V&A exemplifies the style at its best, and depicts Akbar hawking (pl. 75).[86] The anonymous artist has confined the use of gold to those parts of the composition closest to the emperor himself, emphasizing his royal status.

PLATE 76 A lady, perhaps St Catherine
of Alexandria, with preceptors.
Watercolour and gold on paper
*c.*1600
20.4 × 12.7 cm
IM 284-1913

It is particularly difficult to separate works done for Akbar and Salim at
this period, and in this style, where the painting has lost its context and
reflects their shared interests as, for instance in a finely drawn scene that
incorporates elements that seem to have been copied directly from a
European source, but whose subject has not been identified (pl. 76).[87]
Whoever commissioned them, it is nevertheless clear that the *nim-qalam*
effect was retained in the collective consciousness of the atelier, to be
exploited brilliantly in Jahangir's reign, notably in the borders of his finest
'Rose Garden' album, the *Moraqqa'e Golshan*.

5

PAINTING
FOR JAHANGIR

Jahangir's patronage of painting began long before he became emperor at the age of 37 in 1605.[1] As Prince Salim he was closely involved in the work of the royal artists in the northern capital, Lahore, where the court resided from 1585 until 1598 before moving to Agra.[2] This continued at Allahabad, where he established a rival court following his rebellion against Akbar in 1600, and where a small number of manuscripts were produced.[3] For much of his reign he wrote memoirs that include many references to artistic commissions, and by 1618 his estimation of his own connoisseurship was high:

> As regards myself, my liking for painting and my practice in judging it
> have arrived at such a point that when any work is brought before me,
> either of deceased artists or of those of the present day, without the names
> being told me, I say on the spur of the moment that it is the work of such
> and such a man.[4]

Salim, like his father, was deeply curious about the religious art of the Christians and, according to Jesuit accounts, was equally excited by the paintings brought to the court at Lahore with the Third Mission. It was led by Father Jerome Xavier, who wrote to the General of the Society of Jesus in 1595 requesting that 'a beautiful large picture of the Holy Virgin or of the Nativity' should be sent for the king and for Salim.[5] Competition between father and son for European works of art seems to have been intense, as was their desire to have them copied by their own artists. When the Jesuits gave them both copies of Jerome Xavier's Persian text, the *Mirat al-Quds* or 'Mirror of Holiness', completed in 1602, Salim ordered his artists to make a superior version with twice as many pictures, all coloured.[6]

The Jesuits of the Third Mission became sufficiently close to the prince to observe his artists at work. In 1596, an artist in the Jesuit entourage had even been commandeered by Salim: 'The Portuguese painter who came with us

has no time for anything except painting images for [Salim], of Christ, Our Lord and of Our Lady. He makes him paint the ones which his father owns.'[7] Mughal practitioners may have studied the foreign painter's technique, and his work presumably helped them choose suitable colours for their own versions of Christian subjects.[8]

Salim's desire for western pictures and engravings made him occasionally intercept Jesuit consignments for his father, appropriating them for himself, as he would do later with those of the English factors.[9] When he became emperor he continued to add Christian images to his collection, and his acquisitions were carefully studied by artists, who either copied them exactly or used them to create innovative works only loosely inspired by European models. In this way, the Mughal style was continually modified, as the radically different aesthetics and images of the West were absorbed.[10]

Jerome Xavier's account suggests that Salim worked very closely with his artists as the Father once saw him directing two painters 'tracing out by the application of colours' two small pictures depicting the appearance of the angel to the shepherds and the Deposition from the Cross.[11] Deposition scenes in Mughal painting are comparatively rare and it has therefore been suggested that the V&A version may be the one seen by Jerome Xavier (pl. 77).[12] The Mughal artist copied part of a print by Marcantonio Raimondi, making his own additions to the sky, probably based on another painting or engraving.[13]

A recurring theme in Jahangir's life was his desire for artistic novelties of all kinds, and contact with the Jesuits (as well as European merchants) helped to provide them. Annoyed by the failure of the Third Mission to bring any new oil paintings, he must have eagerly scanned the engravings in a book sent to the Jesuits. Father Gerónimo Nadal's *Evangelicae historicae imagines* was published by the Plantin Press in Antwerp in 1593, and its 153 engravings, mainly by the Wierix brothers and Adrien Collaert after original works by Bernardino Passeri and Martin de Vos, were certainly shown to the court artists.[14] One of the illustrations inspired a Mughal version in the V&A (pls 78 and 79). The main features of the original are reversed, and the swirling clouds above the Holy Family are more decoratively billowing, while other details are simplified, and the Latin inscription, 'Gloria in Altissimis Deo', on the scroll held by one of the putti in the original print has been replaced by a meaningless series of letters and pseudo-letters. The presence of an original engraving from Nadal in the Large Clive Album, which must have had some

PLATE 77 The Deposition from the Cross.
*c.*1598
19.4 × 11.3 cm
IS 133-1964 f. 79b
From the Large Clive Album

PLATE 78 The Nativity.
Watercolour on paper
*c.*1605–10
17.7 × 11.6 cm
D 402-1885

connection with the Mughal court in the early eighteenth century, attests to
the continuing value of these images.[15]

THE ALLAHABAD YEARS

Between 1600 and 1605, the character of Mughal painting changed percept-
ibly, but it is difficult to differentiate between work done by Salim's artists
residing at Allahabad from 1600 to 1604 and that of Akbar's atelier during

PLATE 79 The Nativity of Christ.
M[artin] de Vos invect. Hieronymus
W[ierix] sculp.
Engraving from Gerónimo Nadal,
Evangelicae historicae imagines (Antwerp, 1593)

IN NOCTE NATALIS DOMINI.
Natiuitas Christi.
Luc. ij. *Anno 1.*
3
v

A. *Bethlehem ciuitas Dauid.*
B. *Forum vbi foluitur tributum.*
C. *Spelunca, vbi natus eft Chriftus.*
D. *IESVS recens natus, ante Præfepe humi in fœno iacens; quem pannis Virgo Mater inuoluit.*
E. *Angeli adorant Puerum natum.*
F. *Ad Præfepe bos & afinus nouo lumine commoti.*

G. *Lux è Chrifto nato fugat tenebras noctis.*
H. *Turris Heder, ideft gregis.*
I. *Paftores ad turrim cum gregibus.*
K. *Angelus apparet Paftoribus, & cum eo Militia cœleftis exercitus.*
L. *Angelus, qui pie creditur miffus in Limbum ad Patres nuncius.*
M. *Stella & Angelus ad Magos miffi, eos primum ad iter impellunt.*

the same period, unless it is signed or dated, which is rare. Although a very few illustrated manuscripts have colophons recording their completion at Allahabad and the names of some of the small group of artists working there, Salim's residence there was not continuous.[16] In March 1602 he left to mount an assault on Agra with a force of 30,000, but thought better of this hostile act towards his father and returned to his rebel court.[17] In 1603, however, he was temporarily reconciled with Akbar (despite having been responsible for Abu'l Fazl's murder the previous year), and lived at Agra for some

months between March and October.[18] The Jesuits who saw him there reported that good images of Jesus or the Virgin were the most acceptable presents they could make, 'though he employed the most skilled painters and craftsmen in his father's kingdom in making him the like'.[19]

Although Salim's fascination for Christian art remained acute, it did not stem, as the Fathers fondly imagined, from his 'devotion to our Saviour and His holy Mother, whose images he held in the highest veneration'.[20] He commissioned new paintings with Christian themes during his brief interlude at Agra: 'He had painted in a book pictures illustrating the mysteries of His life, death, and passion; and because at the beginning of the book there was a cross illuminated in gold ... he ordered the artist to paint thereon the figure of Jesus Christ crucified; and on another page on which was the name Jesus, encircled with rays, he had painted in the midst a picture of our Lady and her infant Son with His arms about her neck.'[21]

PLATE 80 A Turkman prisoner.
Drawing and wash on cotton
Signed by Aqa Reza, *c.*1600–05
21.1 × 14.9 cm
IS 133-1964, f.49b
From the Large Clive Album

It is difficult to believe that Salim could have been so closely involved in artistic pursuits when he returned to Allahabad in November 1603. His wife, Shah Begum, to whom he was greatly attached, committed suicide in May 1604 and his dependency on alcohol and opium made his behaviour increasingly volatile. Reports of the prince's disturbed and extremely cruel behaviour in August 1604, when one servant was flayed alive in his presence and another publicly castrated, reached Akbar, who was horrified and marched towards Allahabad, but had to return because of the serious illness of his mother.[22] Her death led Salim to go back to Agra in November, where he appeared full of remorse and was forgiven, though Akbar had him imprisoned for ten days under the care of a physician, without wine or opium.[23]

It is impossible to assess the degree to which Salim's absences or behaviour affected his artists. The leader of the small group associated with Allahabad seems to have been Aqa Reza, who had trained in Iran and came to Hindustan to find a new patron.[24] Aqa Reza entered Salim's service some time before 1598,[25] and his earliest dated works are in the decorated margins of the Golshan Album in Tehran, where an inscription notes that a group of Christian subjects was done in Agra on 28 Ramadan AH 1008 (March 1600), some months before Salim's rebellion.[26] The marginal drawings and full-page paintings in the Golshan Album by Aqa Reza, not all published, suggest an artist of far greater range and skill than the V&A example of his work (pl. 80).[27] His son clearly inherited his talent, as is seen

in 1618 when the emperor records bestowing the title Nader al-Zaman ('Wonder of the Age') on the artist Abu'l Hasan: 'His father, Aqa Riza of Herat, at the time I was a prince, joined my service … There is, however, no comparison between his work and that of his father. One cannot put them in the same category.'[28]

A signed painting on cotton done by Aqa Reza after Salim's accession is preserved in the Large Clive Album, its *nasta'liq* inscription recording that it is 'the work of Jahangir Shah's Reza' (*amal-e Reza-ye Jahangir Shah*).[29] The painting is one of several versions of a portrait of an Uzbek identified in 1912 by F. R. Martin as Murad Akkuyunli,[30] who was defeated and imprisoned by Shah Isma'il, the founder of the Safavid dynasty, in AH 907 (1501). They may all have been based on an original portrait by Behzad, as suggested by Martin, as the great master's work was often copied by artists at the Mughal court. Murad Akkuyunli's face, with its wrinkled brow, downward-sloping, hooded eyes, aquiline nose and wide jaw, is highly distinctive, as are his turban, collar and the folds of his long-sleeved undergarment. The same man appears in two guises in the different versions, either holding an arrow, as here, or with his wrist fettered by a wooden *palahang*, a device made from a tree branch and a standard way of disabling captives.[31]

On the same opening of the Large Clive Album is a painting on paper by an anonymous artist of an Uzbek with high cheekbones and sharply-drawn beard and moustache, wearing similar clothes but with a peaked hat rather than a turban (pl. 81). Identified in two inscriptions as 'Ibrahim Beg', he is also one of several variations on the same theme, of different dates.[32] Intriguingly, one of these bears an attribution to Farrokh Beg and is labelled 'Bayram Oghlan' in what seems to be Jahangir's hand.[33]

PLATE 81 Ibrahim Beg.

*c.*1600–05

24.9 × 14.2 cm

IS 133-1964 f.50a

From the Large Clive Album

The few details known of Aqa Reza's career show the varied skills that might be possessed by an artist in royal service. Aqa Reza's role in the construction of a monument for Jahangir is recorded in the inscription on the main gateway of the Khusrow Garden in Allahabad dated AH 1014 (1606–67), stating that 'this lofty edifice' (i.e. the tomb of Shah Begum, of the same date) was erected under the supervision of Aqa Reza *musavvir* ('the painter').[34]

Aqa Reza's students presumably included his sons Abu'l Hasan and Abed, who was to become a leading member of Shah Jahan's atelier (see pl. 114), and a painting in the Golshan Album has an inscription stating that he also taught Nadare Banu, 'the daughter of *Mir* Taqi'.[35] Another female artist who may be

PLATE 82 Shah Tahmasp.
By Sahifa Banu, *c*.1600–05
15.1 × 9.2 cm (page 38.7 × 25.3 cm)
IM 117-1921
Bequeathed by Lady Wantage

associated with this period painted a portrait of Shah Tahmasp (pl. 82). Inscribed 'Sahifa Banu', about whom nothing is known, and mounted on a page from one of Jahangir's albums, it has a distinctive style owing more to Iran than India.[36]

Two related paintings in the V&A date from these early years of the seventeenth century and travelled together from the Mughal imperial collection to the rulers of Udaipur before arriving at the V&A.[37] The first is a delicately coloured study of a prince, who seems to be the youthful Salim, spearing a lioness who attacks him on his elephant (pl. 83). Although the resemblance to the prince is close, this identification has previously been rejected because he does not have the distinctive curling sideburn that appears in almost all the portraits of Salim as a prince, and later as the emperor.[38] There is a significant exception, however: a painting of Salim in a manuscript dated 1602, and copied at Allahabad, also omits the curl.[39]

The identification of the scene is problematic, as the written account of the most likely incident does not fit the details in the painting precisely. In May 1597 one of the Jesuit Fathers reported that Salim had been hunting lions near Lahore when his elephant killed some lion cubs. Their furious mother suddenly appeared and leapt at the prince, who wounded her with an arrow, enraging her further. Salim then shot at her with his matchlock, but still failed to kill her: 'Goaded to even greater fury, she sprang upon the elephant, and so nearly reached the prince that he was splashed with foam from her mouth.'[40] Finally, he smashed her head with the butt of his gun, and an attendant killed her with his sword.

In the painting, the elephant is not tuskless, as recorded, and Salim's weapon is a long spear, not an arrow or matchlock. Yet, such dangerous attacks on a Mughal prince cannot have been common, and Jahangir claimed that he always tried to avoid killing lionesses.[41] The minor discrepancies between a written report and its illustration are probably not of great significance, as the depictions of a famous incident in 1610, when Jahangir saved one of his personal servants, Anup Rai, from the claws of a lion, also differ in details from the contemporary accounts, though its identification is certain.[42]

The long association of this painting with the 'Dead lioness carried by bearers' (pl. 84) strengthens the argument in support of it depicting Salim killing a lioness in 1597, as they both derive from different parts of the composition of an earlier court painting. Robert Skelton first noted the similarity between the painting of the dead lioness and the lower half of a painting by Miskina.[43] The upper half of the same painting shows the incident that led to the animal's death, where a figure who is unequivocally Jahangir raises himself up in the howdah of his elephant, his gun held aloft, ready to be brought down butt first on the head of the lioness, whose claws grip the edge of the howdah. The exaggerated position of his arms is exactly the same as that of the V&A painting. The 'Dead lioness' must have been done in the Allahabad years, as the pale tones of blue, green and yellow counterpointed by a brilliant

PLATE 83 Salim spearing a lioness.

*c.*1600–05

14.5 × 17.6 cm

IM 97-1965

Given by the National Art Collections Fund,

purchased from the executors of the late

Capt. E.G. Spencer-Churchill

PLATE 84 Dead lioness carried by bearers.
Possibly Allahabad, *c.*1600–04
14.9 × 17.4 cm
IS 96-1965
Given by the National Art Collections Fund,
purchased from the executors of the late
Capt. E.G. Spencer-Churchill

من بدم وگنجی وکتابی و پرورد یے

غم راکہ نشان او و بلارا کہ خبر کرد

PLATE 85 St Luke.

c.1600–04

10.6 × 5.7 cm (excluding calligraphy)

IS 218-1952

Given by Col. T.G. Gayer-Anderson, CMG, DSO,

and his brother Major R.G. Gayer-Anderson, Pasha

OPPOSITE: PLATE 86 Jahangir receiving

Qutb ad-din Khan Koka.

By Manohar, *c*.1605

19.8 × 12.8 cm (page 38.7 × 26 cm)

IM 111-1921

Bequeathed by Lady Wantage

vermilion compare closely to pages of the 1603–04 *Raj Kunwar* manuscript now in the Chester Beatty Library.[44]

A final painting in the V&A may be associated with Salim's life before he became emperor (pl. 85). A group of pages scattered across different collections is known collectively as the 'Salim Album' because of an inscription to the prince on one of the paintings.[45] Many of them depict holy figures from different traditions, mostly Hindu and Christian, and the V&A painting that seems to belong to the group follows this theme.[10] Its source was identified by Dr Emma Devapriyam as an engraving of St Luke by Hans Sebald Beham, and the same print was also copied in miniature in the margins of Jahangir's Golshan Album.[47]

THE EMPEROR'S TASTE

Akbar died in October 1605, less than a year after his reconciliation with Salim, and the prince became emperor, inheriting the royal library and its precious contents. Jahangir's atelier was smaller than Akbar's at its peak in the 1590s, when there had been more than 100 artists of high quality, with many others of lesser renown. Working practices also changed, with a single artist having greater responsibility for the final appearance of a painting, which made the characteristics of particular individuals more apparent.

Manohar, for example, had presumably been trained by his father, the great artist Basawan; their relationship is recorded by the young artist in a signed self-portrait.[48] Manohar had worked on the V&A *Akbarnama*, and painted an early portrait of the new emperor (pl. 86) receiving Qutb ad-din Khan Koka, Raja Sangram and the *zamindar* of Kharakpur, with the *zamindar's* son in attendance behind Jahangir.[49] Rather ungainly in its composition, the signed painting shows none of the complex tonal harmonies and dissonances, or experiments with recession and perspective that are apparent in Manohar's work in the 1595 *Khamsa* in the British Library, when he worked beside Akbar's finest artists at the height of their powers.[50]

A few years later, the artist was more assured. Jahangir continued Akbar's practice of collecting portraits of court personalities, usually depicted full-figure with their faces in profile against a green ground, though other colours such as a deep burnt sienna now appear. Jahangir's artists began to manipulate these images, pasting some in groups of four on single pages for his albums, and occasionally disguising the joins so that the characters seem to inhabit a fantastic landscape.[51]

PLATE 87 Jahangir receiving Prince Parviz
in a garden.
Attributed to Manohar, c.1610–15
23.7 × 15.6 cm
IM 9-1925
From the Minto Album

OPPOSITE: PLATE 88 Mirza Ghazi (d.1612).
By Manohar, c.1610–12
Inscribed Mirza Ghazi, the son of Mirza Jani
13.5 × 6.4 cm (page 38.8 x 26.1 cm)
IM 118-1921
Bequeathed by Lady Wantage

Manohar used the official portrait format in a very different way, as seen
in his painting of Jahangir in a walled garden receiving a jewelled gold cup
from his son, Parviz, surrounded by high-ranking members of the court
(pl. 87). The subtlety of the colours draws attention away from the odd qual-
ity of the composition, in which the scale of each figure in relation to the
others is slightly wrong. Comparison with other, individual portraits of the
figures, who are carefully labelled with their names or titles in minute writ-
ing on their clothing,[52] reveals why: they must all have been traced from
extant portraits, meaning that the posture and size of each is predetermined.

OPPOSITE: PLATE 89 Prince Khurram
receiving the submission of Rana Amar
Singh of Mewar.
A page from the *Jahangirnama*
Signed by Nanha, *c.*1618
31.3 × 20.1 cm
IS 185-1984

PLATE 90 Detail of plate 89, showing the
artist Nanha.

Thus, Mirza Ghazi looks out into the middle distance because that is how his separate portrait shows him (pl. 88); Asef Khan (immediately behind Parviz) has a larger head than Mirza Ghazi because their official portraits would have been of slightly different scales, and the hands of the unidentified figure behind Jahangir's left shoulder appear above the turban in front, because in his portrait they were clasped over a tall stick. The uninscribed noble is Raja Man Singh of Amber, a loyal supporter of Jahangir: his daughter, Manjunwar (Shah Begum), married Jahangir in 1584, and his granddaughter followed suit in 1608.[53]

The specific event in the painting cannot be identified but must have taken place soon after Jahangir's accession, when the nobles presented themselves to be given their official positions in the new order. The process was lengthy, as the emperor recorded: 'If the details were to be described of all the commanders and servants appointed by me, with the conditions and connections and rank of each, it would be a long business.' He therefore omits them.[54] Most of the individuals in the painting are, however, named in the opening pages of Jahangir's personal history but soon dispersed across the empire, not to be mentioned as being together again at court. The scene may also be connected with Jahangir's decision in the early days of his reign to send his most trusted military campaigners, including Asef Khan, against the Rana of Mewar under the command of Parviz.[55]

Manohar may be identified as the artist because of the similarity between the colours in this painting and another court scene in the British Museum attributed to him in a contemporary hand. Both works also depict a distinctive white marble pond and fountain in the foreground at the same angle.[56] Other paintings by Manohar in the V&A include portraits that are convincingly ascribed to him, rather than signed, but share certain characteristics in their palette and in the strongly curved, springy line given to shoes.[57]

THE *JAHANGIRNAMA*

Jahangir's memoirs provide an idiosyncratic account of important political events interspersed with personal reflections, particularly on the natural world, from the earliest days of his reign until the seventeenth regnal year.[58] Ill health then forced him to hand over the task to Mu'tammad Khan, a historian who continued the record until Jahangir's death in 1627.[59] The memoirs give a unique quality of immediacy to many paintings of the reign. Early in 1618, for example, Jahangir wrote:

> On this day [Sunday, 24 Tir AH 1027], Abu'l Hasan, the painter, who has been honoured with the title of Nadir uz-zaman, drew the picture of my accession as the frontispiece to the Jahangirnama, and brought it to me. As it was worthy of all praise, he received endless favours. His work was perfect, and his picture is one of the masterpieces of the age.[60]

ABOVE LEFT: PLATE 91 An aged *mulla*.
By Farrokh Beg, *c.*1615
Inscribed by Jahangir 'the work of Farrokh
Beg in his seventieth year'
16.8 × 11.2 cm (page 38.8 × 27.1 cm)
IM 10-1925
From the Minto Album

ABOVE RIGHT: PLATE 92 A *darvish*.
By Farrokh Beg, *c.*1615
13.7 × 7.7 cm (page 38.4 × 26.4 cm)
IM 11-1925
From the Minto Album

It is not known whether the *Jahangirnama* was copied and illustrated in a definitive volume for the emperor. Certain subjects identifiable beyond doubt with the *Jahangirnama* were inherited by Shah Jahan and placed in albums with new borders, suggesting that they had never been used as book illustrations, and even the frontispiece is now in an album including other royal Mughal paintings.[61]

One of the few paintings that must have been planned for a manuscript depicts the defeat of the Rana of Mewar (pl. 89), ruler of the fiercely independent Rajput kingdom.[62] Akbar had failed to force the submission of the Mewar rulers, and the army led by Parviz at the beginning of Jahangir's reign also failed. Another campaign dragged on without success until 1614, when the ruthless perseverance of the emperor's favoured son, Khurram, now in command of the army, achieved the desired result. Rana Amar Singh capitulated, offering his obedient service to Jahangir, who recorded the enormous significance of the event:

> The real point was that as Rana Amar Singh and his fathers, proud in the strength of their hilly country and their abodes, had never seen or obeyed any of the kings of Hindustan, this should be brought about in my reign.[63]

The Rana formally submitted to Khurram on 26 Bahman AH 1023 (6 February 1615), but in deference to his age he was spared the humiliation of travelling to the court to bow before Jahangir.[64]

The painting is interesting in many ways. A catchword at lower left shows that it was intended as a manuscript illustration. The nobles have identifying labels, meaning that they are recognizable in other, unlabelled paintings; and there is one remarkable detail – the artist has discreetly included himself in the scene, painting the Rana's portrait and signing his name, Nanha, on the page he holds (pl. 90). Nanha was one of a number of Akbari artists inherited by Jahangir and contributed several works to the Golshan Album, including a painting of fighting camels dated AH 1017 (1608–09) and inscribed 'This is the work of Ustad Behzad seen by Nanha *musavvir*.'[65] As usual, little is known of Nanha's personal life beyond the fact that he was the uncle of the Jahangiri artist Bishndas, whom the emperor described as 'unequalled in his age for taking likenesses'.[66]

Although the *Jahangirnama* is by far the most important source of information concerning painting of the reign, details concerning individual artists are often frustratingly allusive. The first to be mentioned by name is Farrokh Beg, who had come to Akbar's court from Kabul in 1585, following the death of his patron, Akbar's half-brother Mirza Muhammad Hakim.[67] In AH 1018 (1609), Jahangir gave him 2,000 rupees as part of the New Year celebrations at the beginning of the fourth regnal year, remarking 'he is unrivalled in the age.'[68] Two paintings in the V&A, an aged *mulla* (pl. 91) and a *darvish* (pl. 92), date from this period, when the artist was himself an old man. Jahangir wrote on the painting that the *mulla* is 'the work of Farrokh Beg in his seventieth year'. The outline for both figures must have been traced from the same model, as their height and the width of their shoulders match exactly, though the subsequent painting of their very different clothes disguises the common source.

Another artist held in the highest regard by Jahangir is nevertheless mentioned by name only once in the *Jahangirnama*. Abu'l Hasan's closeness to the innermost court circle may be inferred only from surviving inscribed paintings, such as the signed portrait of Shah Jahan that had been personally approved by its subject, who wrote on the border: 'this is a good likeness of me in my twenty-fifth year and it is the fine work of Nadir az-Zaman' (pl. 93). The painting may have been done immediately before the prince left to direct the major Deccan campaign in 1616, when Jahangir increased his rank and added 'Shah' to his name.[69] Fifteen years later, the mature features of the prince who had now become emperor were recorded in a remarkably similar painting, also approved by Shah Jahan: 'A good likeness of me in my fortieth year, the work of Bichitr' (pl. 94).

Another portrait presents unresolved difficulties. The prince glides impassively through a mountainous landscape on a white stallion with a young

OVERLEAF

LEFT: PLATE 93 Shah Jahan as a prince.
Signed by Nader al-Zaman (Abu'l Hasan),
*c.*1616–17
Inscribed by Shah Jahan on the lower border: 'this is a good likeness of me in my twenty-fifth year and it is the fine work of Nader al-Zaman'
20.6 × 11.5 cm (page 39 cm × 26.7 cm)
IM 14-1925
From the Minto Album

RIGHT: PLATE 94 Shah Jahan.
By Bichitr, *c.*1631
Inscribed by Shah Jahan: 'A good likeness of me in my fortieth year, the work of Bichitr'
22.1 × 13.4 cm (page 38.7 × 26.6 cm)
IM 17-1925
From the Minto Album

سمیه عبدالله خان اوزک عمل یا در ایمان

PRECEDING SPREAD

LEFT: PLATE 95 Shah Jahan and his son
riding with an escort.

By Manohar; portraits of the emperor and
his son signed by Murar, *c.*1618–20

23.6 × 16.8 cm (page 38.8 × 26.6 cm)

IM 12-1925

From the Minto Album

RIGHT: PLATE 96 Abdullah Khan Uzbek
hawking.

By Abu'l Hasan, *c.*1618

28 × 15.8 cm (page 38.8 × 26.6 cm)

IM 20-1925

From the Minto Album

RIGHT: PLATE 97 A pair of cranes.

Brush drawing

Attributed to Mansur, *c.*1615

17.1 × 10.3 cm (max. dimensions)

IM 42-1925

Given by Maj. Denzil Macaulay

prince as his companion (pl. 95). His appearance barely differs from Abu'l
Hasan's portrait of about 1616, and an ascription on the lower border con-
vincingly attributes the scene to Manohar, as it is in his style and has his
sophisticated colour palette. It must have been painted in the middle years
of Jahangir's reign, probably not long after the court circle adopted the
fashion of pierced ears in 1614.[70] However, minute inscriptions in gold near
the heads of Shah Jahan and his companion clearly identify them as the
work of Murar.[71] This artist came to prominence much later, as a court

PLATE 98 A pair of cranes.
Copy of a seventeenth-century original,
ascribed to Mansur
29.9 × 11.3 cm (page 38.6 × 26.1 cm)
IM 122-1921
Bequeathed by Lady Wantage

artist of Shah Jahan, and it is possible that the faces are inexplicable later additions, perhaps added when the painting was given a new border for one of Shah Jahan's albums, facing a painting of his sons (see pl. 117).[72]

Jahangir's general desire for accuracy in the portraits he commissioned is shown by a story concerning one of Abu'l Hasan's paintings (pl. 96). When Mutribi al-Asamm Samarqandia came to Lahore from Central Asia in 1626, Jahangir showed him portraits of the Uzbek rulers Abdullah Khan and Abd al-Mu'min, and asked Mutribi how accurate they were. When the visitor said Abdullah Khan had been thinner, with a crooked chin, Jahangir summoned the artist (who is not named in Mutribi's account) to make corrections.[73] Five contemporary versions of the portrait have survived, including a fine drawing in the Boston Museum of Fine Art.[74]

The other artist singled out for high honour by Jahangir was Mansur, who was given the title Nader al-Asr ('Wonder of the Age') at the same time Abu'l Hasan was honoured.[75] Ustad Mansur is mentioned by name more than any other artist in the memoirs, and always by his full title, Nader al-Asri Ustad Mansur *naqqash*, the last component meaning 'designer', again suggesting a man of many talents. This versatility is corroborated by signed illumination on manuscripts,[76] and the existence of at least one work that may plausibly be a design for metalwork.[77] He worked on two V&A *Akbarnama* paintings in which animals feature prominently, and in Jahangir's reign became renowned for his studies of wildlife and flowers.[78]

The emperor singled out Mansur's skill at drawing as being 'unique in his generation', and one of his sketches may be identified in the V&A (pl. 97). The story of two rare cranes exemplifies Jahangir's close scrutiny of the natural world.[79] The birds had been taken into his menagerie at the age of one month, given the names Layla and Majnun after the renowned tragic lovers of Persian literature, and after five years, in August 1618, were ready to mate.[80] Their mating ritual, the hatching of the eggs and the efforts taken by the cranes to protect them, are all carefully documented. Mansur's authorship of the drawing is strongly suggested

PLATE 99 A turkey cock.

Signed by Mansur, *c.*1612

12.9 × 12.5 cm (page *c.*38.6 × 26 cm;

edges slightly damaged)

IM 135-1921

Bequeathed by Lady Wantage

by the fine calligraphic lines of the quickly sketched birds, and by a nine-teenth-century copy of the original work, now lost, ascribed to the master (pl. 98). It was also said by the donor to have been purchased from a descendant of Mansur.

Jahangir's love of nature runs through the pages of the *Jahangirnama* as he observes the ravishing beauty of the flowers in Kashmir, or the unusual birds he saw there. Once or twice he mentions calling Mansur to paint them, though more often he simply records seeing something that happens to have survived as a painting signed by Mansur, such as the turkey cock sent to court by Muqarrab Khan (pl. 99). Muqarrab Khan was one of Jahangir's

closest companions and a man of many accomplishments and interests, including horticulture.[81] He had been asked by the emperor to procure rarities of all kinds at the port of Cambay; in a 1612 consignment he included exotic animals and birds that caused a sensation. Jahangir wrote:

> Although King Babur has described in his Memoirs the appearance and shapes of several animals, he had never ordered the painters to make pictures of them. As these animals appeared to me to be very strange, I both described them and ordered that painters should draw them in the Jahangirnama, so that the amazement that arose from hearing of them might be increased. One of these animals in body is larger than a peahen and smaller than a peacock.[82]

Several versions of the turkey cock, or its progeny reared at the court, have survived, the V&A's example bearing an authentic signature of Mansur.[83]

Other works by the master include the famous painting of a zebra presented to Jahangir by *Mir* Ja'far, who had obtained it in AH 1030 (1621) from Turks travelling to India from Africa (pl. 100). When the zebra arrived,

PLATE 100 A zebra.

By Mansur

Inscribed by Jahangir: 'A zebra that the Turks who came with *Mir* Ja'far from Abyssinia had brought, completed by Nader al-Asri Ustad Mansur in the sixteenth year of the reign, 1030 [1621]'

18.1 × 24.1 cm

IM 23–1925

From the Minto Album

Jahangir used an apt metaphor to describe the strangeness of a beast which seemed to him like a horse painted with stripes: 'One might say the painter of fate, with a strange brush, had left it on the page of the world.'[84] Jahangir does not mention ordering one of his artists to record the zebra's appearance before it was sent to Shah Abbas, but he wrote the artist's name and the details of how it came to court on the painting.[85]

The presence of unnamed artists is noted regularly in the *Jahangirnama*. Similarly, the accounts of foreigners at the court, such as the ambassador of King James I of England, Sir Thomas Roe, in 1616, refer to Jahangir's 'Cheefe Paynter' rather than to a named individual.[86] In addition to painting particularly

interesting or bizarre specimens of the natural world, including humans,
they were sent to decorate the walls of newly built or refurbished buildings,
and called in to copy European paintings. Mansur's closeness to the
emperor is evident from the fact that he is mentioned as part of the
entourage travelling to Jahangir's beloved Kashmir, notably in 1620 when
the emperor described the beauty of the scenery and its wildlife in a lyrical
reverie in his diary, noting that he ordered Mansur to paint birds (pl. 101)
and flowers.

Manohar also produced important animal studies for Jahangir. A fine study
of a black buck led by its keeper is inscribed at the bottom, '*manohar bandeh-*

PLATE 102 A black buck being
led by its keeper.
Signed by Manohar, *c.* 1610–15
16.8 × 15.8 cm (page 38.9 × 26.3 cm)
IM 134–1921
Bequeathed by Lady Wantage

PLATE 103 The Flight into Egypt.
By Albrecht Dürer
From the series *The Life of the Virgin*,
first published *c.* 1504–05
9.8 × 20.7 cm
24910.14

ye', and top, '*jahangir shahi*' ('Manohar, servant of Jahangir Shah'), recording
Manohar's service to the emperor (pl. 102).[87] The posture of the animal's
keeper is highly unusual. Depictions of keepers leading animals are not
uncommon in Mughal painting, or in the Iranian works that probably
inspired them, but none has the gait of the man in Manohar's painting.[88] He
bends one knee, crouching slightly, while looking over his shoulder, in an
idiosyncratic manner strongly reminiscent of Joseph in Albrecht Dürer's *The
Flight to Egypt* (pl. 103). Such parallels are not fanciful; Dürer's engravings
were copied several times by Jahangir's artists, and the series to which this
belonged had been brought to the court by the Jesuits.[89]

PORTRAITS

During the reign of Jahangir, portraiture became increasingly realistic, the finest practitioners developing an acute psychological perception of their subjects. This tendency was already apparent in the astonishing portraits done by Dowlat in the borders of the Golshan Album on a minute scale, where individuals are shown in natural postures, deeply engrossed in their work.[90] Exposure to European works, and the constant copying and adapting of European subjects, must have contributed to this development.

In Jahangir's reign, the jewel-like miniatures of such English artists as Isaac Oliver and Nicholas Hilliard also appeared at court and appealed instantly to the emperor. His artists copied these, too, as is known from the much-quoted account of the English ambassador, Sir Thomas Roe, detailing how Jahangir's 'Cheefe Paynter' took away Roe's precious portrait of a lady, producing five almost indistinguishable versions over several weeks in 1616.[91] The V&A collection includes a real Isaac Oliver, its subject and history unknown, that was added to an Indian album page in the eighteenth century with suitable embellishment (pl. 104).

Other portraits seem to have a more complex relation to reality. Two related paintings arrived in the Museum by separate routes. The first was variously identified as Henri IV of France (r.1589–1610), to whom he bears a striking lack of resemblance, and the Holy Roman Emperor Charles V (r.1519–58), whom he resembles slightly (pl. 105), before entering the Museum's records as 'an English sea captain'.[92] The second was bought from the dealer Imre Schwaiger, and identified by him for no obvious reason as Sir Thomas Roe (pl. 106). Both seem to date from the middle years of Jahangir's reign, when '*farangis*' (i.e. 'Franks' or Europeans), particularly the Portuguese, would have been a familiar sight at court, arriving as traders and mercenaries, craftsmen and adventurers. A letter sent from Agra in 1610 by William Finch to the English East India company mentions in passing '3 French soldiers, a Dutch enginer and a Venetian merchant with his sonne', giving a flavour of the cosmopolitan nature of the court.[93] Over their long residence in India, the Portuguese had adapted their dress to the demands of the climate, retaining their usual cloaks and doublets (though the materials would have been lighter in the hot season), but replacing tight knee breeches and hose with loose trousers gathered in at the ankle for coolness and protection against mosquitoes.[94] This kind of costume is often depicted in Mughal painting from the 1590s.[95]

Some of the details in both paintings, however, reflect earlier styles of European dress. The pinked soft leather boots and open fronted lace ruff are seen in European portraits of the 1580s,[96] while the rapier may be as early as the 1560s.[97] Together, these suggest that the artist or artists of both paintings copied a sixteenth-century European portrait, perhaps brought to the court by a Portuguese visitor from Goa, adapting it to reflect contemporary life.

PLATE 104 Portrait of an unknown man. By Isaac Oliver

*c.*1595, mounted on a Mughal album page of *c.*1775–1800

Miniature 3.8 × 3.1 cm (6.3 × 4.6 cm including blue frame)

IS 60-1978

ABOVE LEFT: PLATE 105 A European.

c.1610–20

29.5 × 18.3 cm

IM 386-1914

Bought from Mr Imre Schwaiger

ABOVE RIGHT: PLATE 106 A European.

c.1610–20

32.8 × 18.7 cm

IM 9-1913

From the collection of Arthur Churchill, Esq.

Another painting, by Bishndas, is similarly not quite what it seems (pl. 107). In 1618, Jahangir mentioned a visitor from Gujarat in his memoirs: 'his name is Jassa, Jam is his title.'[98] He travelled with Jahangir during the twelfth and thirteenth regnal years, finally leaving at the Nowruz, March 1618.[99] His companion in the painting, the 80-year-old Bihari Rai, was from the same region (Jahangir described them as being 'from one stem'), but their visits to the court did not coincide.[100] The painting should perhaps be regarded as belonging to the series of allegorical paintings of the middle of Jahangir's reign.[101] The significance of the harmonious atmosphere in the painting is that individuals such as the Jam of the remote Kathiawar peninsula had never before appeared at the Mughal court, but now found it prudent to attend in order to extract a *sanad*, or written patent, from the emperor to be able to retain their lands unchallenged.[102]

Jahangir's artists also painted personalities of the court whose existence is otherwise unrecorded. The emperor's interest in wrestling is evident from a passage where he notes requesting wrestlers to be sent from Bijapur to the court.[103] The title of the stocky individual honoured with a portrait by Manohar does not

140

OPPOSITE: PLATE 107 The rulers of Gujarat,
Bihari Rai and Jassa Jam.
By Bishndas, *c.* 1618
22.8 × 15.8 cm (page 37.2 × 24.5 cm)
IM 124–1921
Bequeathed by Lady Wantage

RIGHT: PLATE 108 Jahangir's court wrestler.
Signed by Manohar, *c.*1615
Inscribed by Jahangir:'Likeness of *Fil-e safid*
[White Elephant] the great wrestler'
21.7 × 13.2 cm
IS 217–1951
From the collection of Sir William Rothenstein.
Purchased with the assistance of Lady Rothenstein
and the National Art Collections Fund

appear anywhere in his writings, however, and 'Fil-e safid' ('White Elephant'),
might have disappeared from history had his name not been written by Jahangir
on the painting, in his distinctive spidery writing (pl. 108).[104] Interestingly, the
wrestler is shown with his face turned towards the viewer, rather than in the
standard profile of most Mughal court portraits. It is tempting to explain this in
terms of ancient traditions such as those represented by the *Chitrasutra* (see
Chapter One), where it is explicitly stated that combatants such as wrestlers
should not be depicted looking sideways, and should be shown 'tall and well-
built, thick-necked, large-headed and close-cropped, overbearing and massive'.[105]

6

PAINTING FOR
SHAH JAHAN

◆

Shah Jahan's involvement with his artists is as discreetly concealed as the character of the emperor himself. He left no personal memoirs in the style of his father, and the official histories of the reign lack the commentaries on the views of the emperor, or intimate details of his life, that provide such a vivid picture of Akbar's personality in Abu'l Fazl's writings. There are few illustrated manuscripts associated with Shah Jahan, but the carefully detailed splendour in the pictures of court assemblies in the major manuscript of the reign, the Windsor Castle *Padshahnama*, and in similar scenes surviving in albums, makes it difficult to dismiss him, as he occasionally has been, as a man uninterested in painting. The error of this has been pointed out by Ebba Koch in a monograph on the Windsor Castle *Padshahnama*, in which she quotes the unambiguous testimony of a contemporary historian that part of the emperor's daily routine was to examine progress on the entire range of his artistic commissions, with painters and designers showing their work alongside goldsmiths, enamellers and architects.[1]

Shah Jahan's reign was relatively peaceful, the administration of the empire was extremely efficient, and his resources were of a richness unparalleled in Mughal history. He was a renowned connoisseur of gems, and this influenced the character of his greatest passion, architecture, where white marble walls and pillars are embellished with the bright, pure colours of semi-precious stone inlays. Paintings of the reign pay similar attention to decorative detail, and the interplay between the patterns on the borders of album pages, objects and architecture implies that the same painters and designers were involved in the creation of many of them.

When Jahangir died, Shah Jahan inherited the great royal library and followed his father's example by annotating precious manuscripts with his own evaluations.[2] He must have pored over the paintings and calligraphies in Jahangir's albums, and had some of them remounted for inclusion in his own

PLATE 110 Muhammad Beg,
Zu'lfiqar Khan.
By Nanha, *c.*1618; the border
signed by Dowlat
Inscribed: 'Likeness of Zu'lfiqar Khan,
the work of Nanha' and, by Shah Jahan,
'In archery and *gaz* archery he was without
equal among my good servants.'
15.8 × 9.7 cm (page 38.9 × 26.7 cm)
IM 24-1925
From the Minto Album

albums, the pages adorned with beautiful borders in the latest style (e.g. pls 109 and 110). Distinguishing between borders painted in the later part of Jahangir's reign and those done for Shah Jahan in the years immediately after his succession is highly problematic, as will be seen.

Shah Jahan's personality remains elusive, and many of the paintings of his reign, with their formal perfection and mannered presentation of the ceremonial of court life and the people who walked through it, lack the immediacy and, to some extent, the appeal of those of his predecessors. The albums would undoubtedly have given a valuable insight into Shah Jahan's tastes, from his personal selection of inherited paintings and calligraphies, and choice of portraits of friends, family and foes, as well as the poetry that surrounded them. Not a single intact album survives, however, making it impossible to determine whether or not they had dominant themes, or to draw conclusions from the juxtapositions of calligraphy and paintings.

The pictures in the V&A directly associated with Shah Jahan, almost all from his albums, are predominantly portraits – of himself, of his sons, of high-ranking personages of the court, distinguished visitors, or distinguished foes – and all have fine specimens of calligraphy on the verso. They came to the Museum with pages from Jahangir's albums, also mounted on folios with calligraphy on the verso, and include works by Mansur, Manohar, Bichitr and Hashem. Most belong to two groups: the first to be acquired was known as the Wantage Album (though it seems never to have been bound) after Lady Wantage, whose bequest came to the Museum in 1921; the second, the Minto Album, was named after Lord Minto, who sold it at Sotheby's in 1925. The fact that the two groups are known after their early twentieth-century British owners has suggested a unity to each which is misleading.

THE WANTAGE ALBUM

The Museum's link with Harriet, Lady Wantage began in 1903, when she gave a copy of the recently printed catalogue raisonné of the European pictures in her collection to the National Art Library.[3] A catalogue of the Wantage porcelain, furniture and other works of art followed in 1913, and three years later the director, Sir Cecil Harcourt Smith, visited Lady Wantage at Lockinge House, returning with '33 Indian (Mogul) Paintings' for 'inspection' and a typewritten descriptive list by Dr G. Oppert, who noted 'the seal of the Great Mogul Emperor, Gehanghir' on some of the folios.

The Museum's files record the excited commentary of Caspar Stanley Clarke, the Keeper of the Indian Department, who wrote that the collection 'is composed, without exception, of Mogul works of the best period – magnificent illustrations of the 16th and 17th century school (Delhi, Agra, Fathpur Sikri) – and all of the type so eagerly sought for by European collectors in recent years. *I sincerely trust the collection will remain here on loan.* It

will create quite a sensation.'[4] Sir Cecil then wrote to Lady Wantage that the paintings were of 'surprising interest and importance', 20 of the 33 folios having been owned by Jahangir, and the remaining 13 'probably part of the royal collection at Delhi in the 17th century'.

It was agreed that the folios should be lent to the Museum for exhibition in 1917, but wartime economies prevented the publication of an illustrated catalogue. Three bound volumes were, however, printed in 1922, reproducing each page actual size and including an essay by Clarke, translations of some of the Persian verses by E. Dennison Ross, Director of the School of Oriental Studies, and information on the inscriptions concerning artists' names and other details by Thomas Arnold of the British Museum.[5] One volume was retained by the Indian Department, another was sent to Lady Wantage, and the third was despatched to Queen Mary at her own request.

Nothing is known of the previous history of the Wantage folios. Clarke's introduction states that they were bought in London during the 1867–68 season by the immensely wealthy banker and collector Baron Overstone to give to his daughter, the Hon. Harriet Lindsay (later Lady Wantage), on her thirty-first birthday in 1868.[6] Clarke seems to have regarded the presence of Jahangir's seal on some pages as proof that they had been in the royal Mughal library until the Indian Mutiny in 1857, though nothing in the Museum archives supports this.

The authenticity of the Wantage collection, which included 'signed' works by leading artists of the reigns of Jahangir and Shah Jahan, was not questioned until 1949, when the great Indian scholar Moti Chandra analysed the characteristics of some of the paintings, which identified them as 'fakes' (see pl. 98), probably done in the late eighteenth century.[7] The draughtsmanship, depiction of landscape and the colouring of the borders was, he noted, markedly inferior to the seventeenth-century originals in the same collection and the paint was thinner. Most obviously, the artists who must have copied original seventeenth-century works had used lampblack stippling to produce shading that was particularly noticeable on faces, and perhaps imitated European steel engravings.

The circular stamp on the calligraphy page of some of the folios seems to have been made using an authentic seal of Jahangir dated regnal year six (AH 1020; 11 March 1611–8 March 1612),[8] but appears on pages with paintings definitely of later date, as well as on some of the copies, suggesting that it had fallen into the hands of whoever masterminded the copying.[9] A second seal stamp of oval form appears on the borders of paintings on all the folios with Jahangir's seal, and is equally inexplicable, naming one Nandaram Pandit and seemingly dated AH 1161 (1748), though the impression is usually slightly smudged.[10]

It was immediately apparent from Moti Chandra's analyis that the majority of the paintings (19 out of 33) were copies, but the remaining authentic works were nevertheless extremely important, including work by the finest court artists of the reigns of Jahangir and Shah Jahan.

THE MINTO ALBUM

On 6 April 1925, lot 480 of a sale of manuscripts and rare books at Sotheby's, London, comprised 'An Album of Superb Indian Miniatures and Calligraphy'.[11] It was widely known to have come from the Minto family, but it has never been established which Lord Minto had originally acquired it. The first Earl was Governor General of India from 1807 to 1813, and the fourth Earl was Viceroy from 1905 to 1910. This is not necessarily relevant, however, as other albums or groups of album pages left India when Nader Shah of Iran sacked the Mughal treasury in 1738-39, or later in the eighteenth century as the Mughal empire declined, or first surfaced in the West.[12] Sotheby's has no information in its archives on the earlier history of the Minto pages, and there is no clue in the papers of the Minto heirs or the records of the V&A.[13]

As soon as the Sotheby sale was announced, the V&A's director, Sir Eric Maclagan, acted quickly to acquire the album, fully appreciating the high price it was likely to fetch. He saw the paintings for the first time on the evening of 20 March 1925, and urgently sought the advice of the Rector of the Royal College of Art, Sir William Rothenstein. The artist, a keen collector of Indian painting, was familiar with the small circle of collectors who might compete against the museum.[14] He wrote back that 'the most formidable rival' would be Alfred Chester Beatty, and arranged to go with Maclagan to Sotheby's the following day, commenting, 'One rarely has a chance of seeing examples, dated and signed, of the best Moghul portraits. And these, from all accounts, are exceptionally good.'[15]

There is a single reference to the provenance of the album in the V&A archives, in Maclagan's long minute detailing the case for acquiring the paintings: 'The name of the owner is being kept a secret but, as a matter of fact, they belong to Lord Minto. They must have come originally from one of the royal collections in India; they were all at one time the property of the great Emperor Shah Jahan.'[16]

Letters in the Museum's files record the frantic but ultimately unsuccessful efforts to tempt rich benefactors to support the acquisition of the paintings. Laurence Binyon and T.W. Arnold of the British Museum ruled themselves out as rivals, and an interview was held with Alfred Chester Beatty as soon as he arrived in London for the auction preview. Keen to avoid a bidding contest that could only harm both parties, the collector immediately agreed to a joint purchase and 'squared Mr Gulbenkian, a big Armenian collector, who was also after the book and had agreed to stand down.'[17]

When the 'Property of a Nobleman' was auctioned, the hammer fell on a bid of £3,950 from Bernard Quaritch, the dealer in rare books and manuscripts acting on behalf of the Museum and Mr Beatty. The museum paid £2,073 15s for '20 drawings of the very highest quality', including Quaritch's commission.[18] By 18 April the final division of the spoils had been made, the Museum losing Caspar Stanley Clarke's favourite paintings of a group of holy

men by Govardhan and Bichitr's allegorical painting of Mu'in ad-Din Chishti presenting a globe to Jahangir,[19] but gaining an extra page in an arrangement that left both parties satisfied: the V&A had 21, and the Chester Beatty Library 19 pages from what was known thereafter as the 'Minto Album'.[20]

Some of the Minto pages had clearly also been available to copyists of the late eighteenth or early nineteenth century, and the copies had been combined with authentic pages in a bound album that appeared in a Scottish dealer's shop in the summer of 1929.[21] Shortly afterwards, this volume was sold at Sotheby's to the dealer Hagop Kevorkian (bidding against Chester Beatty).[22] It was later sold in instalments, the Freer Gallery of Art buying nine folios in 1938 and 1948, and the Metropolitan Museum acquiring the remaining folios in 1955 with funds provided by Hagop Kevorkian, after whom it became known.[23] Following Moti Chandra's publication, the Freer pages were reassessed as copies in the Wantage style. All the authentic pages in the Wantage, Minto and Kevorkian groups have minute numbers on the inner gold frame of the picture that accord with pairing of folios established by their related subjects or decorative borders, but these numbers are not necessarily from the original pagination.[24] It is, however, certain that there is no comprehensive run of pages from any single group.[25] Various theories have been put forward concerning the number of original albums from which they came, but the conclusions remain highly tentative, given their incomplete nature.[26]

ROYAL PORTRAITS

It is clear that the general rule applicable to Jahangir's albums, whereby each folio has a painting on one side and calligraphy on the other, and the folios are arranged so that each opening has two thematically related paintings, alternating with two calligraphies, was followed by Shah Jahan in his own albums.[27] The Minto Album, however, includes the two known exceptions to this rule. One of the V&A paintings is ascribed to Govardhan and depicts Timur handing his crown to Babur in the company of Humayun and their respective viziers (pl. 112); its verso is entirely filled by an arabesque design (pl. 113) rather than the standard calligraphic panel.[28] A companion painting in the Chester Beatty Library Minto pages depicts Akbar, Jahangir and Shah Jahan, also with their chief ministers, and has a similar design on the reverse. This suggests they are the opening and closing folios of a single album of Shah Jahan, as the arabesque pages would have broken the rhythm of alternating pictures and calligraphy if placed together.[29] The line of descent from Timur (for whom there seems to have been a standard likeness at the Mughal court, because the same model has been used for the Minto page and in Shah Jahan's *Padshahnama*) was one to which the Mughal emperors constantly drew attention.[30]

A portrait of Shah Jahan in imperial splendour (pl. 114) bears the number 2

PLATE 112 Timur handing the imperial crown to Babur in the presence of Humayun.
By Govardhan, c.1630
29.5 × 20.4 cm (page 38.5 × 26.1 cm)
IM 8-1925
From the Minto Album

but seems highly unlikely to have any connection with the previous dynastic image that has a minute 'I' in the narrow gold frame round the painting. It arrived in the Museum in 1921, the same year in which the Wantage paintings were bequeathed; it was given to the Museum by the executors of Sir Robert Nathan with a number of other paintings that the Indian civil servant had bought from Maulvi Muhammad, a judge in the Small Cause Court in Delhi, in 1905.[31] The portrait of Shah Jahan holding a very large, faceted emerald is signed by an artist belonging to one of the most illustrious families of the royal studio, his lineage written in gold on the green ground of the painting: 'painted by [raqam-e] Muhammad Abed, son of Aqa Reza and

PLATE 113 Arabesque design
on the verso of plate 112.
Page 38.5 × 26.1 cm
IM 8a-1925
From the Minto Album

brother of Nader al-Zaman [Abu'l Hasan] this came to completion in the
paradise-like assembly.' The painting is dated 'year 41', or AH 1041 (1631–32).

The golden halo behind Shah Jahan's head is clearly defined, following a
convention that became established in Mughal painting in the late sixteenth
century. The halo was an Iranian concept that would spread east and west,
and Abu'l Fazl explained its significance in the Islamic world:

Royalty is a light emanating from God, and a ray from the sun, the
illuminator of the universe, the argument of the book of perfection, the
receptacle of all virtues. Modern language calls this light *farr-i izadi* [the
divine light] and the tongue of antiquity called it *kiyan khura* [the Kiyan halo;

PLATE 115 Dara Shokuh with a tray of jewels.
By Chitarman; dated AH 1050 (1640–41)
24.6 × 15.8 cm (page 38.8 × 26.4 cm)
IM 19-1925
From the Minto Album

i.e. that of the ancient line of Kiyanid kings of the Persian national epic,
the *Shah Nama*, or Book of Kings]. It is communicated by God to kings
without the intermediate assistance of anyone, and men in the presence
of it bend the forehead of praise towards the ground of submission.[32]
European art provided Mughal artists with new models for this familiar con-
cept, and Jahangir famously elaborated it in the allegorical paintings he com-
missioned from Bichitr and Abu'l Hasan in which the vast shimmering disc
alludes, among other things, to his title Nur ad-Din ('Light of the Faith').[33]
Reduced again to a more modest form during Shah Jahan's reign, the sig-
nificance of the halo remained unchanged.

Abed's portrait is important for its signature and date,
but the page has an additional interest. Although the deep
indigo borders have been cut down, enough remains to
appreciate the high quality of the gold design. Hidden
between leaves, the gilder's name, Harif, appears twice:
beneath the third plant from the top on the right, and at
the top of the left margin, beneath the first complete
flower. His signature is also found on two pages in the
Kevorkian Album, similarly disguised in one of them.[34]

Shah Jahan's albums also included portraits of his sons,
done in very different styles. His favourite son, Dara
Shokuh, is shown in the conventional portrait manner,
standing in profile against a pale green ground, in a
painting dated AH 1050 (1640–41), annotated by Shah
Jahan, 'a good likeness of Baba Dara Shokuh by
Chitarman' (pl. 115).[35] The prince holds a turban jewel
taken from a tray of jewels that includes a European
cameo of the kind that inspired a cameo portrait of Shah
Jahan in the V&A.[36] Completely different in feeling is
the equestrian portrait by Govardhan of the same prince
with his father, in restrained ochre, brown and green
tones softly highlighted with gold (pl. 116). Govardhan
was one of the greatest Mughal artists, whose career
spanned the reigns of Akbar, Jahangir and Shah Jahan.[37]
The painting must have formed part of a carefully con-
ceived programme for one of the royal albums, as it complements an earlier
painting done by Govardhan of Timur, inscribed by Jahangir.[38]

Shah Jahan's three sons are brought together in a painting inscribed by the
emperor with their names, and that of the artist, Balchand (pl. 117). It origi-
nally faced the painting of the emperor and Dara Shokuh by Manohar and
Murar (see pl. 95), and has the same restrained tones and exquisite detailing
of textiles. The artist has arranged his composition with subtle symmetry; the
heads of the princes and their horses follow the same lines, and their spears

154

OPPOSITE: PLATE 116 Shah Jahan
with his son Dara Shokuh.
By Govardhan, *c.*1635
22.3 × 14.1 cm
IM 18-1925
From the Minto Album

PLATE 117 The sons of Shah Jahan.
By Balchand, *c.*1635
23.8 × 16.9 cm (page 38.8 × 26.5 cm)
IM 13-1925
From the Minto Album

and reins set up counter rhythms. Colour is handled with the same delicacy, the elder prince's dark horse allowing the soft grey of his brother's horse to stand out, these pale tones in turn giving emphasis to the black head of Murad Bakhsh's piebald horse.

PORTRAITS OF THE COURT

Other portraits in the albums are of individuals closely associated with Shah Jahan's life, both as a prince and as emperor. Abu'l Hasan, called Asef Khan (pl. 118), could not have been more intimately connected with the royal

family: his sister was Nur Jahan, Jahangir's formidable Iranian wife and for a
long period the real power in the Mughal empire,[39] and Shah Jahan had
married his daughter, Arjumand Banu Begum, in 1612.[40] Asef Khan was one
of the prince's most trusted confidants and supporters, and held extremely
influential positions during both reigns.

When Jahangir died in 1627, Shah Jahan was campaigning in the Deccan
and was therefore unable to reach Delhi or Agra quickly to establish his
claim to the throne. The possibility of a war of succession was strong, as Nur
Jahan had long harboured ambitions for her son-in-law Shahriyar, through
whom she could have continued to wield power. Shah Jahan's sons were in a

vulnerable position under her protection in Lahore, and Asef Khan acted swiftly and ruthlessly. Declaring Khusrow's son, Dawar Bakhsh, emperor in order to hold the capital until Shah Jahan should reach it, Asef Khan sped to Lahore and took the fort, which was occupied by Shahriyar's forces.[41] The prince was captured and blinded to deprive him of further claims to the throne, and on 29 January 1628 the address (*khutba*) was delivered in Shah Jahan's name in the northern royal capital.

On 1 February Shah Jahan reached Delhi, and two weeks later, on 8 Jumada II AH 1037 (14 February 1628), his coronation took place. The emperor was 37, according to his lunar birthday.[42] At the beginning of March, in time for the Nowruz (New Year), Asef Khan brought the princes to the court and was given the highest rank at court, *vakil*, in recognition of

ABOVE LEFT: PLATE 119 Detail of plate 118.

ABOVE RIGHT: PLATE 120 Detail of the date on plate 118.

IM 26-1925

his loyal service, and entrusted with the royal seal that was used to stamp all royal orders.[43] At the end of November in the third regnal year, he was appointed supreme commander of the Mughal army in the Deccan, an event that may be commemorated in the V&A portrait. The detailed background scene almost certainly relates to the events in Lahore, in which case Prince Shahriyar must be one of the three prisoners being led away in chains and manacles to the left, in front of the rows of horsemen (pl. 119). Above Asef Khan's head, a putto holds a scroll (pl. 120) on which are written the words 'God is great', followed by the Koranic quotation: 'Victory comes from God and triumph is near', with the date of the painting, regnal year

PLATE 121 Abdu'l Hadi, Shah Jahan's
mir bakhshi (d.1647).

c.1640–45

21.4 × 11.4 cm (including extended areas)

IS 48–1956 folio 6a

From the Small Clive Album

three (16 January 1630–4 January 1631).[44] A later inscription records Asef Khan's titles, *khan-i khanan* and *sipahsalar* (Commander in Chief), both conferred on him at the Nowruz in March 1635, and the name of the artist.[45]

The painting exemplifies a developed style of official portraiture that emerged in the later years of Jahangir's reign. The Akbari convention of placing a single figure in profile against a pale green ground has been retained almost unaltered; the figure is portrayed without a context, though his status may be discreetly conveyed through clothing or jewellery. At the same time, however, new colours (solid brown or dark green) were introduced for monochrome backgrounds, though the earlier pale green continued to be used. The background might be sprinkled with flowering plants (see pl. 93), but it was not until the 1620s that a distant landscape began to appear behind the subject.[46] An important development is seen in a painting dated 1623, which has a lightly sketched narrative in the background, still in monochrome, alluding to important events in the life of the individual being portrayed.[47] Shah Jahan's artists drew on all these conventions, adding full colour to the background by the 1630s.[48]

The convention of including a distant narrative scene may have been influenced directly by Western prints. Engravings made in the 1580s by Hendrik Goltzius and his student Jacques Gheyn II depict military and other figures, and use the same compositional device of a large figure dominating the foreground, with a faraway scene with a low horizon populated by a small, sketchy figures.[49] At least one of these engravings was copied exactly by a Mughal artist in the early seventeenth century.[50]

Traditional conventions in portraiture were to endure beside these more progressive elements. A portrait datable to about 1645 is done in the archaic style of the middle of Jahangir's reign (apart from the addition of sky streaked red and gold), and depicts a leading member of Shah Jahan's court (pl. 121). Finely drawn flowering plants and tufts of grass round the man's feet hint suggest a setting without defining it. He is Abdu'l Hadi, an Iranian who had followed his father into Mughal service, arriving at the court after 1613.[51] He was given the title Asalat Khan in 1630 and was a military commander, becoming *mir bakhshi* in 1644, meaning he was in charge of all *mansab* (rank) awards. This was presumably the time his portrait was painted; he died in 1647.[52]

A single exception to the portraits of royalty and individuals of high rank at court in the V&A paintings of Shah Jahan's era is Bichitr's study of a musician with singer companion (pl. 122), in which three figures are placed weightlessly in a scene otherwise demonstrating perfectly assimilated European techniques of modelling, foreshortening and shading. The painting is strongly influenced by the work of the great Govardhan, notably in the fine detail of the background structures and the delicacy of the palette with its pale washes of green, yellow, light brown and purplish pink, all reminiscent of Govardhan's own depiction of musicians in an encampment dating to

PLATE 122 A singer and companions.
By Bichitr, c. 1640
18.8 × 12 cm (page 38.8 × 26.8 cm)
IM 27-1925
From the Minto Album

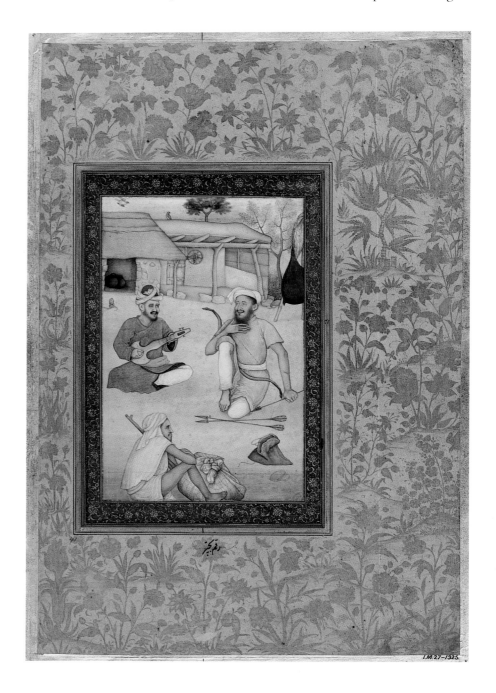

PLATE 123 Malik Ambar of Ahmadnagar.
Signed by Hashem, *c.*1624–25
Inscribed: 'the likeness of Ambar
by Hashem'
19.5 × 11.7 cm (page 38.6 × 26.5 cm)
IM 21-1925
From the Minto Album

*c.*1620–30. Bichitr even copied the posture of the figure whose forearm rests on his upright knee, his toes pointing out towards the viewer, while the splayed fingers of his other hand gesture in front of his beard.[53]

PRINCELY COMMISSIONS

Other portraits in Shah Jahan's albums date from his father's reign but depict individuals of particular importance in the events of his own life as a prince, and may have been done by artists attached to his entourage as he travelled around the empire. Two paintings in the Minto group were obviously

PLATE 124 Sultan Muhammad Qutb
Shah of Golconda.
Signed by Hashem, *c.*1624–25
Inscribed by Jahangir: 'a good likeness
of Sultan Muhammad Qutb al-Mulk'
19.6 × 11.7 cm (page 38.6 × 26.5 cm)
IM 22-1925
From the Minto Album

intended to be seen as a double page as they are of similar size and have
related subjects and complementary borders in the floral style of Shah Jahan's
reign. Both portraits were, however, done during Jahangir's reign by
Hashem, who signed them.[54] The great Deccani enemy of the Mughal state,
Malik Ambar (pl. 123), emerged as the greatest challenge to Mughal territor-
ial ambitions in the Deccan, and in the album faced his contemporary,
Muhammad Qutb Shah, ruler of Golconda from 1612 to 1626 (pl. 124).

Malik Ambar was born in Ethiopia in about 1549 and sold into slavery.
He was eventually bought by a leading member of the Nizam Shahi court of
Ahmadnagar, one of the fragile sultanates of the Deccan.[55] The slave became

PLATE 125 Jahangir shooting the head
of Malik Ambar.

Signed by Abu'l Hasan, c. 1616

From the Minto Album

Chester Beatty Library, Dublin: Ind. 7A.15

a soldier, and eventually a commander of the Nizam Shahi army, leading it against Akbar's forces. By 1600 his position had become so powerful that he was able to place a compliant young Murtaza Nizam Shah on the throne and present to him his own daughter in matrimony. Malik Ambar became Regent of the Kingdom (*vakil us-saltanat*), effectively ruling Ahmadnagar until his death in 1626.[56]

When Jahangir came to power and was distracted in the first year of his reign by the revolt of his son, Khusrow, and by the Iranian siege of Qandahar in the far north-west of the empire, Malik Ambar retrieved land that had been taken by the Mughals. Major campaigns were launched in retaliation against the Deccan sultanates, whose rulers formed constantly shifting alliances between themselves and, if advantageous, occasionally united with the Mughals against each other. Prince Parviz led unsuccessful campaigns in the Deccan over a period of seven years before being replaced in 1616 by Shah Jahan, whose military skills had proved so successful where Parviz had also previously failed, against the Mewar ruler two years earlier.[57] Shah Jahan's reputation alone made the Deccani rulers sign treaties and pay huge tribute without a weapon being brandished. As soon as Mughal attention was diverted, however, Malik Ambar again improved his position, inflicting a devastating defeat upon Shah Jahan's forces at the Battle of Bhatvadi in 1624.[58]

Jahangir, fully apprised of each setback by the reports sent to the court from the Deccan, was clearly infuriated by Malik Ambar's activities. One of the most complicated allegorical paintings of his reign shows the emperor standing on a globe, staring at a severed head resting on a long spear immediately in front of him (pl. 125).[59] He has just shot an arrow straight through the bodiless victim's mouth (pl. 126), and is preparing to unleash another. The enemy is Malik Ambar, named in a long, vituperative Persian inscription near by.[60] Shah Jahan had more direct contacts with the Mughal enemy that may explain the strong sense of realism in Hashem's portrait, especially when it is compared with his cartoon-like representation in the earlier allegorical painting.

Following the Battle of Bhatvadi, Shah Jahan rebelled against his father and was unable to return to the north. Unfortunately, at this point the precise details of his movements become sketchy. He appealed to his erstwhile enemy Malik Ambar for help, but the shrewd politician 'observed benevolent neutrality',[61] keeping his options open while being careful not to attract the

hostility of Jahangir's army. Shah Jahan turned to Muhammad Qutb Shah for permission to cross his territory to reach Bengal; by November 1624 he was in Masulipatam. He soon returned, briefly forming an alliance with Malik Ambar in a siege against the Mughals at Burhanpur, his former fortified residence (and that of all previous Mughal generals leading the Deccan campaigns since 1601).[62] While it is possible that Shah Jahan met both of the men in Hashem's portraits, it is certain that his emissary Afzal Khan visited them on the prince's behalf.[63] Hashem could have been present on either occasion as part of the entourage, as Nanha had been during the Mewar campaign.

It has been suggested that the artist was from the Deccan and changed his style when he came into contact with Mughal naturalism.[64] However, the only surviving Deccani portraits that seem to depict Malik Ambar clearly spring from a different tradition to which expressive naturalism is entirely foreign, even though the features are recognizably similar to those in Hashem's portrait.[65] In any event, Malik Ambar in the Mughal version, almost certainly observed from life, is nothing like Bichitr's imagined portrait.

Malik Ambar is depicted by Hashem with the artist's typical economy of means.[66] The traditional featureless pale green of the background provides the perfect foil for the touches of strong colour chosen by the artist. Malik Ambar's skin is of such a dark brown tone that it is difficult at first to appreciate the precision with which he has been painted, his lips pressed tightly together, suggesting great determination. The opacity of the overlapping layers of white muslin in the pleated skirt of his jama[67] contrasts with the translucency of the fine covering of the upper part of his body. Colour is used sparingly: his crimson velvet sword scabbard matches the colour of his narrow belt, the pale shading typical of velvet is sharply observed, as it is on Muhammad Qutb Shah's crimson shoes. His long white jama does not quite conceal the deep blue of his trousers, whose soft fabric falls in narrow folds.

The companion portrait is identified in Jahangir's inscription as 'a good likeness of Sultan Muhammad Qutb al-Mulk'. The sensitivity of the Deccani ruler shines from a face that is almost as pale as his fine muslin jama and the shawl that falls almost to his shoes. The use of colour is equally restrained, with the pastel hue of the background and dominance of white contrasting with the vivid colours of jewels, shoes and turban-band. The distinctive Deccani gilt-copper sword hilt wraps round the ruler's knuckles, drawing attention to his long, slender fingers. His jewellery is unlike that of the Mughal court at the time, including, for example, a fine mesh of gold, emerald-set chains entwined round the wrist. His emerald, ruby and pearl-set gold belt, which sits immediately below the waist, gathering up the folds of the skirt that protrude over it, is also very precisely shown.

Malik Ambar and Muhammad Qutb Shah both died in 1626. Shah Jahan,

PLATE 126 Detail of plate 125 showing Malik Ambar's features as seen by Abu'l Hasan.

OPPOSITE: PLATE 127 Muhammad Ali Beg,
the ambassador of Shah Abbas to the
Mughal court in 1631.
Signed by Hashem, c.1630
Inscribed 'likeness of Muhammad Ali Beg
ilchi [ambassador], the work of Hashem'
21.3 × 14.4 cm (width slightly increased from
its original 13.2 cm) (page 38.7 × 26.4 cm)
IM 25-1925. From the Minto Album

PLATE 128 Dara Shokuh riding the imperial
elephant, Mahabir Deb.
Tinted brush drawing with gold details
c.1635–50
32.5 × c. 40.6 cm
IM 23-1928. Given by Mr R.S. Greenshields

reconciled with his father, returned to the north and must have presented
one, if not both, of the portraits to Jahangir. Hashem's career as a court por-
traitist continued, and he painted such luminaries as Muhammad Ali Beg,
the Iranian ambassador who came to court at the 1631 Nowruz (pl. 127).[68]
Again, Hashem carefully noted his distinctive features, dress and jewellery,
and the portrait was copied exactly by another artist, Bhola, for inclusion in
a scene of the court witnessing the weighing ceremony for Shah Jahan's
forty-second lunar birthday.[69]

After Jahangir's death and his own accession to the throne, Shah Jahan moved
vigorously forward in his policy of annexing the Deccan. Ahmadnagar fell in
1633, and Golconda was neutralized and paid annual tribute from 1636.[70]
The main force in the Deccan was then the Adil Shahi dynasty of Bijapur.
Although Shah Jahan tried to subdue the territory of Muhammed Adil
Shah, whose rule (1627–56) coincided almost exactly with his own, a
treaty was concluded between them in 1636 after a bitter campaign.[71] For

ABOVE LEFT: PLATE 129 Portrait
of the emperor Babur.
Inscribed in Persian, 'likeness
of Babur Shah'. *c.*1630–40
21.4 × 9.7 cm (page: 40 × 26.1 cm)
IS 37-1972 From an album of Dara Shokuh

ABOVE RIGHT: PLATE 130 Panel
of calligraphy in *nasta'liq* script.
Written in Burhanpur, probably by Dara
Shokuh, in the third regnal year, AH 1040
(1 January 1630–4 January 31).
21.4 × 9.6 cm (page: 40 × 26.1 cm
IS 37a-1972

OPPOSITE: PLATE 131 Persian verses.
Page: 38.8 × 26.7 cm
IM 28a-1925 From the Minto Album

the rest of their shared time as rulers, relations were officially amicable, with presents exchanged between them. To reinforce this pleasant atmosphere, Muhammad Adil Shah sent lavish tribute, including on one occasion an elephant (pl. 128).[72] An inscription notes the change of the elephant's name from Khush Khan to Mahabir Deb and that it was 'the present of Adil Khan' (Muhammad Adil Shah), with its enormous valuation of 300,000 rupees.[73] A note on the back of the painting in Persian identifies the haloed rider as Dara Shokuh.[74]

PATRONAGE AT COURT

Patronage throughout the Mughal period extended beyond the immediate circle of the emperor and his wives, sons and daughters. High-ranking nobles and provincial governors also built monuments, commissioned paintings, manuscripts and *objets d'art*. The V&A collection, with its high proportion of works specifically associated with the emperors, does not reflect this range, although one page is associated with Dara Shokuh, Shah Jahan's

chosen successor. Had this connoisseur and patron of the arts not been murdered on the orders of his brother Aurangzeb in the war of succession that broke out during Shah Jahan's serious illness in 1657, the history of Mughal court painting might have been very different. The painting of the emperor Babur (pl. 129) was probably mounted on a page for inclusion in one of the prince's albums as other, related pages are apparently signed by him (pl. 130).[75] Between the lines of the Persian poem on the reverse are minute inscriptions recording that it was calligraphed in Burhanpur in the third regnal year, AH 1040. This dates it to between 10 August 1630 and 4 January 1631. The close similarity of the decoration to that of a page with illuminated calligraphy from one of Shah Jahan's albums (pl. 131) suggests that both shared the same artists and designers while residing at the city where the emperor's beloved wife, Mumtaz Mahal, died in June that same year.[76]

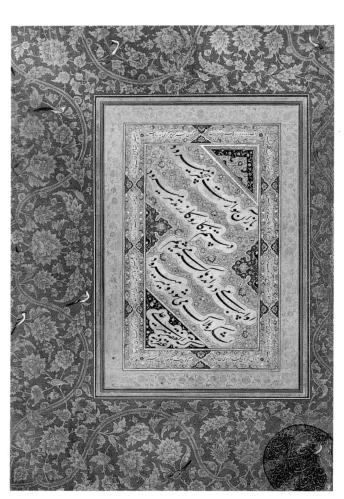

PLATE 132 Persian verses.
Calligraphed by *Mir* Ali
Page 39 × 26.3 cm
IM 134a-1921
Bequeathed by Lady Wantage

BEAUTIFUL BORDERS

The most detailed analysis to date of the calligraphy mounted on the pages belonging to Shah Jahan was made by Annemarie Schimmel with specific reference to the Kevorkian Album.[77] Some of the verses or prose extracts from these folios are repeated or continued in the V&A Minto and Wantage pages. The selection includes work by Timurid, Safavid and Mughal poets, written by masters of calligraphy such as the sixteenth-century *Mir* Ali of Herat, who was himself also a poet.

Dr Schimmel translates verses by one of Shah Jahan's court poets, Abu Talib Kalim (who died in 1645), in which he muses on the beauty of an undentified royal album where 'each line of writing is as heart-ravishing as the province of Kashmir.'[78] The mention of Kashmir would inevitably evoke images of the luxuriant beauty of the flowers in the province rhapsodized by Babur and Jahangir in their memoirs. The notion is continued in verse in which word and image are inextricably linked: 'if the dignity of beauty would not prevent the lovely painted figures from moving, they would happily strut in the garden of the page.' Most significantly, in a second poem, the poet states that 'the Lord of paradisiacal abode [i.e. Jahangir]' had laid out the sketch of the album, but it could not be finished, and was completed by Shah Jahan.[79] The V&A album pages have borders clearly dating from the reigns of both Jahangir and Shah Jahan, and therefore perfectly match the ideas expressed in these poems, even if their original relationship

cannot now be determined. Particularly relevant is the poet's theme of the 'colourful manuscript from the springtime of the garden of Paradise', as Shah Jahan's borders include spring flowers such as daffodils and crocuses.[80] The floral borders of the pages of the Wantage, Minto and Kevorkian groups have always been considered to postdate 1620, most being consigned broadly to Shah Jahan's reign. It is, however, clear that some were done earlier, though more detailed conclusions must await the reproduction of many more pages in their entirety.[81]

It has been shown that Mughal artists often had multiple skills, being involved in architectural decoration as well as book painting, and architecture provides an important clue to the dating of some of Jahangir's album borders. A Wantage page (pl. 132) has an indigo border finely adorned with gold scrolling lines forming ogival arches with looped cusps, intersected by scrolling lines in a counter rhythm and bearing flamboyant palmettes. Small birds, highlighted with opaque watercolour, perch on the foliage, pecking at berries or grapes. The same design is repeated twice in the Kevorkian Album, though the birds are painted in gold (*tazhib az amal-e faqir dowlat*, 'illumination from the work of the lowly Dowlat').[82] Variations in the quality of the painting on each page suggest that different artists used the same tracing to reproduce identical designs.

Akbar's cenotaph on the upper level at Sikandra has a similar design of cusped and ogival arches filled with palmettes that also relate to those on the borders carved into the white marble (pl. 133), suggesting that both were produced at the same time. The cenotaph is undated, but inscriptions on the south gateway record that the complex was completed in AH 1022 (1613–14).[83] It had been begun by Akbar, but Jahangir found it unsatisfactory and in 1608 ordered it to be demolished and rebuilt.[84] The work was still far from completion in 1611, when the English traveller William Finch saw it,[85] but an inscription on the front of the south gateway records that the tomb itself was finished in the seventh regnal year, AH 1021 (i.e. March 1612–March 1613). The cenotaph was probably added between about 1611 and 1613, and there are further parallels between its finely carved decoration and Jahangir's album borders. The rectangular ends of the tomb bear Arabic inscriptions within cartouches surrounded by a variety of flowering plants (pl. 134), with Chinese clouds scudding across the top and insects hovering over the blossoms.[86] The general scheme and its details derive from Iranian ornament and

PLATE 135 Verses in Persian and Turki.
Calligraphed by *Mir* Ali in Bukhara,
possibly in the 1520s
Border and illumination signed by Dowlat
21.7 × 12.8 cm (page 38.8 × 26.6 cm)
IM 12a-1925
From the Minto Album

are found, for example, on silk brocades of the late sixteenth or seven-
teenth century.[87] The density of the plants on the cenotaph and the variety
of their forms are similar to the gold designs on the indigo borders of a
group of Wantage pages (see pl. 88), strongly suggesting that they derive from
designs of the same period.

The relationship between the illumination of the calligraphic panels and
the decoration of their borders is more complex. Some pages in the V&A
Minto Album are signed by Dowlat, whose name is also on some Kevorkian
Album pages, but it is not always clear whether he was responsible for the
illuminated ground to the calligraphy, or the decoration of the border. Given

PLATE 136 Persian verses.
Calligraphed by *Mir* Ali
18.7 × 10.1 cm (page 38.9 × 26.6 cm)
IM 25a-1925
From the Minto Album

the position of his signature on a spectacular Minto page (pl. 135), Dowlat probably painted the gold ground and its highly distinctive flowers. Annemarie Schimmel has noted that the poem repeats that on a Kevorkian page, but that it has the important addition of two lines of Turki poetry about Babur, and is signed by its scribe, 'the scribe, the lowly, poor, sinful *Mir* Ali, *al-katib as-sultani* in the abode of glory, Bukhara', which she surmises may have been written during Babur's conquest of Hindustan.[88] When the calligraphic fragment was mounted on a page for this royal Mughal album, Dowlat filled the golden ground with extraordinary flowers in a style that is almost unique in Mughal painting. His signature in minuscule letters, slightly to the left of

centre below the bottom line of calligraphy, merely states 'work of Dowlat' (*amal-e Dowlat*), lacking his more usual self-deprecating commentary.[89]

The freedom of the arrangement of Dowlat's flowers contrasts with the rigidity of those in the borders of Shah Jahan's albums, but is consistent with decoration of the middle years of Jahangir's reign, as far as it is known from the few surviving dated pieces, such as Jahangir's jade inkpot of AH 1022 (1618–19), which has similarly swaying, fantasy flowers.[90]

PLATE 137 Two kinds of crocus illustrated in *Hortus floridus* or *Jardin de fleurs* (Utrecht, Arnhem, 1614–16). Crispijn van de Passe National Art Library: R.C.A.22

Two signed examples of Dowlat's work seem at first to be utterly different but derive from the same traced design. A portrait of Zu'lfiqar Khan has three inscriptions: the first, by Jahangir, on the green ground of the painting, identifies the subject and the artist, Nanha (see pl. 110). Shah Jahan has added his own commentary to the lower border, noting that Zu'lfiqar Khan had been unequalled in his skill at archery. In this august company, it is easy to overlook Dowlat's modest addition at bottom right of the narrow gold frame dividing the picture area from the indigo border: 'gilding/illumination the work of Dowlat' (*tazhib amal-e Dowlat*). On another page (pl. 136), Dowlat's handwriting is similarly placed on the narrow gold frame surrounding the Persian verses, but he refers to himself here as 'the illuminator, the lowly Dowlat' (*amal-e tazhib faqir Dowlat*).

The decoration of the precious calligraphy collected for decades by the emperors afforded particular opportunities for Jahangir's artists to demonstrate their skill at painting on a miniature scale. The typical arrangment of sloping lines with the calligrapher's signature (or a copy of the signature by a later practitioner eager to emulate the style of a particular master) in a triangular space at the lower left allowed a matching space at top right to be decorated, often with sensitive studies of animals, which were sometimes set free to occupy the interlinear space as well (see pl. 136). No artists' signatures have been recorded for these miniature masterpieces, but their quality suggests that leading artists must have been involved.

There seems to be a considerable period dividing the preparation of Jahangir's albums from those of his son, as represented in the pages of the Minto, Wantage and Kevorkian groups. Flowering plants predominate, but there are many more designs that have yet to be assigned to a reign. There is, nevertheless, a clear correlation between the formal symmetry of the flowering plants carved in marble or inlaid with semi-precious stones on Shah Jahan's most renowned monuments in Delhi, Agra and Lahore dating from

the 1630s and 1640s, and the carefully separated, regularly spaced flowers on the borders enclosing paintings by his court artists. The influence of European herbals, such as Crispin van de Passe's *Hortus floridus*, which was first noted by Robert Skelton, may have tamed the wilder fantasies of the Mughal atelier, and would have been perfectly attuned to a court where its leading artist, Mansur, made more than 100 closely observed studies of flowers while in Kashmir with the emperor in 1620.[91] Conventions derived from Western herbals may be seen in tiny details, such as the tulip petal that drops forward in the border of the portrait of Shah Jahan (see pl. 94),[92] or the precise way that a butterfly or other insect hovers over a plant (pl. 138; compare the border of pl. 127).[93] Occasionally, details may have been copied directly, as suggested by an unusual flower with a sheathed and cut lower stem painted on an album border (see pl. 94, left of lower border) that compares closely with a crocus in a Western herbal, where the stem is bisected by the line indicating the ground from which it grows (pl. 137).[94]

PLATE 138 Two kinds of narcissus illustrated in *Hortus floridus* or *Jardin de fleurs* (Utrecht, Arnhem, 1614).
Crispijn van de Passe
National Art Library: R.C.A.22

On the evidence of the V&A folios, the assembly of albums of calligraphy and paintings with borders in the predominant floral style of Shah Jahan's reign cannot have been completed before AH 1050 (1640–41), the date of Dara Shokuh's portrait (see pl. 115).[95] A further stylization was to emerge in a series of pages from an album imaginatively dubbed 'The Late Shah Jahan Album'.[96]

In 1557 Shah Jahan fell so seriously ill that he was expected to die. He nominated his eldest son, Dara Shokuh, as his successor, but a violent fight broke out between the emperor's sons, the ruthless Aurangzeb emerging as the winner. Aurangzeb's brothers were imprisoned and put to death, and the character of the Mughal court gradually changed from one of extreme opulence to asceticism, reflecting the increasingly pious leanings of the new emperor. Shah Jahan, however, lived until 1666, held in captivity at Agra Fort. Few details are known of his activities during this long period, except that relations between the former emperor and his successor were extremely bitter and that he was cared for by his daughter, Jahanara.[96] He is said to have been deprived of writing materials, and it is not clear whether or not he was able to turn the pages of the albums and manuscripts of the royal library he had inherited from his ancestors, or had collected and commissioned during his own reign. Surrounded by the designs of his artists and craftsmen preserved in marble or paint on the walls of the fort, he must have been acutely aware of the ebbing away of a great artistic age.

APPENDIX

CORRECT SEQUENCE OF PAINTINGS IN THE AKBARNAMA[1]

The terms conventionally understood
to indicate the artists responsible
for each element of the paintings
are as follows:
(*tarh*) composition
(*amal*) painting [work]
(*chehreh nami* or *nami chehreh*) portraits
(*rang amiz*) colour mixing

Some folios record the number
of days the artists took (or were
instructed to take) to complete
their work.[2]

The appellations 'Khord' and 'Kalan'
mean 'the younger' and 'the elder';
thus Banwali Khord (8/117) should be
distinguished from his older colleague,
Banwali Kalan (11/117).

REGNAL YEAR 5
AH 967 (1560–61 AD)

82 IS 2-1896 2/117
Tarh: Tulsi; *amal*: Narayan

83 IS 2-1896 3/117
Tarh: Tulsi; *amal*: Narayan
on the same opening as:

84 IS 2-1896 4/117
Tarh: Tulsi; *amal*: Durga

85 IS 2-1896 5/117
Tarh: Tulsi; *amal*: Tiriyya

86 IS 2-1896 6/117
Mukund *(no indication of role)*

87 IS 2-1896 7/117
Amal: Anant

88 IS 2-1896 8/117
Tarh: La'l; *amal*: Banwali Khord
on the same opening as:

89 IS 2-1896 9/117
Tarh: La'l; *amal*: Sanwala

REGNAL YEAR 6
AH 968 (1561–62 AD)

90 IS 2-1896 10/117
Tarh: Jagan; *amal*: Qabu[…],
possibly Qabul Chela
double composition with:

91 IS 2-1896 11/117
Tarh: Jagan; *amal*: Banwali Kalan
[?4 days]

92 IS 2-1896 12/117
Tarh: Kanha;
amal: Khiman Sangtarash
on the same opening as:

93 IS 2-1896 13/117
Tarh: Kanha;
amal: Banwali Khord
[50 days]

94 IS 2-1896 14/117
Amal: Madhav Kalan
[55 days]

95 IS 2-1896 15/117
Khem Karan

96 IS 2-1896 16/117
Tarh: Kesav Kalan;
amal: Dharmdas

97 IS 2-1896 17/117
Tarh: Basawan; *amal*: Tara Kalan;
nami chehreh kar-e: Basawan
[portraits the work of Basawan]
double composition with:

98 IS 2-1896 18/117
Tarh: Basawan; *amal*: Sarwan

99 IS 2-1896 24/117
Tarh: Basawan; *amal*: Dharmdas

100 IS 2-1896 19/117
Tarh: Kesav; *rang amiz*: Chetar
double composition with:

101 IS 2-1896 20/117
Tarh: Kesav Kalan;
amal: Madhav Kalan

102 IS 2-1896 21/117
Tarh: Basawan; *amal*: Chetar
double composition with:

103 IS 2-1896 22/117
No attribution

104 IS 2-1896 23/117
Tarh: Basawan; *amal*: Ikhlas;
chehreh nami: Nanha

REGNAL YEAR 7
AH 969 (1562–63 AD)

105 IS 2-1896 25/117
Tarh: Mukund;
amal: Khiman Sangtarash

106 IS 2-1896 26/117
Tarh: Miskina; *amal*: Paras

107 IS 2-1896 27/117
Tarh: La'l; *amal*: *Nand walad-e
Ramdas* [Nand, son of Ramdas]
double composition with:

108 IS 2-1896 28/117
Tarh: La'l; *amal*: Ibrahim Kahar

109 IS 2-1896 29/117
Tarh: Miskin; *amal*: Shankar;
nami chehreh: Miskin

110 IS 2-1896 30/117
Tarh: Jagan; *amal*: Naman
[60 days]

REGNAL YEAR 8
AH 970 (1563–64 AD)

111 IS 2-1896 31/117
Tarh: Tulsi; *amal*: Bhawani;
chehreh: Sanwala

112 IS 2-1896 32/117
Tarh: La'l; *amal*: Naman;
chehreh nami: Mukund

113 IS 2-1896 33/117
Tarh: Jagan; *amal*: Bhawani Kalan;
chehreh nami: Madhav

REGNAL YEAR 9
AH 971 (1564–65 AD)

114 IS 2-1896 34/117
Tarh: Jagan; *amal*: Asir

115 IS 2-1896 35/117
Tarh: Kesav; *amal*: Jagannath
double composition with:

116 IS 2-1896 36/117
Tarh: Kesav Kalan;
amal: Nar Singh

117 IS 2-1896 37/117
No ascription

118 IS 2-1896 38/117
No ascription

119 IS 2-1896 40/117
Tarh: Mohesh; *amal*: Kesav Khord
on the same opening as:

120 IS 2-1896 39/117
Tarh: Lal; *amal*: Sanwala
[50 days]

121 IS 2-1896 41/117
Tarh: Mohesh; *amal*: Anant

122 IS 2-1896 42/117
Tarh: La'l; *amal*: Ram Das

123 IS 2-1896 49/117
Amal: Bhagwan;
nami chehreh: Madhav

REGNAL YEAR 10
AH 972 (1565–66 AD)

124 IS 2-1896 43/117
Tarh: La'l; *amal*: Hari (?) [45 days]
double composition with:

125 IS 2-1896 44/117
Tarh: La'l; *amal*: Khem

126 IS 2-1896 45/117
Tarh: Miskina [sic]; *amal*: Sarwan
double composition with:

127 IS 2-1896 46/117
Tarh: Miskin [sic];
amal: Tulsi Khord

128 IS 2-1896 51/117
Tarh probably Miskina, but not
attributed; *amal*: Nanha
double composition with:

129 IS 2-1896 52/117
Tarh: Miskina; *amal*: Bhagwan

130 IS 2-1896 47/117
Tarh: Tulsi Kalan; *amal*: Jagjivan

131 IS 2-1896 48/117
Tarh: Kesav; *amal*: Banwali Khord

132 IS 2-1896 50/117
Tarh: Basawan;
amal: Mah Muhammad

133 IS 2-1896 96/117
Amal: Farrokh Beg

134 IS 2-1896 97/117
Tarh: Kanha; *amal*: Mukhlis

REGNAL YEAR 11
AH 973 (1566–67 AD)
No paintings for this year

REGNAL YEAR 12
AH 974 (1567–68 AD)

135 IS 2-1896 55/117
Tarh and *nami chehreh*: Miskina;
amal: Sarwan
double composition with:

136 IS 2-1896 56/117
Tarh: Miskina; *amal*: Mansur

137 IS 2-1896 53/117
Tarh: Jagan; *amal:* Narayan;
chehreh nami: Madhav Khord

138 IS 2-1896 54/117
Tarh: La'l; *amal:* Sanwala

139 IS 2-1896 61/117
Tarh: Basawan; *amal:* Tara Kalan
[60 days]

double composition with:

140 IS 2-1896 62/117
Tarh: Basawan; *amal:* Asi, *baradar-e
Miskina* [Asi, Miskina's brother]

141 IS 2-1896 64/117
Tarh: Kanha; *amal:* Nandi,
walad-e Ramdas [son of Ramdas]

NOTE 64/117 and 57/117 are on different
folios but seem compositionally related;
57/117 and 58/117 are on same opening
but do not match, though the catchword
on 57/117 links it to 58/117

142 IS 2-1896 57/117
Tarh: Kanha; *amal:* Nanha
[40 days]

on the same opening as:

143 IS 2-1896 58/117
[same folio as 59/117]
Tarh: Jagan; *amal:* Nand Gwaliari

144 IS 2-1896 59/117
Nand Gwaliari

on the same opening as:

145 IS 2-1896 60/117
Amal: Ikhlas; *nami:* Madhav

146 IS 2-1896 63/117
Tarh and *nami chehreh:* Kesav
Kalan; *amal:* Chetar Muni

on the same opening as:

147 IS 2-1896 115/117
Artist unidentified

148 IS 2-1896 65/117
Tarh: Kesav Kalan;
amal: Madhav Kalan

149 IS 2-1896 89/117
Artist unidentified

on the same opening as:

150 IS 2-1896 90/117
Tarh: Miskina;
amal: Banwali Kalan

151 IS 2-1896 66/117
Tarh: Miskina; *amal:* Sarwan

double composition with:

152 IS 2-1896 67/117
Tarh: Miskina, *amal:* Bhura

153 IS 2-1896 68/117
Artist(s) not identified

on the same opening as:

154 IS 2-1896 69/117
Artist(s) not identified

REGNAL YEAR 13
AH 975 (1568–69 AD)

155 IS 2-1896 71/117
Tarh: Mukund; *amal:* Manohar

double composition with:

156 IS 2-1896 70/117
Tarh: Mukund; *amal:* Narayan
[44 days]

157 IS 2-1896 73/117
Tarh: Khem Karan;
amal: Khem Karan

REGNAL YEAR 14
AH 976 (1569–70 AD)

158 IS 2-1896 72/117
Tarh: Miskina; *amal:* Paras

159 IS 2-1896 74/117
Tarh: Miskina; *amal:* Bhura

160 IS 2-1896 75/117
Tarh: Mukund; *amal:* Shankar

161 IS 2-1896 76/117
Tarh: La'l; *amal:* Shankar
[68 days]

162 IS 2-1896 78/117
Tarh: Kesav Kalan;
amal: Dharmdas

on the same opening as:

163 IS 2-1896 79/117
Tarh: Kesav Kalan; *amal:* Chitra

164 IS 2-1896 77/117
Tarh: Basawan;
amal: Nand Gwaliari

REGNAL YEAR 15
AH 977 (1570–71 AD)

165 IS 2-1896 80/117
Amal: Bhura;
chehreh nami: Basawan

166 IS 2-1896 81/117
Farrokh; *chehreh nami:* Basawan

167 IS 2-1896 82/117
Tarh: Kesav Kalan;
amal: Chatarmuni

double composition with:

168 IS 2-1896 83/117
Tarh: Kesav Kalan; *amal:* Bhagwan

169 IS 2-1896 84/117
Amal: Mohes[h],
chehreh nami: Kesav
[44 days]

REGNAL YEAR 16
AH 978 (1571–72 AD)

170 IS 2-1896 85/117
Tarh: Kesav Kalan;
amal: Chetarmuni

171 IS 2-1896 94/117
Tarh: Jagan; *amal:* Sur Das;
[in a different hand]
chehreh nami: Madhav

double composition with:

172 IS 2-1896 95/117
(on back of 92/117)
Tarh: Jagan; *amal:* Asir

173 IS 2-1896 92/117
Tarh: La'l; *amal:* Sanwala

174 IS 2-1896 93/117★
Tarh: La'l; *amal:* Kesav Khord

175 IS 2-1896 91/117
Tarh: Tulsi; *amal:* Bandi;
chehreh nami: Madhav Khord

double composition with:

176 IS 2-1896 86/117
Tarh: Tulsi; *amal:* Bhawani

REGNAL YEAR 17
AH 979 (1572–73 AD)

177 IS 2-1896 87/117
Tarh: Miskina; *amal:* Kesav Khord

on the same opening as:

178 IS 2-1896 88/117
Tarh: Miskina; *amal:* Sarwan

179 IS 2-1896 106/117
Tarh: La'l; *amal:* Babu Naqqash
[4[?] days]

double composition with:

180 IS 2-1896 107/117
Tarh: La'l; *amal:* Sanwala

181 IS 2-1896 108/117
Tarh: La'l; *amal:* Dhanun

double composition with:

182 IS 2-1896 109/117
Tarh: La'l; *amal:* Mani

183 IS 2-1896 117/117
Farrokh Beg

REGNAL YEAR 18
AH 980 (1573–74 AD)

184 IS 2-1896 104/117
Tarh: Tulsi Kalan; *amal:* Banwari

double composition with:

185 IS 2-1896 105/117
Tarh and *amal:* Khem Karan

186 IS 2-1896 113/117
[*Tarh* not given, but probably
Basawan] *amal:* Hussain Naqqash;
chehreh nami: Kesav

double composition with:

187 IS 2-1896 112/117
Tarh: Basawan; *amal:* Mansur

188 IS 2-1896 116/117
Tarh: Kesav Kalan;
amal: Chetarmuni
[60 days]

189 IS 2-1896 98/117
Tarh: Miskina;
amal: Banwali Khurd
[60 days]

190 IS 2-1896 99/117
Tarh: Miskin; *amal:* Mohes[h]

191 IS 2-1896 110/117
Tarh: Kesav Kalan;
amal: Nar Singh
[40 days]

double composition with:

192 IS 2-1896 111/117
Tarh: Kesav Kalan; *amal:* Jagjivan

REGNAL YEAR 19
AH 981 (1574–75 AD)

193 IS 2-1896 100/117
Amal: Asi; *tarh:* Miskin
[4[?] days]

194 IS 2-1896 101/117
Tarh: La'l; *amal:* Nand

REGNAL YEAR 20
AH 982 (1575–76 AD)
No paintings for this year

REGNAL YEAR 21
AH 983 (1576–77 AD)

195 IS 2-1896 102/117
Tarh: La'l; *amal:* Premjiv Gujarati
[50 days]

196 IS 2-1896 103/117
Tarh and *amal:* Tulsi Kalan

REGNAL YEAR 22
AH 984 (1577 AD)

197 IS 2-1896 114/117
Tarh: Miskin; *amal:* Sarwan;
chehreh nami hasht surat
[eight portraits]: Madhav

NOTES

1 The correct sequence has been established
by checking that the catchwords on each page
accord with the first word of the following
page, which demonstrates that the enumeration
usually in red in the centre of the lower
margin should be the one followed.
Other sequences in red and black relate
to previous arrangements of the illustrations
in the manuscript.

2 The number of days allotted to each painting
is taken from John Seyller's 'Scribal Notes on
Mughal Manuscript Illustrations', *Artibus Asiae*,
vol. 48, 1987, pp. 247–77 with minor corrections.

NOTES

PREFACE

1 Blochmann, vol. III, p. 444.

2 See M. Athar Ali, 'The perception of India in Akbar and Abu'l Fazl', in Irfan Habib, ed., *Akbar and his India* (Oxford University Press, Delhi, 1997), pp. 215–24, especially p. 216: 'India had two names, the Arabic "Hind" from Ancient Iranian "Hindu" (the Avestan variant of Vedic "Sindhu"), whence the Greek "India" also came; and the late Iranian "Hindostan", created by the Iranian tendency to add "–stan" as a suffix to territorial names.'

3 Thus, the V&A's 'Minto Album' pages are included in the sumptuous volume produced by the Metropolitan Museum of Art, *The Emperor's Album*, for comparative purposes. Many articles have been written on particular paintings in the V&A, but the only monographic book is Geeti Sen's *Paintings from the Akbar Nama* (Delhi, 1984). Caspar Stanley Clarke wrote a short introduction to the *Hamzanama* paintings collected by his father, Caspar Purdon Clarke, the first Keeper of the Indian Department and subsequently Director of the V&A; Andrew Topsfield's *An Introduction to Court Painting* (HMSO, London, 1984) is a useful but designedly brief introduction to the V&A's collection, with only part devoted to Mughal paintings.

4 See, for example, W. Staude, 'Contribution à l'étude de Basâwan', *Revue des Arts Asiatiques*, vol. VIII (1934), no. 1, pp. 1–18; W. Staude, 'Basâwan', *Encyclopedia of World Art* (New York, 1960), pp. 384–88 and pls 221–24; S.C. Welch, 'The paintings of Basawan', *Lalit Kala* (1961), no. 10, pp. 7–17; Milo Cleveland Beach, *The Imperial Image: Paintings for the Mughal Court* (Washington, DC, 1981), pp. 89–90; Geeti Sen, 'An unpublished study of a Sadhu by Basawan and its relation to other drawings', *Lalit Kala* (1982), no. 20, pp. 24–28; Amina Okada, 'Cinq dessins de Basâwan au musée Guimet', *Arts Asiatiques*, vol. XLI (1986), pp. 82–88; Amina Okada, 'Basawan', in Pal, ed., pp. 1–16; Verma, 1994, pp. 83–94, listing 137 potential works of Basawan.

5 Including the *Baharistan* of 1595 in the Bodleian Library, Oxford; the 1596 *Jamia al-Tawarikh* in the National Library, Golestan Palace, Tehran; and the *Khamsa* of Amir Khusrau Dihlavi dated 1597–98 and divided between the Metropolitan Museum of Art, New York and the Walters Art Gallery, Baltimore.

6 See Verma, 1994, pp. 248–49.

CHAPTER ONE

1 See R.C. Majumdar, *The Mughul Empire*, vol. VII of *The History and Culture of the Indian People* (Bharatiya Vidya Bhavan, Bombay, 1974), pp. 59–63.

2 Beveridge, vol. I, pp. 643–44.

3 Much has been written on these artists: see Verma, 1994, pp. 40–46 for a summary of the literature on *Khwaja* Abdu's Samad with a list of signed or attributed works, and pp. 277–80 for similar details of *Mir* Sayyed Ali. See more recently, however, a more critical appraisal of works attributed to the master in A.S. Melikian-Chirvani in Das, ed., 1998, pp. 30–51.

4 Beveridge, vol. I, p. 657–58.

5 Beveridge, vol. II, p. 28; see Professor Sukumar Ray and M.H.A. Beg, *Bairam Khan* (Institute of Central and West Asian Studies, University of Karachi, 1992), esp. ch. 7, for a detailed account of this period.

6 See Shireen Moodsvi, trans. and ed., *Episodes in the Life of Akbar: Contemporary Records and Reminiscences* (National Book Trust, India, New Delhi, 1994), pp. 18–19 for the English translation of a letter sent to Bayram Khan by Akbar quoted by Muhammad Arif Qandahari in his *Tarikh-i Akbari*.

7 See Beveridge, vol. II, pp. 199–203. Bayram Khan's son grew up at court and later attained the most powerful rank in the empire, that of *khan-i khanan*. He shared the emperor's artistic and literary interests, and had his own artists. See John Seyller, *Workshop and Patron in Mughal India: The Freer Ramayana and Other Illustrated Manuscripts of 'Abd al-Rahim*, *Artibus Asiae*, suppl. XLII (Museum Rietberg Zurich, Switzerland, Washington, DC, 1999).

8 See, for example, the account of Akbar written by the Jesuit Father Pierre du Jarric, who knew the emperor. He mentions the daily news reports being read out to him, after which 'he used to sit in a great hall, surrounded by numerous people whose duty it was to read books to him' (Moodsvi, p. 119).

9 See Bailey, 1999, pp. 116–17 for the Jesuit inventory of the Mughal library; Seyller, 1997, p. 243.

10 Blochmann, vol. I, p. 103.

11 Ibid., p. 113.

12 Ibid., p. 114.

13 Ibid., p. 115.

14 See Seyller, *Workshop and Patron*, p. 28.

15 Irfan Habib has demonstrated the impressive range of Akbar's technological interests from textile and weapons manufacture to ship-building and architecture ('Akbar and technology', in Irfan Habib, ed., *Akbar and his India* [Oxford University Press, Delhi, 1997], pp. 129–48). Ahmad, p. 64, quotes Qandahari's comments on the emperor's inventions and encouragement of craftsmen. This history was not available to Abu'l Fazl and can be taken as independent corroboration. See also Brand and Lowry, p. 107, for a summary of Akbar's skills and patronage, mentioning also one of the accounts of the Jesuits.

16 Aznaveh *et al.*, pl. 194, p. 267. Brand and Lowry, p. 23 suggest that a companion page to this one could depict Akbar presenting his own painting to Humayun.

17 Moodsvi, p. 7; cf. Rogers and Beveridge, p. 40.

18 Beveridge, vol. II, p. 67.

19 The usual title of the stories was *Qissa-ye Hamza* or *Dastan-i Amir Hamza*, meaning 'The Story of [Amir] Hamza'. Most art historians now refer to them as the *Hamzanama*, or 'Book of Hamza'.

20 See Pritchett, p. 2.

21 For Hamza b. 'Abd al-Muttalib, see G.M. Meredith-Owens in *The Encyclopaedia of Islam*, new edition, ed. B. Lewis *et al.*, vol. III (H-IRAM, Leiden, 1971), pp 152–54. For the various versions of the *Hamzanama*, see Rizvi, p. 205.

22 Pritchett, p. 3.

23 Ibid., pp. 2–3; see also Rizvi, p. 205.

24 Pritchett, p. 4.

25 Beveridge, vol. II, p. 343. The editor notes that, according to the *Iqbalnama*, Darbar Khan (the nickname of Mulla Inayat), was Akbar's reader, and his father had been the court reciter of Shah Ismail of Iran.

26 Other manuscripts were being illustrated concurrently (see Chandra, 1976, pp. 72–74), but the major preoccupation of the atelier, and the project during which the new Mughal style in painting was formed, was the *Hamzanama*.

27 Blochmann, vol. I, p. 115.

28 See Glück, p. 155; Beach, 1981, pp. 58–59.

29 Acquired in 1873 from the Persian Pavilion at the Vienna International Exhibition of that year. They are thought to have been taken in 1738–39 from the royal library in Delhi when Nadir Shah of Iran raided Mughal India. See Beach, 1981, p. 58. A facsimile of the illustrations only, ignoring the text on the back of each page, was published in 1974.

30 Glück listed the 110 pages known in 1925 (op. cit., p. 155); Ernst Grube, *Islamic Paintings from the 11th to the 18th century in the Collection of Hans P. Kraus* (New York, n.d.), pp. 252–54, expanded this to 137 pages, giving full bibliographic references. Corrections and additions have been made by a number of authors, notably Beach, who added eight folios to the list (1981, p. 65) and Lowry, Beach *et al.*, *An Annotated and Illustrated Checklist of the Vever Collection* (Washington, DC, 1988), pp. 30–32. John Seyller's book, *The Adventures of Hamza* (2002) accompanying the first exhibition devoted to the manuscript will provide a definitive list.

31 I thank A.S. Melikian-Chirvani for providing a new translation of this famous passage from the text edited by Mu'inu-din Nadwi, Azhar Ali Dihlawi and Imtiyaz Ali Arshi, *Tarikh-i-Akbari Better Known as Tarikh-i-Qandahari* (Rampur, 1962), pp. 45–46.

32 The passage from *Mir* Ala al-Dowla's 'Riches of Glorious Traditions' (*Nafa'is al-Ma'asir*) is in Chandra, 1976, pp. 179–81, translated by Professor Naim.

33 Chandra, 1976, p. 180.

34 Chandra, 1976, covered all possibilities from a detailed examination of a manuscript he believed to be autograph. Evaluating the complex evidence provided by chronograms in the title, and numerous marginal notations, he suggested a probable time frame of *c.*1562–77 (see pp. 65–68 and 174–81).

35 See Linda York Leach's lucid summary of the various positions (Leach, 1986, p. 39), to which should be added John Seyller, 'A dated Hamzanama illustration', *Artibus Asiae*, vol. III/IV (1993), notice I, pp. 502–05. He suggested a new chronology stretching from *c.*1557–58 to 1572–73, but this is determined by the assumption that numbers on V&A page IS 1508-1883 represent a date. This is rejected by A.S. Melikian-Chirvani, 'Mir Sayyid ʿAli', p. 50, fn. 7, on the basis that there is no known parallel for a date being written in this way.

36 IS 2516-1883: illustrated *Hamza Nama*, II (1982), V&A 26. Glück, p. 155, suggested that this page was from the beginning of the eighth book. The implications of the presence of figures in Spanish or Portuguese costume were first noted by Wilhelm Staude, 'Les artistes de la cour d'Akbar et les illustrations du Dastan-i Amir Hamzah', *Arts Asiatiques*, vol. II, no. 1 (1955), fig. 2, discussed p. 53.

37 *Hamza-Nama* (1974), 19 (V40). See Koch, 1991, p. 60, for the Gujarati source of the Fathpur column and other motifs.

38 Translated in Chandra, 1976, p. 180. Zahra Faridany-Akhavan's unpublished PhD thesis is the first detailed evaluation of the text in relation to image (*The Problems of the Mughal Manuscript of the Hamza-Nama 1562–77: A Reconstruction* [Harvard University, June 1989]). The author notes that the subject of the painting is summarised in the text adjacent to the painting (p. 250), but that the text of the V&A pages is not always relevant to the painting on the same folio. Dr Faridany-Akhavan makes the point (pp. 226 and 229) that the great number of missing pages makes it extremely difficult to draw definitive conclusions.

39 Glück, pp. 25ff.

40 Clarke, 1921, p. 3.

41 Clarke, loc. cit. The Museum already had one *Hamzanama* page: the scene of Hamza's death (pl. 6) had been bought in Tehran by a Madame Schindler in about 1876, who gave it to the Museum in 1882 (125-1882: *Hamza Nama* II, V&A 1). In 1921 two further pages were given by Lt-Col. Sir Raleigh Egerton (IM 4-1921 and IM 5-1921); another was bequeathed in 1949 by the collectors P.C. Manuk and Miss Coles (IS 7-1949), and in the same year Sir Leigh Ashton, the Museum's director, gave two fragments he had bought in Srinagar (unpublished).

42 See Anna Hillcoat-Imanishi, Pauline Webber and Michael Wheeler, 'Conservation, mounting and storage solutions for two *Hamzanama* folios', *The Paper Conservator*, vol. XXII (1999), for a detailed description of two V&A folios; cf. Antoinette Owen, 'Discovering new layers in the structure of the *Hamzanama* illustrated folios', in J. Eagen, ed., *IPC Conference Papers, London, 1997* (Leigh: IPC, 1998), pp. 64–69, based on close examination of four folios in the Brooklyn Museum of Art and a brief survey of the Vienna folios.

43 Cf. Seyller, op. cit., fn. 8, pp. 504–05, who notes similar combinations on two other pages.

44 John Seyller identified the numbers on this folio as a date.

45 See Chandra, 1976, pp. 69 ff.

46 IS 1512-1883.

47 IS 1517-1883.

48 This feature of cropping is first discussed by A.S. Melikian-Chirvani in 'L'école de Chiraz et les origines de la miniature moghole', see R. Pinder-Wilson, ed., *Paintings from Islamic Lands* (Oxford, 1969), pp. 124–41.

49 I am very grateful to A.S. Melikian-Chirvani for his comments on this point. For the Demotte *Shah Nama*, see e.g. Basil Gray, *Persian Painting* (Skira/Rizzoli, New York, 1977), pp. 28–34.

50 See, for example, Ebadollah Bahari, *Bihzad: Master of Persian Painting* (I.B. Tauris, London, 1996), pp. 232–333. Abdu's Samad was still copying the master's work in Mughal India at the very end of his life, when he was 85 (Bahari, p. 216).

51 See, for example, the *Zafarnama* manuscript dated AH 872 (1467–68) later owned by Akbar and Jahangir, with illustrations by or attributed to Bihzad (Bahari, pl. 29, p. 71 [foreground figures, two at left and figure in red at right]; pl. 38, p. 80 [archers in foreground]). The feature is seen in an illustration to a *Khamsa* for Shah Tahmasp done by *Mir* Sayyed Ali (Bahari, pl. 126, p. 226 [crouching figure left foreground]).

52 See A.S. Melikian-Chirvani, 'Mir Sayyid ʿAli', pl. 1, p. 30.

53 By the late 1590s, the artists numbered over 100, the Hindus among them being singled out for high praise: Blochmann, vol. I, p. 114.

54 See B. N. Goswamy, *A Jainesque Sultanate Shahnama and the Context of pre-Mughal painting in India* (Museum Rietberg, Zurich, 1988), esp. pp. 5–8, for a lucid summary of Sultanate period painting, developing the framework suggested by Jeremiah P. Losty, *The Art of the Book in India* (The British Library, 1982).

55 Their gold *thalis* are threaded on black cotton with an array of auspicious pendants on black cotton: cf. a nineteenth-century south Indian necklace in the V&A (illustrated in colour in Susan Stronge, Nima Smith and James Harle, *A Golden Treasury: Jewellery from the Indian Subcontinent* [Mapin/Victoria and Albert Museum, London, 1988], cat. 70, pp. 78–79).

56 See Chandra, 1976, p. 165, for a brief note on the depiction of water.

57 C. Sivaramamurti, *Chitrasutra of the Vishnudharmottara* (Kanak Publications, New Delhi, 1978), ch. 2, pp. 17–42, 'The Chitrasutra and its date', especially pp. 20–21, 24. There are various arguments to support an earlier date, not least the absorption of large parts of it into a Tibetan text, the *Chitralakshana*, made available to a wider audience when its German translation by Berthold Laufer was translated into English by B.N. Goswamy and A.L. Dahmen-Dallapiccola, *Citralaksana of Nagnajit* (Manohar Book Service, New Delhi, 1976) (see Sivaramamurti, pp. 37–38).

58 Sivaramamurti, op. cit., p. 191. He compares the prescription in the text with a painting in the Mughal manuscript of the Anwar Suhayli of 1571 in the School of Oriental and African Studies, fig. 105, text pp. 93, 96.

59 Illustrated frequently: see for example, Bahari, op. cit., pl. 126, p. 226.

60 The idea that the surviving evidence does not reflect the reality of painting in the sixteenth-century Indian subcontinent is put forward by several commentators. Pramod Chandra, for

example, wrote that the figures on the pages of the *Hamzanama* 'find a conceptual parallel in ancient Indian wall painting done a thousand years before, as though the artists had once again tapped the hidden springs of a rich and vital artistic imagination which had gone underground to lie dormant and forgotten for long centuries' (pp. 68–69). While deeming the connection to be unprovable, he noted shared idioms between the *Hamzanama* and pre-Mughal painting, for example in the shape of certain heads, some details of ornament and foliage, and the outline of narrow-waisted, full-breasted women.

61 Sivaramamurti, op. cit., pp. 176–77.

62 See Goswamy, op. cit., pp. 5–35, where the illustrations show the widely differing conventions for depicting eyes in 'Jainesque' and Sultanate manuscript painting in the centuries immediately before Mughal rule. To these may be added conventions in the manuscripts generally known as the *Chaurapanchasika* and *Chandayana* style groups, for which see Daniel J. Ehnbom in Jane Turner, ed., *The Dictionary of Art* (Macmillan, London, 1996), vol. XV, pp. 574–77.

63 For the Western Indian style, see Saryu Doshi's article in *The Dictionary of Art*, 'Indian subcontinent, VI, 3 (ii) (a) 'Miniature and other painting ...' (Macmillan, London, 1996), especially pp. 564 ff.

64 Illustrated, for example, in John Irwin, 'Golconda cotton paintings of the early seventeenth century', *Lalit Kala Akademi* (New Delhi), no. 5, pp. 11–48, see fig. 26; also *South Indian Painting* and Milo Cleveland Beach, *Mughal and Rajput Painting*, *The New Cambridge History of India*, vol. I/3 (Cambridge University Press, 1992), fig. 3, p. 7.

65 For example, A.S. Melikian-Chirvani, 'Mir Sayyid ʿAli', op. cit., pl. 11, p. 42, a painting done by the master in Tabriz c.1539–43, cf. his 1555–56 self-portrait, probably done in Lahore; see also Bahari, op. cit., 1996, pl. 17, p. 55, 'A Youth amongst Flowering Branches', by Bihzad, c.1480–85.

66 A Sultanate example is illustrated in Chandra, 1976, p. 70.

67 Illustrated in Chandra, 1976, fig. 3, p. 126. For the colophon and its translation, see Beach, 1992, Appendix, p. 232.

CHAPTER TWO

1 Obituary in *The Times*, 26 February 1895. Clarke left India in 1862. Oudh was also the source of the magnificent illustrated *Padshahnama*, the history of the reign of Shah Jahan now in the Royal Library at Windsor Castle. Its owner, Asaf ad-Daula, Nawab of Oudh, had offered it to Lord Teignmouth, then Governor-General of India, who suggested it should instead be presented to the King of England. See Beach and Koch, 1997.

2 V&A Registry: Nominal File, Major-General John Clarke.

3 H. Beveridge, ICS (retired), FASB, *The Akbar Nama of Abu-l-Fazl (History of the Reign of Akbar Including an Account of his Predecessors): Translated from the Persian* (Asiatic Society of Bengal, Calcutta), vol. I (1902), vol. II (1900), vol. III (1900); reprinted 1973 (Ess Ess Publications, Delhi). Beveridge used the Persian text edited by Maulawi 'Abd-ur-Rahim (Asiatic Society of Bengal, Calcutta), vols I and II (1877), vol. III (1886).

4 For a complete list of the artists see Sen, pp. 158–66, Appendix I and Appendix II (but the sequence given of the miniatures in the manuscript contains errors, and the author has misread the numbers on the early folios, so that those given as 22–29 should be corrected to 82–89).

5 Beveridge's typescript (*Note*. an illuminated M.S. of the Akbarnama in the Victoria and Albert Museum, South Kensington) is preserved in the Clarke Nominal File.

6 Beveridge published a brief notice of the manuscript in the *Journal of the Royal Asiatic Society*, vol. 1905, pp. 365–66, concluding, 'I have made a catalogue of the illustrations and hope to publish it some day', though this was not fulfilled before his death in 1906.

7 See H.M. Elliott and J. Dowson, *The History of India as Told by Its Own Historians: The Muhammadan Period*, 2nd edition (Calcutta, 1953), pp. 102–04, describing the return of Akbar's emissary from the Deccan sultanates in 1604, when he brought tobacco to the court for the first time.

8 I am grateful to Robert Skelton for drawing my attention to the reproduction of the covers in T.H. Hendley, 'Sport in Indian art', *Journal of Indian Art*, vol. XVII (1916), pl. 1, p. 66. This seems to be the latest reference to their existence, as they had disappeared by 1950, when Robert Skelton began his Museum career. Though he illustrated only two covers, Hendley noted that there were four panels accompanying the book, the unpublished ones depicting 'Akbar on a journey'. Hendly suggested the covers were made about a hundred years after the probable date of the manuscript. Caspar Stanley Clarke (Keeper of the Indian Section and no relation to John Clarke) stated that the 'Clarke manuscript', as it had come to be known, had consisted of two volumes; although the acquisition description states clearly that 'One Book' was acquired, the manuscript does, in fact, have a binding strip dividing the pages into two blocks.

9 The seals and inscriptions in the manuscript were first published by Ahmad Nabi Khan in a short notice, 'An illustrated Akbarnama manuscript in the Victoria and Albert Museum, London', *East and West*, IsMEO, new series, vol. XIX, nos 3–4 (September–December 1969), pp. 424–29. A detailed account of the writing of the *Akbarnama* is given by the historian S.A.A. Rizvi (1975). Geeti Sen published the first monograph on the manuscript in 1984; Brand and Lowry, *Akbar's India*, are among the minority of art historians to mention Abu'l Fazl's five drafts of his text and the early circulation of different versions. John Seyller, 'Codicological aspects of the Victoria and Albert Museum *Akbarnama* and their historical implications', *Art Journal*, vol. XLIX, no. 4 (Winter 1990), pp. 379–87 also mentions them, and is the first to analyse the text of the manuscript in any detail. In his comprehensive article on the valuations of Mughal manuscripts (1997), Seyller includes minor corrections to Ahmad Nabi Khan's translations, and some additional translations. The date given on the seal stamp of Alamgir, the title taken by Aurangzeb on his accession, as AH 1079 (1668–69) should, however, be corrected to AH 1075 (1664–65).

10 Beveridge cites two pieces of evidence for these dates (noted by Seyller, 1990, p. 379). The first, in a manuscript of the *Akbarnama* belonging to the Royal Asiatic Society (MSS no. 117), included two clauses that he had not found in other manuscripts. These gave the dates of the two imperial orders, respectively, '22nd Isfandarmaz, 33rd of the Divine Era' (i.e. 1589) and '26 Ardibihisht of the 34th year, or 3rd Rajab 997' (1590) (Beveridge, vol. I, p. 33 'Note'). A second manuscript giving the same information, which Beveridge judged to be a rough draft for the final text, was in the private collection of 'Saiyid ʿAli Bilgrami Shamsu'l Ulama' of Hyderabad (Beveridge, 'A new MS. of the Akbarnama', *Journal of the Royal Asiatic Society* [January 1903], pp. 115–22, especially pp. 116–17).

11 Beveridge, vol. I, p. 31.

12 Blochmann, vol. I, pp. 268–69.

13 Blochmann, vol. III, p. 472.

14 Ibid., p. 473.

15 For Bayzid Bayat and his career, see Rizvi, pp. 242–49.

16 Ibid., p. 246.

17 Ibid., p. 242.

18 Ibid., p. 240.

19 See Annette S. Beveridge, trans. and ed., *Humayun-Nama (The History of Humayun) by Gul-Badan Begum* (Sang-e-Meel Publications, Lahore, 1974), p. 83, Persian text from BM MS given in the same volume.

20 Rizvi, pp. 250 ff.

21 Rizvi, loc. cit.

22 For histories mentioned by Abu'l Fazl (Blochmann, vol. II, p. 32, with comments by Jarett and Sarkar, eds, pp. 33–37). Biographies included the *Nafa'isu'l-Ma'asir* of Mir 'Ala'u'd (see Rizvi, p. 248).

23 Rizvi, pp. 264 ff.

24 Rizvi, pp. 264 ff. for a detailed description of Abu'l Fazl's style and the content of his work.

25 Blochmann, vol. III, p. 473.

26 See Blochmann, vol. II, pp. 29–30.

27 Beveridge, vol. III, p. 4.

28 Ibid., p. 5.

29 Blochmann, vol. III, p. 474.

30 Muhammad Akbar, *The Punjab under the Mughals* (Idarah-i Adabiyat-i Delli, Delhi, 1974), p. 104–05.

31 Beveridge, vol. II, pp. 559–60.

32 Blochmann, vol. III, p. 474.

33 Beveridge, vol. II, pp. 560–61.

34 See Beveridge, vol. II, p. 561 and Blochmann, vol. III, p. 474.

35 Beveridge, vol. II, p. 544; Seyller, 1990, p. 379 and fn. 11.

36 Blochmann, vol. III, p. 475–76 and p. 516; Rizvi, p. 266.

37 The various datings for the paintings are surveyed by John Seyller, 1990, p. 379.

38 See Skelton, 1969, p. 38.

39 The suggestion was first made by Milo Cleveland Beach, *The Imperial Image*, pp. 83, whose argument rests on the assumption that the illustrations could not have been started before 1596, when the text was completed, yet are clearly earlier than the late 1590s in style. As will be seen, work on the illustrations could have begun much earlier than 1596. See also Beach, 1987, especially pp. 114 and 128. Brand and Lowry, pp. 76–79, follow Beach's suggestion, which is greatly elaborated by John Seyller, 1990.

40 Seyller, 1990, especially pp. 380–81. He notes such peculiarities as replacement catchwords that seem to support his thesis that the illustrations were intended for another manuscript.

41 See Rizvi, op. cit., p. 264. For a discussion of the *Tabaqat-i Akbari* and its author, see Brajendranath De, *The Tabaqat-i-Akbari of Khwajah Nizamuddin Ahmad (A History of India from the Early Musulman Invasions to the Thirty-sixth Year of the Reign of Akbar* (Asiatic Society of Bengal, Calcutta, 1927), vol. I, p. v. The Persian text of the section mentioning Abu'l Fazl and the *Akbarnama* is on p. xx, fn. 1.

42 All photographic techniques failed to expose the text under the paper, because the pasted paper is flecked with gold that blocks X-ray or infra red penetration. The text could, however, be read on IS 2-1896 (20/117) by holding a colour transparency of the image over a light box. Here, it could be seen that the 'new' text simply repeats part of the original, and the new catchword has been added next to the old one.

43 Seyller, 1990, fig. 6, p. 383 (month given as Day, not Deymah).

44 Beveridge, vol. II, p. 544; Persian text, vol. I, p. 376.

45 The V&A text thus jumps from vol. II, p. 544 of the English translation to vol. III, p. 6 (Calcutta edition Persian text goes from vol. II, p. 376 to vol. III, p. 4).

46 See Chandra, 1976, p. 184, where the *Akbarnama* passage is translated from Persian by Professor Naim.

47 See Beveridge, vol. II, p. 186 and vol. III p. 310 respectively.

48 Beveridge, vol. II, p. 530.

49 Khan, 1969, pp. 424–29.

50 See Chandra, 1976, p. 57, n. 21 and pp. 183–84.

51 Blochmann, vol. I, p. 114.

52 See Appendix.

53 See Appendix for attributed paintings. Miskina is the same artist as 'Miskin', as seen by the double-page composition in which both versions of his name appear (45/117 and 46/117).

54 IS 2-1896, 62/117.

55 IS 2-1896, 64/117 and 101/117 (illustrated in Sen, p. 67, pl. 150).

56 Premjiv Gujarati, IS 2-1896, 102/117.

57 Nand Gwaliori, IS 2-1896, 58 and 58/117; 17/117 (illustrated in Sen, pl. 59, p. 134).

58 Beveridge, vol. III, p. 714. See ch. 5, fn., for the literature on Farrokh Beg.

59 Folio 170 (unpublished).

60 Both are junior artists on 56/117 and 57/117; Manohar also worked on 71/117 (see pl. 38).

CHAPTER THREE

1 See Rizvi, ch. 7, pp. 223–29 for a discussion of the contemporary historians of Akbar's reign. For grudging admiration of Abu'l Fazl's reliability, see for example, Jamsheed K. Choksy and M. Usman Hasan, 'An emissary from Akbar to 'Abbas I: inscriptions, texts, and the career of Amir Muhammad Ma'sum al-Bhakkari', *Journal of the Royal Asiatic Society*, series 2, vol. I, part I (1991), pp. 19–29. They conclude in their analysis of the life of a Mughal noble through inscriptions: 'while the Akbar nama does indeed glorify Akbar and aggrandise the Mughal empire, its conformity in chronology and events with these independently produced inscriptions demonstrates that the text may be utilized with confidence, as it has previously, for the documentation of Akbar's reign' (p. 29).

2 Blochmann, Conclusion, p. 464.

3 Beveridge, vol. II, p. 1.

4 Blochmann, vol. III, p. 459.

5 Ibid., p. 461.

6 Bayram Khan had been given charge of 'all affairs of state and finance' at the time of Akbar's accession (Beveridge, vol. II, p. 26); Abu'l Fazl makes it clear that this was still the case: 'His Majesty the Shahinshah had made over the whole business of sovereignty to Bairam Khan and was remaining behind a veil

and testing the characters of men' (Beveridge, vol. II, p. 132).

7 See Majumdar, pp. 108 ff.; Professor Sukumar Ray and M.H.A. Beg, *Bairam Khan* (Karachi, 1992), chs 9 and 10.

8 Beveridge, vol II, p. 151.

9 Beveridge, loc. cit.

10 Beveridge, vol II, p. 202–03 includes a chronogram of his assassination by Afghans, which gives the date 31 January 1561 (Friday, 14 Jumada al-awwal AH 968).

11 Abu'l Fazl states that the emperor's aim now was that, by turning 'his attention to the administration of justice, new vigour might be given to the perturbed universe, and that certain regulations should be established which should be codes for the use of administrators'. For this reason, he was returning to Delhi (Beveridge, vol. II, p. 186).

12 Beveridge, vol. II, p. 186–87.

13 Cf. Ahmad, p. 271: Akbar's hunting expedition in the Panjab lasted several months, so that he could make sure his subjects were being properly governed, and inspect the encampments of soldiers there.

14 Beveridge, vol. II, pp. 222–23.

15 Ibid., pp. 416 ff.

16 Ibid., p. 416, fn. 2; *Tarikh-i Alfi*, p. 627. See also Ahmad, pp. 128–29.

17 Dr Mubarak Ali, 'The Turah-i-Chingizi at the Mughal court', *Lahore Museum Bulletin*, vol. VII, nos 1 and 2 (January–December 1994), pp. 99–102, especially p. 101.

18 Beveridge, vol. II, pp. 207 ff.

19 Ibid., p. 214.

20 Ibid., pp. 218–19.

21 Ibid., p. 217.

22 Ibid., p. 218.

23 Ibid., p. 219.

24 Blochmann, vol. I, p. 52.

25 See Sen, p. 67 for a discussion of this scene, including comments on the costume and dance portrayed.

26 Beveridge, vol. II, p. 272. Another version of this scene is in the Chester Beatty Library, see Sen, pl. 26.

27 Pages 27 and 28/117; Beveridge, vol. II, p. 262. Similarly, Muhammad Arif Qandahari notes Akbar's prestige soaring after the conquest of Chitor in 1567: 'the awe and splendour of the emperor increased a thousand times more and the rulers and kings of the different countries started correspondence and exchanged presents and gifts with him' (*Tarikh-i-Alfi*, pp. 150–51).

28 Beveridge, vol. II, p. 324.

29 See Majumdar, pp. 115–16.

30 Ibid., p. 121.

31 Beveridge, vol. II, p. 465.

32 Ibid., p. 468.

33 A statue of this respected foe riding an elephant was later erected at Agra: see Brand and Lowry, pp. 118–19. Jahangir, reminiscing

about some of the major events of his father's life, notes that Akbar was unrivalled in his skill at shooting (Rogers and Beveridge, vol. I, p. 45).

34 Beveridge, vol. II, p. 495.
35 See Majumdar, pp. 125–26.
36 Beveridge, vol. II, p. 538.
37 Beveridge, vol. III, p. 7.
38 Ibid., p. 11.
39 Ibid., p. 22.
40 See Beveridge, vol. II, pp. 115–16.
41 Rogers and Beveridge, vol. II, p. 41.
42 IS 2-1896, 21/117 and 22/117; Beveridge, vol. II, pp. 232–33.
43 Ibid., pp. 234–35.
44 Ibid., p. 236.
45 IS 2-1896, 23/117; Beveridge, vol. II, p. 240 ff.
46 IS 2-1896, 77/117; Beveridge, vol. II, pp. 510–11.
47 See Brand and Lowry, pp. 35 and 139.
48 Beveridge, vol. II, pp. 522–23.
49 Ibid., p. 372.
50 See Brand and Lowry, p. 139.
51 Beveridge, vol. II, pp. 530–31; double-page composition IS 2-1896, 91/117 and 86/117.
52 Beveridge, vol. III, p. 468.
53 A process noted by Seyller, 1990, p. 381.
54 IS 2-1896, 104/117 and 105/117.

CHAPTER FOUR

1 Beach, 1981, pp. 91–99.
2 Now in the National Library, Tehran (see Sa'id Mahmudi Aznaveh, Mohammad-Hasan Semsar, Karim Emami and Mohammad-Ali Davudipur, *Golestan Palace Library: Portfolio of Miniature Paintings and Calligraphy* [Zarrin & Simin Books, 2000], pp. 140–53 for brief introduction and colour plates). See also Beach, 1981, pp. 99–102 and pp. 223–27.
3 The Freer *Ramayana* is the most famous of these. See John Seyller, *Workshop and Patron in Mughal India: The Freer Ramayana and Other Illustrated Manuscripts of 'Abd al-Rahim*, Artibus Asiae, suppl. XLII (Museum Rietberg Zurich in association with the Freer Gallery, Smithsonian Institution, Washington, DC, 1999).
4 Notably the Jaipur *Ramayana* and *Razmnama*, in private collections. Gaining access to Mughal paintings and manuscripts in supposedly public collections, however, may sometimes also be difficult.
5 Verma, *Chronology of Major Illustrated Manuscripts* (1994), pp. 32–33, succinctly demonstrates the problem of missing colophons in providing the various datings assigned to manuscripts such as the various *Baburnama*s, the *Baharistan* in the British Library, and the *Iyar-i Danish* in the Chester Beatty Library.
6 Thackston, 1996, pp. 10–11.
7 Ibid., p. 11; see also p. 12, fn. 9.

8 C.A. Storey, *Persian Literature: A Bio-Bibliographical Survey*, vol. I, part I (Luzacs and Co., 1927–29), pp. 532–33; see also Rizvi, 1975, pp. 220–21.
9 Most authors follow Ellen Smart, 'Four Illustrated Mughal Babur-nama Manuscripts', *Art and Archaeology Research Papers*, vol. III (1973), pp. 54–58, and 'Six folios from a dispersed manuscript of the Baburnama', *Indian Painting* (Colnaghi, London, 1978), pp. 111–14, based on her unpublished PhD thesis. See also Beach, 1981, p. 77; and Ellen Smart in Skelton, *et al.*, eds, pp. 105–15.
10 V&A Registry files. Twenty were bought from Luzac's, London: seventeen cost £15 12s 6d each; three of higher quality and depicting Babur cost more (IM 276 & a-1913 together cost £39 2s 6d, and IM 275-1913 cost £21). The page bought in 1950 from Mlle Marian Densmore, Arts d'Asie, 184 Avenue Victor Hugo, Paris, was the equivalent of £41 10s 5d (IS 234-1950). The ascriptions to artists on some of the pages are in a contemporary hand, presumably that of the librarian: Devji Gujarati (IM 261-1913), La'l and Durga (IM 265-1913), Mukund and Khiman Sangtarash (IM 266-1913), Paras (IM 267-1913), Isma'il Kashmiri (IM 269-1913), Yaqub Kashmiri with faces by La'l (IM 273-1913), Madhav Chela (IM 273-1913) and Ram Das (IM 275-1913). See Canby, cats 82–84, pp. 113–17, for three more pages from the same manuscript, and the reference to the original having had 191 illustrations (p. 113).
11 See Thackston, 1996, p. 329.
12 For a related page from the V&A manuscript, see Ehnbom, cat. 7, p. 34.
13 Thackston, 1996, pp. 173–74. See Asher, 1992, pp. 19–24 for a discussion of Babur's gardens.
14 See Smart in Skelton, et al., eds, p. 106.
15 Goswamy and Fischer, cats 34 and 35, pp. 82–83.
16 See for example, Ahmad, pp. 216, 248. See also Asher, p. 20, quoting Zayn Khan's *Tabaqat-i Babari*, translated by S. Hasan Askari (Delhi, 1982).
17 *Akbarnama*; see Rizvi, p. 365.
18 Beveridge, vol. II, pp. 332 and 487. Rizvi, p. 365, suggests that the theory has been adapted from the Hindu Rajniti.
19 First noted in British Museum, *Paintings from the Muslim Courts of India*, cat. 26, p. 36. For the incidence of marginal notes on the pages of Akbari book illustrations, see John Seyller, 1987, pp. 247–77.
20 For the translation bureau, see Rizvi, ch. 6, pp. 203–22.
21 Majumdar, p. 134. The night-time debate is illustrated in the Chester Beatty Library *Akbarnama*, reproduced for example in Leach, vol. I, col. pl. 41, p. 287.
22 Abu'l Fazl's preface to the *Mahabharata*, quoted in Rizvi, p. 209.

23 Abu'l Fazl's preface to the Persian translation of the *Mahabharata* quoted by Rizvi, loc. cit.
24 As translated by Shaykh Chand Husain, p. 279.
25 See Muhammad Abdul Ghani, *A History of Persian Language and Literature at the Mughal Court (With a Brief Survey of the Growth of Urdu Language)*, part III, *Akbar* (Hijra International Publishers, Lahore, 1983), pp. 33–35. See also M.A. Chaghatai, 'The illustrated edition of the Razm Nama (Persian version of the Mahabharata) at Akbar's court', appendix D on p. 329.
26 Notably, the *khan-i khanan* whose *Ramayana* is now in the Freer Gallery (see Seyller, *Workshop and Patron*). For another *Ramayana* dated 1594, see Sam Fogg, *Islamic Manuscripts* (Catalogue 22, London, 2000), cat. 44, pp. 124–29. Probably done for Akbar, the manuscript was in the library of his mother, Hamida Banu Begum, at her death in 1604 and then the libraries of Jahangir and Shah Jahan, as indicated by inscriptions on the volume. This book was intact until the late 1990s, when pages were taken out and sold individually, most recently at Christie's, London, Islamic Art and Manuscripts, Tuesday 10 October 2000, lots 58–62. See also Leach, 1998, pp. 40–49.
27 Al-Badaoni, vol. II, p. 329.
28 His name was *Mir Ghiyas ud-Din Ali* (Al-Badaoni, vol. II, pp. 496–98), and his family were *Sayyids* from Qazvin. His father, *Mir Abdu'l Latif*, had left Iran to enter Humayun's service. He arrived at court, 'just after Akbar had ascended the throne', and was to become a personal friend of the emperor. He was Akbar's reciter, and was given the title Naqib Khan in the twenty-sixth year of the reign.
29 He was the author of the *Muntakhabu-t-Tawarikh*, a secret history of Akbar's reign which ends in AH 1004 (1595–96), suggesting that he may have died at about that time. His skills were not confined to translating: he is also listed as one of the notable physicians of the reign (Blochmann, vol. I, p. 617).
30 Blochmann, vol. I, pp. 110–11.
31 Al-Badaoni, vol. II, p. 330.
32 C. Rieu, *Catalogue of the Persian Manuscripts in the British Museum*, vol. I (1879), p. 57; date given in MS.Add 5642.
33 First published by T.H. Hendley, *Memorials of the Jeypore Exhibition 1883*, vol. IV (1884), p. 1, where he dates it to 1588. See Skelton, 'Mughal paintings', 1972, pp. 43 ff. and fn. 13, p. 53 for the correction of Hendley's conversion of the manuscript's date: AH 995 (12 December 1586–1 December 1587).
34 Originally from the collection of Gerald Reitlinger; sold Sotheby's, London, 24 and 25 October 1921, lot 231.
35 See Losty, pp. 123–24, cat. 88, one page illus. p. 103. Three of the V&A pages were bought

in the Sotheby's, London, 25 October 1921 sale (Circ. 242-244-1922). Two further pages came to the V&A from the collection of J.C. French (IS 459-1950 and IS 121-1955). Seyller, 1985, pp. 37-66, has reconstructed the manuscript using these folios and others.

36 John Seyller's analysis of marginal notes on manuscripts shows that speed was consciously sought: particular pages have notes indicating that they should be completed within a specific number of days (Seyller, 1987).

37 Chaghatai, op.cit., appendix D, p. 329, mentions a poetical version made by Mulla Masih of Panipat during Jahangir's reign. The text of the *khan-i khanan*'s 1616 version, from which two paintings came to the V&A (IS 24 and 25-1958; bought from Maggs Bros, Berkeley Square, for £8 8s) may be the abridged version ordered by Akbar in AH 1011 (1602) (Chaghatai, p. 292).

38 As pointed out by Chaghatai, op. cit., p. 304.

39 See Blochmann, vol. I, pp. 112 and 212 for his appointment as a governor in the Panjab; p. 214 for his death in 1586; and pp. 679–80 for a brief note and some of his verses.

40 The pages were first published by Skelton, 'Mughal paintings', 1972, pp. 41–54. See fn. 1, p. 53 for details concerning the Lucknow manuscript.

41 Ibid., p. 41 and fn. 1, p. 53, for details on the text and location of all the known illustrations. His discussion of their probable date, and the dating information to be found on the Jaipur manuscripts, is on pp. 48–51 (the pages from the collecton of Edwin Binney III are now in the San Diego Museum of Art).

42 In the *Shah Nama* Rostam is characteristically depicted grappling with the White Div against a solid black cave entrance. For an Iranian example of the Mughal period, see Marthe Bernus Taylor, ed., *L'Etrange et le merveilleux en terres d'islam* (Editions de la Réunion des Musées Nationaux, 2001), cat. 127, p. 183 (Shiraz, 1567); cat. 128, p. 185 depicts the scene in a similar way in a Mughal *Shah Nama* manuscript of *c*.1610.

43 This incident, and that of the death of the demon Nikumbha, are considered to be interpolations to the text made after AD 1050, deriving from the bardic traditions: see Parashuram Lakshman Vaidya, ed., *The Harivamsa: Being the Khila or Supplement to the Mahabharata* (Bhandarkar Oriental Research Institute, Poona, 1969), p. xxxiii.

44 See Das, *Dawn of Mughal Painting*, pl. 9, pp. 26–27.

45 See Brend.

46 Illustrated in Brend, fig. 9. The V&A drawing was bequeathed by Percival Chater Manuk, a barrister, and his companion, Miss G.M. Coles. It had been in a French collection at some point, as indicated by an ink inscription on the bottom: 'L'empereur de Delhy'.

47 *The Encyclopaedia of Islam* (E .J. Brill, Leyden, 1913), vol.V, *Tu-Zu*, p. 1202.

48 See Brosh and Milstein, cat. 37, pp. 104–05.

49 Blochmann, vol. I, p. 115.

50 For example in the Golshan Album page illustrated by Atabey, col. pl. opposite text p. 336.

51 See B.N. Goswamy, 'Essence and appearance: some notes on Indian portraiture', in Skelton *et al.*, pp. 193–202.

52 Ibid., esp. pp. 197–99.

53 Bought from the Trustees of the late Captain E.G. Spencer-Churchill in 1965.

54 See Ali. Zayn Khan's entries begin at A193 and end at A821.

55 See Al-Badaoni, vol. III, p. 367 and n. 2, quoting the Ma'asir-i Rahimi.

56 Ibid., p. 327 and n. 2.

57 Habsburg, pl. 91; text vol. pp. 81–82 (the figures identified only as 'Old Man' and 'Old Woman').

58 Goswamy and Fischer, pl. 87, pp. 178–79 (figures not identified). Another version dated *c*.1630 and formerly in the Rothschild collection, was sold at Sotheby's, London, on 21 November 1985, lot 22 (published in Toby Falk, *Persian and Mughal Art: The Rothschild collection of Mughal Miniatures*, P. & D. Colnaghi, London, 1976, no. 107).

59 I am extremely grateful to A.S. Melikian-Chirvani for reading this inscription which is clearly later, and translates as 'God: blessed portrait of His Majesty Junayd and Rab'e of Basra, may God's compassion descend upon them all. From the work of the most contemptible of servants, addressed as the Second Mani, who from the court of His Majesty Akbar Shah I, was . . . known as Mir Kalan-e Hindi in the year 980 of the hijra.' According to Verma, p. 276, the artist's name is known only from one other painting, published by J.R. McGregor in Society for Asian Art, *Indian Miniature Paintings from West Coast Private Collections* (M.H. De Young Memorial Museum, San Francisco, 1964), no. 2, pl. 10. The V&A painting was sent on approval for purchase to Sir Robert Nathan, KCSI, CIE, in Simla in 1905 by Moulvi Muhammad Husain, Judge, Court of Small Causes, Delhi. The price was Rs 80 and it was described as: 'An old man and old woman – very superior art'.

60 See A.S. Melikian-Chirvani, *Islamic Metalwork from the Iranian World: 8th–18th Centuries* (London, HMSO, 1982), cat. 134 for a late sixteenth-century Iranian example illustrated p. 304, and Leach, vol. I, cat. 2.19, for similar bowls depicted in the 1602 *Yog Vashisht* (illustrated p. 177).

61 See notably Sir Edward Maclagan (1932) and the translations of Jesuit missions by C.H. Payne (1926 and 1930). Milo Cleveland Beach has written important articles on specific

influences of European art on Mughal painting, on which see especially the bibliographical essay in *Mughal and Rajput Painting, The New Cambridge History of India*, vol. I:3 (Cambridge University Press, Cambridge, 1992), p. 246. Gauvin Alexander Bailey has added considerably to the subject in his studies of the Jesuits in Mughal India, notably in the chapter 'The Jesuit Mission to "Mogor", 1580–1773', in his *Art on the Jesuit Missions in Asia and Latin America, 1542–1773* (University of Toronto Press, 1999).

62 Correia-Afonso, p. 31.

63 Blochmann, vol. I, p. 113.

64 The image of the Byzantine Virgin, still in the church of Santa Maria Maggiore in Rome, was copied for the Jesuit Mission by permission of Pope Pius V and sent to Goa in 1578 (Maclagan, p. 227). See also Bailey, 1999, pp. 70, 116.

65 See Bailey, 1999, p. 116. The presentation is described by Father Rudolf Acquaviva in a letter from Fathpur Sikri to Father Everard Mercurian, Superior General, dated 18 July 1580 (see Correia-Afonso, p. 58).

66 See Ebba Koch, *Dara-Shikoh Shooting Nilgais: Hunt and Landscape in Mughal Painting*, Occasional Papers, vol. I (Freer Gallery of Art, Arthur M. Sackler Gallery, Smithsonian Institution, Washington, DC, 1998): first title page of vol. I of the Bible illustrated fig. 23, p. 38 includes a harbour landscape in the background of the detail shown.

67 Bailey, 1999, p. 116.

68 Minute pink houses are to be seen in the Golshan Album, folio 74, on a composite page that includes a work by Manohar Das. There were four editions in 1570, all with Latin texts, printed in Antwerp by Plantin, 'issued both plain and coloured' (R.V. Tooley, *Maps and Mapmakers*, London, 1972, 5th edition, p. 126). I am grateful to Steve Bromberg for these references to the publication of coloured editions, which demonstrate that they could have arrived at the Mughal court at this time.

69 Bailey, in O'Malley *et al.*, p. 385.

70 See Bailey, 1999, esp. pp. 122–30. The Fathers took great pains to try to please the emperor, whose fascination for these foreign images was intense. One day, for instance, when Fathers Pigneiro and Xavier were leaving Lahore to see Akbar, they gave him 'a picture of Our Lady beautifully executed on paper'. Fearing, however, that it was not entirely to his taste as it was drawn in ink with no colouring, they took another picture, this time of Our Lady of Lorete, painted in colours on copper'. Their account notes that Akbar treated the image with great reverence (Payne, 1926, pp. 110–11).

71 Das notes an exact replica of this painting in the Maharaja Sawai Man Singh II Museum, Jaipur (Das, 1978, p. 246, fn. 56a).

72 Bailey, 1999, p. 127.

73 Camps, pp. 181–82.

74 See Nusrat Ali and Khalid Anis Ahmed, in Ahmed, ed., pp. 79–91.

75 The painting came from the collection of A. Pendrill Charles sold at Christie's on 10 February 1950 (lot 7, hammer price £28). The Museum bought it through Maggs for £33. It had been published by Maclagan, *The Jesuits and the Great Mogul* (1932), p. 253 and A.P. Charles in the 'Shorter Notices' section of *Burlington Magazine*, vol. LXXI (August 1937), p. 84–89, '"The Inn at Bethlehem": a drawing of the Mogul school', illus. p. 85. Charles notes the inscriptions on the painting, translated as 'Part I – Of His Childhood' and 'The Messiah, the Son of God Most High and of power unlimited, being filled with wonder, was pondering upon the works of God. They were sweeping making clean'.

76 Gauvin Alexander Bailey, 'The Lahore *Mirat al-Quds* and the impact of Jesuit theater on Mughal painting', *South Asian Studies*, vol. XIII (1997), pp. 95–108.

77 See C. Sivaramamurti, *Chitrasutra*, p. 181.

78 As on his work in the Golshan Album, folio 170, which is stylistically close to his *Akbarnama* painting depicting Akbar's entry into Surat. I am greatly indebted to A.S. Melikian-Chirvani for his observation on the calligraphy.

79 Illustrated in Habsburg, pl. 154, folio 3 recto.

80 See above, ch. 5, fn. 76.

81 This was first noted by Brand and Lowry, p. 113. For the Widener Carpet, see Walker, fig. 48, p. 55. For the general theme, see Jagdish Mittal, 'Indian painters as designers of decorative art objects in the Mughal period', in Skelton *et al.*, pp. 243–52.

82 Bought from Mr M. K. Heeramaneck with two Kangra paintings for a total cost of £50 in 1914.

83 See, for example, Walker, pp. 40–41.

84 Ibid., p. 40.

85 See Leach, 1995, vol. I, p. 240 for a discussion of the style, and her chapter 2, 'Paintings from 1600 to 1605', for examples.

86 It was given by the executors of Sir Robert Nathan in 1921. He bought it from Moulvi Muhammad Husain of Delhi in about 1905.

87 Bought from Messrs Luzac & Co., London, for £12 10s.

CHAPTER FIVE

1 See Rogers and Beveridge, vol. I, p. 1: 'I ascended the royal throne in the capital of Agra, in the 38th year of my age'. That is, 'he was 37 years 3 months by the lunar calendar and 36 years 1 month by solar reckoning' (fn. 1).

2 See Brand and Lowry, p. 53 for discussion of the move from Fathpur.

3 See, for example, Beach, 1978, pp. 33 ff.; Das, ch. 3 passim; Leach, vol. I, pp. 150–52, and cat. pp. 155–232.

4 Rogers and Beveridge, vol. II, pp. 20–21; Thackston, p. 268 renders this slightly differently, though the essential details are the same.

5 Sir Edward Maclagan, *The Jesuits and the Great Mogul* (Octagon Books, New York, 1972), p. 226.

6 Letter of Father Jerome Xavier, quoted by Gauvin Alexander Bailey, 'The truth-showing mirror: Jesuit catechism and the arts in Mughal India', in O'Malley *et al.*, p. 392.

7 Bailey, 1999, p. 124.

8 Payne, 1926, p. 67.

9 Bailey, 1999, p. 124.

10 Payne, 1926, pp. 81–82. See also Milo Cleveland Beach, a series of articles listed in the bibliographical essay in Beach, 1992, p. 246.

11 Das, 1978, p. 42.

12 Skelton, 1969, p. 43.

13 The source was identified by Skelton, loc. cit.

14 Bailey, 1999, p. 129 for a contemporary Jesuit source mentioning Salim's artists copying engravings from Nadal's book for a *de luxe* version of the Mirat al-Quds; see also Bailey in O'Malley *et al.*, p. 392.

15 IS 133-1956, folio 14a.

16 See Leach, vol. I, pp. 155–89 for the 1602 *Yog Vashisht*, almost certainly done at Allahabad, and pp. 189–232 for the AH 1012 (1603–04) *Raj Kunwar*, definitely done there.

17 Beveridge, vol. III, p. 1210 and fn. 2.

18 Ibid., pp. 1230 for his arrival at Agra in March 1603 and p. 1234 for Akbar's order for him to return to Allahabad.

19 Payne, 1926, p. 190. From the account of Father Pierre du Jarric (1566–1617), who compiled letters and reports sent from India for an account of the Jesuit missions.

20 Payne, loc. cit. The Muslim prince would have regarded Jesus as a prophet, never the Son of God, and Mary, to whom an entire sura of the Koran is devoted, as the ideal of female purity.

21 Payne, 1926, pp. 190–91. See also Bailey, 1999, p. 129, where similar information is given (cf. fn. 16).

22 Prasad, p. 58, for the death of Shah Begum; Majumdar, p. 168, for the death of Akbar's mother; Beveridge, vol. III, pp. 1242–43, for news of Salim's behaviour reaching court.

23 Beveridge, vol. III, p. 1248; see also Majumdar, p. 168.

24 See Verma, 1994, pp. 62–64 for bibliography concerning Aqa Reza.

25 An inscribed drawing done by Abu'l Hasan in AH 1009 (1600–01) records that he was then 12 years old and was a *khan-i zad*, i.e. born in imperial service. It has often been published, e.g. Beach, 1992, fig. 51, p. 76.

26 Das, p. 44, following Godard, omits the mention of 'Agra', but see Atabey, p. 353 (no. 105). See Richards, p. 55 for the date when Salim tried to seize Agra fort before going to Allahabad.

27 See for example, Aznaveh *et al.*, pls. 203 and 204, pp. 276–77, done for Salim while at Allahabad, as shown by the inscription where he is referred to as 'Padshah Salim'.

28 Rogers and Beveridge, vol. II, p. 20. Cf. Thackston, p. 267–68.

29 The V&A painting has been omitted by Beach, 1978, pp. 33–41; Das, p. 44–55; and Verma, 1994, pp. 62–69 in their lists of works by, or attributed to, the artist. Barbara Schmitz, *Islamic and Indian Manuscripts and Paintings in The Pierpont Morgan Library* (The Pierpont Morgan Library, New York, 1997), cat. 50, p. 129, mentions the V&A painting, noting its 'ascription to [Aqa] Riza Jahangiri Shahi [sic]' and describing it as one of 'two Indian versions of this composition' (i.e. the library's painting of an Uzbek prisoner, dated by Schmitz to c.1600 Herat) in the V&A. The V&A painting inscribed 'Ibrahim Beg', however, clearly belongs to a different group.

30 Martin, vol. II, pl. 83.

31 An unfinished painting on silk (Martin, pl. 90) has exactly the same costume details, though the features differ, and there is a slightly later version (pl. 92, then in the collection of Victor Goulabeff of Paris) ascribed to Sadeq.

32 Martin, pl. 84, for two versions he also deems to be 'copied after Bihzad'. The first is in the Louvre, the second, from the Bellini Album, was then in Victor Goulabeff's collection.

33 Martin, vol. I, p. 45, ignored the inscription and identified the subject as Murad Akkuyunli. Bayram Oghlan was the Uzbek governor of Gharjistan, whose army menaced Herat on several occasions. In July 1550 he was ambushed and surrendered to Takkalu, the governor general of Herat, but was subsequently betrayed and executed. Robert Skelton, accepting it as an authentic Farrokh Beg work, noted the similarity between the handwriting in this painting and others including the *mulla* in the V&A (pl. 91) but attributed it to Farrokh Beg himself ('The Mughal artist Farrokh Beg', *Ars Orientalis* [1957], p. 403).

34 See Asher, pp. 104–05. The Persian inscription is given in M.A. Chaghatai, 'Aqa Riza Musawwar (mentioned in the inscription on the Gateway of Khusru [sic] Bagh, Allahabad', *Proceedings of the Indian History Congress Allahabad Second Session* [Allahabad, 1938], p. 365). The formula used by Aqa Riza in many of his signed paintings is also on the gateway: '*murid-e ikhlas Aqa Reza musavvir*' ('the devoted disciple Aqa Reza, the painter').

35 Atabey, p. 361.

36 See Verma, 1994, pp. 339–40 for two other paintings ascribed to the same artist.

37 See Skelton, 1969, p. 47, fn. 32. After leaving India, the paintings were acquired by Capt. E. Spencer-Churchill, who bequeathed them to the Museum in 1965. They bear seals and inscriptions dating from AH 1069 to AH 1111 (1659–99).

38 This led Robert Skelton to conclude that the prince was Salim's brother, Daniyal (Skelton, 1969, p. 39).

39 Reproduced in Losty, colour pl. 26, cat. 72, p. 94.

40 Payne, 1926, p. 80.

41 Rogers and Beveridge, vol. I, p. 286, as noted by Skelton, 1969, p. 45. In fn. 41 Skelton notes that the translation renders the Persian *shir* (lion) as 'tiger'.

42 Rogers and Beveridge, vol. I, pp. 185–86. This was illustrated in Shah Jahan's history (see Beach and Koch, cat. 30, pp. 76–79); for Jahangir-period examples, see Canby, cats 100–01, pp. 136–37. The same incident was depicted on a cameo (*The Indian Heritage: Court Life and Arts under Mughal Rule* [Victoria and Albert Museum, London, 1982], cat. 377, p. 123).

43 Skelton, 1969, p. 43. The Miskina painting, then in the collection of Sir Bernard Eckstein, was illustrated in Sir Leigh Ashton, ed., *The Art of India and Pakistan* (Faber and Faber Ltd, London, 1950), pl. 134, no. 708 (text p. 157).

44 Cf., for instance, a page from the *Raj Kunwar* done at Allahabad (Leach, 1995, vol. I, colour pl. 45, Salim hunting rhinos and other animals).

45 Nevertheless, some of them date from his reign: see Leach, 1995, vol. I, p. 301, and Leach, 1998, pp. 78–79.

46 See Leach, 1995, vol. I, p. 300, where there are said to be 'twenty or so' pages, though on p. 301, fn. 4, eighteen are listed, including the V&A page, to which should be added the seven in the Chester Beatty Library.

47 The V&A painting was bought from the London dealers Maggs in 1952. Dr Devapriyam's identification is recorded in the Indian Department archives; Beach, *BMFA*, vol. LXIII (1965), no. 332, identifies the source of the marginal figure at top right of a Golshan Album page (illustrated p. 72, text p. 73). There is another version in the Fondation Custodia, Paris (see Okada, 1989, cat. 63, pp. 206–07).

48 Manuscript of Sa'di's *Golestan* in the collection of the Royal Asiatic Society, London (MS 258). For a discussion of the dating, see Das, 1978, p. 59 (illus. pl. 11); although the manuscript was copied at Fathpur in AH 990 (1581), Manohar's self-portrait is a late addition. See also Brand and Lowry, cat. 25, p. 142; fig. 25b, p. 128. For works associated with Manohar, see Verma, 1994, pp. 248–59, to which should be added Terence McInerney, 'Manohar', in Pal, ed., pp. 53–68.

49 It relates in its compositional awkwardness and the pose of the emperor to a painting dated by Terence McInerny to *c.*1602–04 (McInerny, in Pal, ed., pl. 10, p. 62; cf. also pl. 9, p. 61).

50 See Brend, figs. 10, 18 and 19.

51 See, for example, a page from the Golshan Album illustrated in Atabey, facing p. 336.

52 Stchoukine, 192-30, pp. 212–41 records all the inscriptions. The inscription on the eighteenth figure has worn off, but Stchoukine (p. 222) suggested it was Raja Bir Singh.

53 Noted by Robert Skelton, Indian Department archives, 1960. See also Rosemary Crill, 'Mistaken identities: Mughal portrait of Raja Man Singh of Amber and Udai Singh of Marwar', *Oriental Art*, vol. XL, no. 3 (Autumn 1994), p. 3, fig. 3 (reproduced wrong way round). The identification is based on an inscribed painting by Payag in the Chester Beatty Library (Leach, 1995, vol. I, pp. 418–19, illustrated in colour). However, as Leach points out, Man Singh died in 1614 aged 79; the figure in the V&A Jahangiri painting, which must be close to 1614, is younger and must be presumed to have been copied from a now lost earlier portrait. See also Catherine Glynn, 'A Rajasthani princely album: Rajput patronage of Mughal-style painting', *Artibus Asiae*, vol. LX, no.2 (2000), pp. 230–31 and figs 1, 1a and 1b.

54 Rogers and Beveridge, vol. I, p. 18.

55 Ibid., p. 16.

56 See Stchoukine, 1929–30, p. 216.

57 The colour schemes of Prince Khurram riding with Dara Shokuh and Jahangir's garden scene are clearly related and share characteristic colour combinations with Manohar's black buck (pl. 102); the shoes of Qutb ad-Din Khan (pl. 86) and those of the black buck's keeper exhibit the typical curved line.

58 The first translators of his memoirs, Alexander Rogers and Henry Beveridge (1909–14), preferred *Tuzuk-i Jahangiri* ('Institutes, or Regulations of Jahangir'); Wheeler Thackston, in his translation (1999), uses Jahangir's own title, the *Jahangirnama* ('Book of Jahangir').

59 See Rogers and Beveridge, vol. I, pp. vi–vii.

60 Rogers and Beveridge, vol. II, p. 20. For a survey of Abu'l Hasan's development, see Beach, 1980, p. 32.

61 See Beach, 1981, p. 24 (referring to the Leningrad Album, now known as the St Petersburg Album).

62 The painting was acquired in India by a James Graham, probably in the wake of the Mutiny and possibly in Lucknow, and then passed on through a direct line of inheritance before being sold to the Museum in 1984 (V&A Registry, Nominal File: A. Anderson). Scraps of newspaper dated 1879 and contemporary letters were pasted on the back. First published: 'Recent acquisitions', *V&A Album*, vol. IV (London, 1985), pp. 16–17.

63 Rogers and Beveridge, vol. I, p. 274. The historic event was illustrated by La'lchand in the history of Shah Jahan's reign, in a painting based on Nanha's composition (Beach and Koch, no. 7; full page illustration p. 32; discussion on pp. 163–64).

64 His son, Karan Singh, went in his place and was given special honours and lavish presents by Jahangir. Rogers and Beveridge, vol. I, pp. 286–87, 289, 293–94.

65 The Behzad original, 'painted in his 70th year', and the Nanha version are published in Aznaveh, *et al.*, pls 187 and 188.

66 Das, 1978, p. 193, for the relationship between the two artists; Rogers and Beveridge, vol. II, p. 116, for Jahangir's order to Bishndas to go to Iran in 1613 to record the features of Shah Abbas and other luminaries. The results of his work may be seen in Asok Kumar Das, 'Bishandas . . .', in Das, ed., 1998, pls 6–13.

67 Beveridge, vol. III, p. 714 ('Farrokh Beg *musavvir*'). Farrokh Beg's career has inspired lively debate. The dearth of known works between the *Akbarnama* and paintings done for Jahangir, when Farrokh Beg was an old man, has led scholars to search for details concerning the missing years. Robert Skelton suggested that Farrokh Beg travelled to the Deccan, seeing Deccani characteristics in some of his later work, surmising that he was employed by Ibrahim Adil Shah of Bijapur and known as Farrokh Husain ('The Mughal artist Farrukh Beg', *Ars Orientalis*, vol. II [1957], pp. 382–411). Hotly disputed by some authors, the theory has more recently been supported, notably by John Seyller ('Farrokh Beg in the Deccan', *Artibus Asiae*, vol. LV, no. 3/4 [1995], pp. 319–41, including a complete bibliography, to which should now be added Asok Kumar Das, 'Farrukh Beg: studies of adorable youths and venerable saints', in Das, ed., 1998, pp. 96–111). Abolala Soudavar ('Between the Safavids and the Mughals: art and artists in transition', *Iran*, vol. XXXVII [1999], pp. 49–66 and pls 15a–30, especially pp. 55–61) corrects Seyller's reading of an inscription on a painting deemed to be crucial in Farrokh Beg's Deccani *oeuvre*. The remarks of Ziyaud-Din A. Desai in 'Studies in Indian art and culture: some avoidable presumptions and speculative theories', *Marg*, vol. LI, no. 1 (September 1999), pp. 76–77, also remove another supposed Deccani connection (I am very grateful to Asok Das for drawing my attention to this article). The thesis is not yet proved beyond all doubt, and only paintings inscribed to the artist in the V&A are included here.

68 Rogers and Beveridge, vol. I, p. 159.

69 Ibid., p. 338. This date was suggested by Skelton, *The Indian Heritage*, cat. 41, p. 37, where the inscriptions are translated.

70 See Rogers and Beveridge, vol. I, pp. 267–68, when Jahangir recovers from an illness and has his ears pierced in a symbolic act, declaring himself to be the 'ear-bored slave' of Mu'in ad-Din Chishti, to whom he believes he owes his recovery. The court were ordered to follow suit.

71 Near Shah Jahan is the attribution *Chehreh-ye Mubarak amal-e Murar* ('face of the Fortunate One the work of Murar') and near the prince is *chehreh raqam-e Murar* ('face "done" by Murar').

72 The signatures were first noted by Robert Skelton, in W.G. Archer, *Indian Painting* (London and New York, 1957), pl. 5, who suggested that the original painting showed Jahangir and Shah Jahan. Little is known of Murar's work, except that he must have been a leading artist of Shah Jahan's reign (see Beach and Koch for his work in the *Padshahnama*), though Das, 1978, p. 162, refers to a late Jahangir-period work.

73 See Richard Foltz, 'Two 17th-century Central Asian travellers to Mughal India', *Journal of the Royal Asiatic Society*, series 3, vol. VI, part 3 (1996), p. 369 (date of his arrival at court) and p. 373 (conversation about the painting). Abdullah Khan II of the Shaybanid dynasty ruled in Bukhara from 1583 to 1598.

74 See Das, 1978, p. 124.

75 Rogers and Beveridge, vol. II, p. 20.

76 See Beach, 1978, p. 140 for an illuminated frontispiece by Mansur, and Spink and Co., *Islamic Art from India* (London, 1980), p. 36, no. 62 (illus. frontispiece) for a signed *shamsa*. Seyller, 1999, fig. 214, p. 299, reproduces a page with a signed *sarlawh* by Mansur from a Baharistan of Jami in the Bodleian Library dated 1595.

77 As suggested by A.S. Melikian-Chirvani.

78 Much has been written on Mansur: see Verma, 1994, pp. 261–71, and Verma, *Mughal Painters*, 1999.

79 Identified many years ago for Robert Skelton by G.S. Keith of the American Museum of Natural History as the rare Tibetan crane *Grus nigricollis*. It nests in Tibet and winters in the Yunnan, but is not found in India. Letter in Indian Department archives.

80 Rogers and Beveridge, vol. II, p. 16.

81 See Syed Ali Nadeem Rezavi, 'An aristocratic surgeon of Mughal India: Muqarrab Khan', in Irfan Habib, ed., *Medieval India*, vol. I, *Researches in the History of India 1200–1750* (Oxford University Press, Delhi, 1992), pp. 154–67. Shaykh Hasan Hassu, who was given the title of Muqarrab Khan by Jahangir, was a surgeon, but also served as Jahangir's ambassador to Goa and Governor of Cambay and Surat. He studied horticulture, and laid out renowned gardens and orchards at his family seat at Kairana (pp. 165–66).

82 Rogers and Beveridge, vol. I, p. 214.

83 See Asok Kumar Das, 'The turkey in Mughal and Amber-Jaipur paintings', *Journal of the Indian Museum* (Calcutta, 1974), figs 3–5.

84 Rogers and Beveridge, vol. II, p. 201.

85 See Robert Skelton, *The Indian Heritage*, cat. 46, p. 39.

86 William Foster, ed., *The Embassy of Sir Thomas Roe to the Court of the Great Mogul, 1611–1619* (Kraus Reprint Ltd, Nendeln/Liechtenstein, 1967), p. 214.

87 Manohar's contributions to the *Akbarnama* show an early facility at painting animals, as may be seen from the animals in a scene of Akbar hunting (pl. 42, left).

88 For horses and grooms, for example, see Sheila R. Canby, 'The horses of 'Abd us-Samad', in Das, ed., 1998, pp. 14–29.

89 See Bailey, 1999, p. 115: the Jesuits of the First Mission brought 'a few late-16th century versions of Dürer's *Small Passion* and *Virgin and Child*'. A single detail from a European print might be used several times, as shown by Milo Cleveland Beach, 'A European source for early Mughal painting', *Oriental Art*, vol. XXII, no. 2 (1976), pp. 180–88, where Georg Pencz's *Joseph Telling His Dream to His Father*, dated 1544, inspired figures in several different paintings dated by Beach from *c*.1580.

90 Illustrated e.g. by Das, 1978, pls 26–29. Their small scale means that most reproductions fail to capture the extraordinary subtlety of their expressions.

91 Foster, ed., 1967, pp. 214 and 225.

92 The painting was bought from the dealer Arthur Churchill with no provenance details recorded. For images of Charles V, see for example Alfred Scharf, 'Rubens's portraits of Charles V and Isabella', *The Burlington Magazine*, vol. LXVI (January–June 1935), pl. 1, fig. C.

93 Finch in Foster, ed., 1985, p. 146.

94 See PhD thesis by K.J. Crowther, *Portuguese Society in India in the Sixteenth and Seventeenth Centuries*, British Library (Oriental and India Office Collection), 1961, MSS Eur C2564/4, p. 159.

95 See, for example, Rogers, pl. 44, p. 68.

96 I am greatly indebted to Avril Hart, formerly of the V&A's Department of Textiles and Dress, for considering the costume details of this painting with such care. She noted parallel features of dress, for instance in a portrait of Sir Christopher Hatton of *c*.1582 by Cornelius Ketel, illustrated in the catalogue of a Royal Academy exhibition 1955–56, no. 54.

97 I am very grateful to Claude Blair for his expert comments on the sword hilt. He notes similar forms in General Mariaux, *Le Musée de l'Armée: armes et armures*, vol. II (Paris, 1927), pl. 8. These were dated by A.V.B. Norman, *The Rapier* (1980), p. 359, to *c*.1560, with which Claude Blair agrees.

98 Rogers and Beveridge, vol. I, p. 443.

99 Rogers and Beveridge, vol. II, pp. 2–3; see also Das, 1978, p. 137.

100 Rogers and Beveridge, vol. II, pp. 19–21 and 34.

101 For obviously allegorical portraits, see especially Robert Skelton, 'Imperial symbolism in Mughal painting', in Priscilla P. Soucek, ed., *Content and Context of Visual Arts in the Islamic World*, Papers from a Colloquium in Memory of Richard Ettinghausen, Institute of Fine Arts, New York University, 2–4 April 1980 (The Pennsylvania State University Press, 1980), pp. 177–87 with 5 figures.

102 Richards, 1995, p. 96.

103 Rogers and Beveridge, vol. I, p. 335. The wrestler who arrived was called Sher Ali and was taken into royal service.

104 The painting was bought from Sir William Rothenstein's widow.

105 Sivaramamurti, *Chitrasutra of the Vishnudharmottara* (Kanak Publications, New Delhi, 1978), pp. 83 and 85.

CHAPTER SIX

1 In Beach and Koch, pp. 131–32.

2 See John Seyller's important article, 'The inspection and valuation of manuscripts in the imperial Mughal library' (Seyller, 1997).

3 Nominal File: *Bequest: Lady Wantage*, minute dated 3 July 1903 (T.14473/03).

4 Minute 3089, dated 21 September 1916.

5 C.S. Clarke, *Victoria and Albert Museum Drawings: Thirty Mogul Paintings from the School of Jahangir (17th century) and Four Panels of Calligraphy in the Wantage Bequest* (Victoria and Albert Museum, London, 1922).

6 Ibid., 'Prefatory Note'. Clarke adds that they were 'formerly in the Imperial Collection at Delhi, whence the remaining treasures of art were scattered, far and wide, after the Mutiny (1857)', but it is not clear whether this is supposition or fact. I am immensely grateful to Mr Christopher Loyd who very kindly checked through the family papers still at Lockinge but could not find any reference to the acquisition of the paintings.

7 Chandra, 1949, ch. 9, pp. 79–85.

8 See Annabel Teh Gallop, 'The genealogical seal of the Mughal emperors of India', *Journal of the Royal Asiatic Society*, 3rd series, vol. IX, part 1 (April 1999), pp. 77–140. The seal, which measures 56 mm in diameter, is illustrated on p. 115, cat. 4.5 (illustration from IM 124a-1921). The sixth regnal year equivalent is wrongly given as 1610–11 (cf. Thackston, 1996, p. 461).

9 The seal appears on the following pages, whose paintings are definitely later than 1608: IM 112–1921 (portrait of Shah Jahan), IM 120-1921, IM 121-1921, IM 124-1921 (clearest impression).

10 It has been suggested that Nandaram Pandit himself commissioned the copies to sell with

real pages, thus expanding the merchandise (see Rosemary Crill, 'A lost Mughal miniature rediscovered', *V&A Album*, vol. IV [Victoria and Albert Museum, London, 1985], p. 336), though there is no evidence for this. Stuart Cary Welch (Welch *et al.*, p. 26) pointed out that an entire 'imperial' album of calligraphies and miniatures, some of its pages stamped with Jahangir's seal, was acquired in the early nineteenth century from a Delhi dealer. His suggestion that the Fraser Album artists may have been involved in copying authentic pages is intriguing (pp. 26–30), as is that of Linda York Leach (vol. I, p. 377) that the source may have been the Delhi royal atelier during the reign of Akbar Shah II (1806–37).

11 *Catalogue of Highly Important Manuscripts, Extremely Valuable Printed Books, Autograph Letters and Historical Documents, etc.* (Sotheby and Co., London, 6, 7 and 8 April, 1925).

12 The Kevorkian Album, for instance, was purchased in Scotland in 1929 (Welch *et al.*, p. 1).

13 I am extremely grateful to Marcus Fraser and the late Toby Falk of Sotheby's, London, for investigating this question. Enquiries made to the descendants of the family have similarly not produced further information.

14 Rothenstein's collection was bought by the Museum after his death in 1945 from his widow, with assistance from the National Art Collections Fund, and included one Mughal painting illustrated in this book (pl. 108). For a brief note on Rothenstein, see Robert Skelton in Ehnbom *et al.*, p. 13.

15 V&A Registry, Nominal File: Bernard Quaritch, letter from Sir William Rothenstein to Sir Eric Maclagan, dated '4.15 Mon' (21 March 1925).

16 Nominal File: Bernard Quaritch, minute from Caspar Stanley Clarke to the Director, 26 March 1925.

17 Nominal File: Bernard Quaritch, letter from Eric Maclagan to the President of the Board of Education reporting the situation on the eve of the auction (6 April 1925).

18 Nominal File: Bernard Quaritch: Eric Maclagan to the President of the Board of Education, minute of 7 April 1925.

19 Leach, 1995, vol. I, cat. 3.21 (illustrated in colour p. 378) and cat. 3.24 (illus. p. 386) respectively.

20 Nominal File, Bernard Quaritch: letter from Caspar Stanley Clarke to Maclagan, 18 April 1925.

21 E.g. Welch *et al.*, no. 81, pp. 246–47 copied from a Chester Beatty Library Minto Album page; no. 87, pp. 258–59 from a V&A Minto page (IM 25-1925, pl. 127).

22 In a sale of manuscripts on 12 December 1929: see Welch *et al.*, p. 11.

23 Ibid., p. 12.

24 This feature was first noted by Robert Skelton, Indian Department archives.

25 One page has no numbers at all, despite having similar borders to Minto, Wantage and Kevorkian pages: Mansur's famous painting of tulips in Aligarh University apparently has numbers on the reverse but not on the margin next to the painting (Leach, 1995, vol. I, p. 374).

26 Marie L. Swietochowski (Welch *et al.*, pp. 68–69) suggests there were as many as 19; Linda Leach (1995, vol. I, pp. 372 and 380) suggests 8 or more. Each page of the Kevorkian Album has been published, complete with borders (Welch *et al.*), but many pages in other collections, especially those with calligraphy, remain unpublished, or have their borders cropped when reproduced, making any detailed comparison between them almost impossible.

27 See e.g. Welch *et al.*, cat. 40 and 41, pp. 164-67 (two birds); cat. 70 and 71, pp. 224–29, generals of Shah Jahan. In Leach, 1995, vol. I, see cat. 3.15 (pp. 388–89) and 3.21 (p. 398), Mu'in ad-Din Chishti and Jahangir, illustrated together pp. 386–87 though borders cropped.

28 The vizirs are identified by minute gold inscriptions. From left to right they are Bayram Khan, Mirza Shah Rokh, and Mirza Rostam.

29 See Leach, 1995, vol. I, cat. 3.29 (illus. in black and white on p. 411). Marie L. Swietochowski independently made the same connection between the pages and drew the same conclusion (Welch *et al.*, p. 56).

30 See Milo Beach in Beach and Koch, p. 160.

31 See Nominal File, Sir Robert Nathan, in the V&A Registry.

32 Blochmann, vol. I, pp. 2–3 ('Kiyan khura' glossed by A.S. Melikian-Chirvani). See Soudavar, Appendix 3, pp. 410–16 for a detailed commentary on 'The Divine Glory'.

33 See Jahangir preferring a Sufi Shaykh to kings by Bichitr in e.g. Beach, 1981, cat. 17a, p. 168, and Jahangir embracing Shah Abbas by Abu'l Hasan, ibid., cat. 17b, pp. 169–70 (cover illus. in colour).

34 See Welch *et al.*, cat. 34, illus. p. 152. See also cat. 40, illus. p. 166.

35 See Skelton *et al.*, *The Indian Heritage* (1982), cat. 67, p. 44. For works by Chitarman, all of Shah Jahan's reign, see Verma, 1994, pp. 121–22 (date not mentioned on V&A painting), who suggests Chitarman may have been in Dara Shokuh's entourage by the late 1630s.

36 See Skelton *et al.*, cat. 376, pp. 122–23. The cameo portrait is the work of a European, probably done at the Mughal court.

37 For works associated with Govardhan, see Verma, 1994, pp. 160–67. For a brief survey of his career, and references to earlier studies by, for example, Milo Beach, see John Seyller, *The Dictionary of Art*, vol. XIII, pp. 235–36.

38 See Leach, 1995, vol. I, pp. 385, illus. p. 384 (black-and-white, no borders shown). Leach suggests that the two pages were near each other, but probably not on the same opening as their borders are not complementary.

39 See Ellison Banks Findly, *Nur Jahan: Empress of Mughal India* (Oxford University Press, New York, 1993) for an accessible biography.

40 Begley and Desai, p. 6.

41 Ibid., pp. 12–13.

42 Ibid, p. 17.

43 Ibid., pp. 20–21. The event is illustrated by Bichitr in the *Padshahnama* (Beach and Koch, no. 10, colour illus. p. 41), and includes Asef Khan standing behind the princes, in privileged proximity to Jahangir.

44 The painting has often been published, but the date has so far been overlooked. It has therefore been dated between 1628 (Okada, 1992, fig. 196 on p. 164) and 1635 (British Museum, 1976, cat. 152). Verma, 1994, p. 107, no. 14, suggested that the painting was done after Asef Khan's Bijapur campaign, but this took place in 1631. See Begley and Desai, p. xxxviii for a table of Shah Jahan's regnal years.

45 Begley and Desai, p. 148.

46 E.g. Okada, 1992, fig. 174, Jadhu Rai Deccani by Hashem, *c*.1622.

47 See Losty in Pal, ed., p. 84 fig. 14, for a portrait of Jahangir dated Nowruz 1623, with a battle raging behind him, far away in the background (described p. 82).

48 See Leach, 1995, vol. I, pp. 430–40 for a series of Shah Jahan-period official portraits in very traditional style.

49 Walter L. Strauss, ed., *The Complete Engravings, Etchings and Woodcuts* (Abaris Books, New York, 1977), e.g. vol. I, no. 160, illus. p. 273, and vol. II, no. 252, illus. p. 433.

50 Listed as 'Portrait of Albuquerque', after the Persian inscription on the back of the painting. Accession number 1990:0303. Binney had identified its source as 'after a 1587 "Soldier of the bodyguard of the Emperor Rudolph II" by Jacques de Gheyn II, after Hendrik Goltzius'. For the series see Ger Luijten, ed., *The De Gheyn Family: Part 1*, in *The New Hollstein: Dutch and Flemish Etchings, Engravings and Woodcuts 1450–1700* (Sound and Vision Publishers, Rotterdam 2000), pp. 19–33, dated to 1589. The prototype for the Binney painting is illustrated p. 27, no. 181/1.

51 I am greatly indebted to Asok Kumar Das for his identification of this portrait. See Catherine Glynn, 'A Rajasthani princely album: Rapjut patronage of Mughal-style painting', *Artibus Asiae*, vol. LX, no.2 (2000), pp. 222–23, where four paintings of Asalat Khan are illustrated fig. 11a–d, p. 249. Fig. 11a has an identifying Persian inscription; fig. 11b is closely similar to the Clive Album portrait.

52 Glynn, op.cit., pp. 239–40. See Ali, 'Introduction', for the *mansab* system.

53 Illustrated in Leach, 1995, vol. I, colour pl. 57, p. 378.

54 And consecutive numbers, though this may be of less significance.

55 Shyam, pp. 34–35.

56 Majumdar, p. 436.

57 Ibid., pp. 439-40.

58 Ibid., pp. 440–42.

59 Illustrated in Leach, 1995, vol. I, cat. 3.25, pp. 398–405, illustrated (black-and-white), p. 399.

60 Thackston, 1999, p. 476, n. 1 gives the full inscription with translation (though the illustration on p. 65 is a later copy of the Chester Beatty painting), which ends: 'Your enemy's innards are like a pig; the tip of your spear is satiated with his blood'. See also Robert Skelton, 'Imperial symbolism in Mughal painting', in Priscilla P. Soucek, ed., *Content and Context of Visual Arts in the Islamic World: Papers from a Colloquium in Memory of Richard Ettinghausen, Institute of Fine Arts, New York University, 2–4 April, 1980* (Pennsylvania State University Press, 1988), pp. 179–80.

61 R. Shyam in Sherwani and Joshi, eds, p. 268.

62 Sherwani p. 462, based on the *Iqbalnama*, pp. 233–34, 238–39. For Burhanpur, see Michell and Zebrowski, p. 53.

63 Shyam, pp. 105–06.

64 Welch *et al.*, p. 120, but cf. Seyller, ibid., who disagrees with the assumed biography given by Welch, noting that Hashem's style 'falls entirely within the parameters of Mughal painting' (p. 109).

65 See Zebrowski, fig. 21, p. 37.

66 The V&A painting is signed, as is another version of the same portrait, now in the Musée Guimet (illustrated in Seyller, 'Hashim', fig. 2, p. 107). Hashem was known as 'Mir Hashem', according to inscriptions on other paintings (see Verma, 1994, p. 170).

67 '*Jama*' is used here in the conventional way to describe any long-sleeved, side-fastening robe, despite this probably being too generalized: see B.N. Goswamy in *Indian Costumes in the Collection of the Calico Museum of Textiles*, vol.V of *Historic Textiles of India at the Calico Museum, Ahmedabad* (1993), pp. 27–35.

68 See Begley and Desai, p. 62.

69 See Beach and Koch, pp. 169–70.

70 Majumdar, p. 475.

71 Ibid., p. 457.

72 The drawing was from the collection of Robert Scott Greenshields, an Indian Civil Servant between 1879 and 1910 (see V&A Registry Nominal File).

73 Seyller, 1997, points out that even the most lavishly illustrated manuscripts were worth only a fraction of the most valuable elephant.

74 Indian Department archives. There are seals of Alamgir on the back. Cf. another painting of a royal elephant, again ridden by a prince thought to be Dara Shokuh, in Asok Das, 'The elephant in Mughal painting' (in Verma, ed., 1999, fig. 15, p. 50).

75 The page was bought at Sotheby's, London, in 1972. The Museum's registered description notes comparable pages but does not provide further references.

76 See Asher, p. 210.

77 'The calligraphy and poetry of the Kevorkian Album', in Welch *et al.*, pp. 31–44, and catalogue entries for the individual pages.

78 Ibid, p. 42.

79 Loc. cit.

80 Loc. cit.

81 The borders of the Kevorkian, Minto and Wantage groups are paid scant attention in general catalogues. The Kevorkian pages have all been published in the Metropolitan Museum's exemplary monograph (Welch *et al.*) but related pages of calligraphy in other collections have rarely been reproduced; when the picture side is published, the border is often cropped or omitted. Few authors hazard a guess as to their dates, Stuart Cary Welch being a conspicuous exception (ibid., pp. 24–26), though he regards the Jahangiri borders as postdating *c.*1620 (following Skelton, 'A decorative motif', 1972), dismissing those of Shah Jahan's reign in a single paragraph (p. 26) as 'less individualised'. This broad distinction is followed by Leach, 1995, vol. I, p. 372, though she concludes 'It is impossible to discriminate between the borders of Jahangir's reign and those probably done in the first ten years of Shah Jahan's rule' (p.372). M.L. Swietochowski in Welch *et al.*, considers the design of each border of the Kevorkian pages in detail, and makes valiant attempts to reconstruct serial pages, but draws back from dating the border designs, though following Skelton, 1972, for the post-1620 dating.

82 Welch *et al.*, cat. 15 illus. p. 109 and cat. 27, illus. p. 135.

83 Ibid., p. 17; see also pp. 32–35.

84 Rogers and Beveridge, vol. I, p. 152.

85 Quoted in Edmund W. Smith, *Akbar's Tomb, Sikandrah, Near Agra, Archaeological Survey of India*, vol. XXXV (1909; reprinted by Archaeological Survey of India, New Delhi, 1994), p. 7.

86 Ibid., p. 15 for a detailed description of the inscriptions on the tomb, which include the 99 names of God on the upper surface.

87 See the unpublished pattern-woven silk panel in the V&A's Islamic Gallery (T.9-1915), dated very broadly on the gallery label to 'late 16th or 17th century'. The palmettes suggest an early seventeenth-century date, though little research has been carried out on Safavid textiles of this period.

88 Welch *et al.*, cat. 10, p. 99.

89 For works by Dowlat, see Verma, 1994, pp. 126–30, though not all his signed works in the V&A are included.

90 Published, for example, in Welch *et al.*, cat. 122, p. 194.

91 Skelton, 'A decorative motif', 1972, p. 151.

92 See Welch, *et al.*, p. 237, where M.L. Swietochowski notes a similarly idiosyncratic tulip in the Kevorkian album.

93 See, for example, the Martegon Lily from Pierre Vallet's *Le jardin du roi* (1608), illustrated in Skelton, 'A decorative motif', 1972, pl. 90. It is certainly the case that insects hovering over plants are found in Indian art much earlier than Shah Jahan's reign, as has been shown, but their depiction in the borders of his albums is closely similar to that found in a very small number of widely published European herbals, notably that of Pierre Vallet.

94 See Welch *et al.*, cat. 77 for a similar crocus motif, singled out for comparison with herbal illustrations by Swietochowski (ibid., p. 237).

95 As pointed out by Leach, 1995, vol. I, p. 373, though the painting is wrongly dated 1645–46.

96 See, for example, the series illustrated in Leach, 1995, vol. I, pp. 425–51.

GLOSSARY AND NOTE TO THE READER

ain custom, rule, ritual: hence *Ain-i Akbari*, The Institutes of Akbar, or Akbarian Regulations

Akbarnama Book of Akbar (hence also *Baburnama* = Book of Babur, *Jahangirnama* etc.)

div demon

jama conventionally used to mean a robe worn by men, having a tie-fastening under one shoulder

karkhana workshop, atelier

khan-i khanan Khan of khans, or 'first among khans'. Khan was a Mongol title adopted in Iran after the Mongol invasion and was used in Persianized Hindustan

Khwaja respectful mode of address applied to ministers and literati

mansab rank or office granted to all Mughal officials to determine their status and salary

Mir Persianized form of Arabic *amir*: title with various connotations including chief, leader, prince, governor

musavvir figural painter

naqqash designer, painter

nasta'liq Iranian style of cursive Arabic script reputedly invented by *Mir* Ali of Herat

Nowruz New Year

Padshah king, monarch

qamargah form of royal hunt of Mongol origin in which an area is enclosed to trap game

Razmnama Book of War, the Persian translation of the Sanskrit *Mahabharata*

Shahinshah King of Kings, used only of the emperor in the Iranian world

Simurgh mythical bird of Persian literature

suba province

tasvir khana painting studio

vakil the highest-ranking minister at the Mughal court, but without a department

zamindar landowner

zenana the womens' quarters in the royal residence

NOTE TO THE READER

Except where stated, all paintings are Mughal, and done in opaque watercolour and gold on paper. Height precedes width in the dimensions, and dimensions of paintings exclude all borders and rules. Dimensions for the *Hamzanama* paintings are their minimum size; due to their buckled surface, measurements differ at any given point, and variations may be up to 5 mm. All images are copyright of the Trustees of the Victoria and Albert Museum, except plate 20, reproduced by courtesy of the Trustees of the Prince of Wales Museum of Western India, Bombay; plate 71, copyright of the British Museum; plates 125 and 126, reproduced by kind permission of the Trustees of the Chester Beatty Library, Dublin; and plates 133 and 134, reproduced with the kind permission of Robert Skelton. Diacriticals have been omitted for the sake of simplicity, and the transliteration system followed is based on that devised by A.S. Melikian-Chirvani in *Islamic Metalwork from the Iranian World: 8–18th centuries*, HMSO, London, 1982.

BIBLIOGRAPHY

Ahmad, Tasneem, trans., foreword by Irfan Habib, *Tarikh-i-Akbari: Muhammad Arif Qandhari* (Pragati Publications, Delhi, 1993)

Ahmed, Khalid Anis, ed., *Intercultural Encounter in Mughal Miniatures (Mughal-Christian Miniatures)* (National College of Arts, Lahore, 1995)

Al-Badaoni (Abdu-l-Qadir ibn-i-Muluk Shah), *Muntakhabu-t-Tawarikh*, English trans. 3 vols; rev. and enlarged B.P. Ambashthya (Academica Asiatica, Patna, 1973)

Ali, Ahmed and Abdur Rahim (eds), *Akbarnama* (Bib. Ind., Calcutta, 1873–87)

Ali, M. Athar, *The Apparatus of Empire: Awards of Ranks, Offices and Titles to the Mughal Nobility (1574–1658)* (Oxford University Press, Delhi, 1985)

Alvi, M. A. and A. Rahman, *Jahangir the Naturalist*, National Institute of Sciences of India, Monograph Series no. 3 (New Delhi, 1968)

Asher, Catherine B., *Architecture of Mughal India*, The New Cambridge History of India, vol. I:4 (Cambridge University Press, 1992)

Atabey, Badri, *Fihrist-e muraqqa'-at-i kitabkhana-ye saltanati* [List of the albums in the royal library] (Tehran, 1974)

Aznaveh, Said Mahmudi Aznaveh, Mohammad-Hasan Semsar, Karim Ememi and Mohammad-Ali Davudipur, *Golestan Palace Library: Portfolio of Miniature Paintings and Calligraphy* (Zarrin & Simin Books, Tehran, 2000)

Bailey, Gauvin Alexander, 'The Lahore Mirat Al-Quds and the impact of Jesuit theatre on Mughal painting', *South Asian Studies*, vol. XIII (1997), pp. 31–44

—*Art on the Jesuit Missions in Asia and Latin America 1542–1773* (University of Toronto Press, 1999)

Beach, Milo Cleveland, 'The Gulshan Album and its European Sources', *Bulletin of the Museum of Fine Arts, Boston*, vol. 63, no. 332 (Boston, 1965)

—*The Grand Mogul: Imperial Painting in India 1600–1660* (Williamstown, Mass., 1978)

—'The Mughal painter Abul Hasan and some English sources for his style', *Journal of the Walters Art Gallery*, vol. XXXVIII (1980), pp. 7–33

—*The Imperial Image: Paintings for the Mughal Court* (Freer Gallery of Art, Smithsonian Institution, Washington, DC, 1981)

—*Early Mughal Painting* (Cambridge, Mass. and London, 1987)

—*The New Cambridge History of India*, vol. I:3, *Mughal and Rajput Painting* (Cambridge University Press, 1992)

Beach, Milo Cleveland and Ebba Koch, with new translations by Wheeler Thackston, *King of the World: The Padshahnama: An Imperial Mughal Manuscript from the Royal Library, Windsor Castle* (Azimuth Editions Ltd and Smithsonian Institution, London, 1997)

Begley, W.E. and Z.A. Desai, eds, *The Shah Jahan Nama of Inayat Khan: An Abridged History of the Mughal Emperor Shah Jahan, Compiled by His Royal Librarian: The Nineteenth-century Manuscript Translation of A.R. Fuller (British Library, Add. 30,777)* (Oxford University Press, New Delhi, 1990)

Beveridge, Henry, trans., *The Akbar Nama of Abu-l-Fazl (History of the Reign of Akbar Including an Account of his Predecessors)* 3 vols, reprint edition (Ess Ess Publications, Delhi, 1977)

Blake, Stephen P., 'Shahjahanabad: the sovereign city in Mughal India 1639–1739', *South Asian Studies*, vol. XLIX (Cambridge University Press, 1991)

Blochmann, H., trans., *The A'in-i Akbari by Abu'l-Fazl 'Allami*, second edition, rev. and ed. Lt-Col. D.C. Phillott; third edition (Oriental Books Reprint Corporation, New Delhi, 1977)

Brand, Michael and Glenn D. Lowry, *Akbar's India: Art from the Mughal City of Victory* (The Asia Society Galleries, New York, 1985)

Brend, Barbara, *The Emperor Akbar's Khamsa of Nizami* (The British Library, London, 1995)

British Museum, *Paintings from the Muslim Courts of India: An Exhibition Held in the Prints and Drawings Gallery*, British Museum, 13 April–11 July 1976 (World of Islam Festival Publishing Company Ltd, 1976)

Brosh, Naama, with Rachel Milstein, *Biblical Stories in Islamic Painting* (The Israel Museum, Jerusalem, 1991)

Brown, Percy, *Indian Painting under the Mughals* (Oxford, 1924)

Camps, Arnulf, and Jerome Xavier SJ, *The Muslims of the Mogul Empire: Controversial Works and Missionary Activity* (Nouvelle Revue de Science Missionnaire, Schoneck-Beckenried, Switzerland, 1957)

Canby, Sheila R., *Princes, Poets and Paladins: Islamic and Indian Paintings from the Collection of Prince and Princess Sadruddin Aga Khan* (British Museum Press, London, 1998)

Chandra, Moti, *The Technique of Mughal Painting* (The UP Historical Society, Provincial Museum, Lucknow, 1949)

Chandra, Pramod, *The Tuti-Nama of the Cleveland Museum of Art and the Origins of Mughal Painting*, Codices Selecti Phototypice Impressi: Facsimile vol. LV; Commentarium vol. LV (Akademische Druck-u. Verlagsanstalt, Graz, Austria, 1976)

Clarke, C. Stanley, *Indian Drawings: Twelve Mogul Paintings of the School of Humayun (16th century) Illustrating the Romance of Amir Hamzah* (Victoria and Albert Museum Portfolios, HMSO, London, 1921)

—*Mogul Paintings Period of the Emperors Jahangir and Shah Jahan 1605–1658 and Persian Calligraphy Formerly in the Imperial Collection in Delhi, Lent by Lady Wantage to the Victoria & Albert Museum 1917* (Victoria and Albert Museum, 1918)

Correia-Afonso, John, *Letters from the Mughal Court*, Studies in Indian History and Culture of the Heras Institute, no. 24 (Gujarat Sahitya Prakash, Anand, 1980)

Das, Asok Kumar, *Mughal Painting During Jahangir's Time* (The Asiatic Society, Calcutta, 1978)

—(ed.), *Mughal Masters: Further Studies* (Marg Publications, Mumbai, 1998)

Ehnbom, Daniel J. with essays by Robert Skelton and Pramod Chandra, *Indian Miniatures: The Ehrenfeld Collection* (Hudson Hills Press, New York, in Association with the American Federation of Arts, 1985)

Foster, William, ed., *Early Travels in India 1583–1619* (Oriental Books Reprint Corporation, New Delhi, 1985)

Glück, Heinrich, *Die indischen Miniaturen des Haemzae-Romanes im Österreichischen Museum für Kunst und Industrie in Wien und in Anderen Sammlungen* (Amalthea-Verlag, Zurich, Vienna and Leipzig, 1925)

Goswamy, B.N. and Eberhard Fischer, *Wonders of a Golden Age: Painting at the Court of the Great Mughals: Indian Art of the 16th and 17th Centuries from Collections in Switzerland* (Museum Rietberg, Zurich, 1987)

Hamza-Nama: Codices Selecti Phototypice Impressi, facsimile vol. LII/1 (Akademische Druck-u. Verlagsanstalt, Graz, 1974)

Hamza-Nama: Codices Selecti Phototypice Impressi, facsimile vol. LII/2 (Akademische Druck-u. Verlagsanstalt, Graz, 1982)

Habsburg, Francesca von, *et al.*, *The St Petersburg Muraqqa: Album of Indian and Persian Miniatures from the 16th through the 18th Century and Specimens of Persian Calligraphy by Imad al-Hasani* (ARCH Foundation, Lugano and Leonardo Arte srl, Milan, 1996)

Isacco, Enrico and Josephine Darrah, 'The Ultraviolet-Infrared method of analysis: a scientific approach to the study of Indian miniatures', *Artibus Asiae*, vol. LIII, no. 3/4 (1993), pp. 470–91

Johnson, B.B., 'A preliminary study of the technique of Indian miniature painting', in P. Pal, ed., *Aspects of Indian Art: Papers Presented in a Symposium at the Los Angeles Museum of Art, October, 1970* (E.J. Brill, Leiden, 1972), pp. 141–6

Khan, Ahmad Nabi, 'An illustrated Akbarnama manuscript in the Victoria and Albert Museum, London', in Giuseppe Tucci, ed., *East and West*, IsMeo, new series, vol. XIX, nos 3/4 (1969), pp. 424–29

Koch, Ebba, 'Jahangir and the angels', in J. Deppert, ed., *India and the West* (South Asia Institute, New Delhi, 1983)

—*Shah Jahan and Orpheus: The Pietre Dure Decoration and the Programme of Shah Jahan's Throne in the Hall of Public Audiences at the Red Fort of Delhi* (Akademische Druck-u. Verlagsanstalt, Graz, 1988)

—*Mughal Architecture* (Prestel-Verlag, Munich, 1991)

Leach, Linda York, *Indian Miniature Paintings and Drawings: The Cleveland Museum of Art Catalogue of Oriental Art: Part One* (The Cleveland Museum of Art, in co-operation with Indiana University Press, 1986)

—*Mughal and other Indian Paintings from the Chester Beatty Library*, 2 vols (Scorpion Cavendish/World of Islam Festival Trust, London, 1995)

—*Paintings from India*, The Nasser D. Khalili Collection of Islamic Art, vol. VIII (The Nour Foundation, in association with Azimuth Editions and Oxford University Press, 1998)

Losty, Jeremiah P., *The Art of the Book in India* (The British Library, 1982)

Lowry, Glenn D. with Susan Nemazee, *A Jeweler's Eye: Islamic Arts of the Book from the Vever Collection* (Arthur M. Sackler Gallery, in association with University of Washington Press, Seattle and London, 1988)

Maclagan, E., *The Jesuits and the Great Mogul* (London, 1932)

Majumdar, R.C., *The Mughul Empire: The History and Culture of the Indian People*, vol. VII (Bharatiya Vidya Bhavan, Bombay, 1974)

Martin, F.R., *The Miniature Painting and Painters of Persia, India and Turkey from the 8th to the 18th Century*, 2 vols (Bernard Quaritch, London, 1912)

Michell, George and Mark Zebrowski, *Architecture and Art of the Deccan Sultanates*, vol. I/7 of *The New Cambridge History of India* (Cambridge University Press, 1999)

Moodsvi, Shireen, trans. and ed., *Episodes in the Life of Akbar: Contemporary Records and Reminiscences* (National Book Trust, India, New Delhi, 1994)

Mukhia, Harbans, *Historians and Historiography during the Reign of Akbar* (Vikas Publishing House PVT Ltd, New Delhi, 1976)

Nath, R., *The Transitional Phase of Colour and Design: Jehangir, 1605–1627 A.D.*, vol. III of *History of Mughal Architecture* (Abhinav Publications, New Delhi, 1994)

Okada, Amina, *Miniatures de l'Inde impériale: les peintres de la cour d'Akbar (1556–1605)* (Editions de la Réunion des Musées Nationaux, Paris, 1989), English trans. by Deke Dusinberre as *Imperial Mughal Painters: Indian Miniatures from the Sixteenth and Seventeenth Centuries* (Flammarion, Paris, 1992)

O'Malley SJ, John W., Gauvin Alexander Bailey, Steven J. Harris, and T. Frank Kennedy SJ, *The Jesuits: Cultures, Sciences and the Arts 1540–1773*

(University of Toronto Press, Toronto, Buffalo and London, 1999)

Pal, Pratapaditya, ed., *Master Artists of the Imperial Mughal Court* (Marg Publications, Bombay, 1991)

Payne, C., *Akbar and the Jesuits: An Account of the Jesuit Missions to the Court of Akbar: By Father Pierre du Jarric, S.J.*, Translated with Introduction and Notes, The Broadway Travellers (George Routledge & Sons, Ltd, London, 1926)

—*Jahangir and the Jesuits: An Account of the Travels of Benedict Goes and the Mission to Pegu: From the Relations of Father Fernao Guerreiro* (New York and London, 1930)

Porter, Yves, *Painters, Paintings and Books: An Essay on Indo-Persian Technical Literature, 12–19th Centuries* (Manohar, Centre for Human Sciences, New Delhi, 1994)

Poster, Amy with Sheila R. Canby, Pramod Chandra and Joan M. Cummins, *Realms of Heroism: Indian Paintings at the Brooklyn Museum* (Hudson Hills Press, New York, in association with The Brooklyn Museum, 1994)

Prasad, Beni, *History of Jahangir*, fifth edition (The Indian Press [Publications] Private Ltd, 1962)

Pritchett, Frances W., *The Romance Tradition in Urdu: Adventures from the Dastan of Amir Hamzah* (Columbia University Press, New York, 1991)

Randhawa, M.S., *Paintings of the Baburnama* (National Museum, New Delhi, 1983)

Richards, John F., *The Mughal Empire*, vol. I/5 of *The New Cambridge History of India*, second edition (Cambridge University Press, 1995)

Rizvi, S.A.A., *Religious and Intellectual History of the Muslims* (Munshiram Manoharlal Publishers Pvt Ltd, New Delhi, 1975)

Rogers, J. M, *Mughal Miniatures* (British Museum Press, London, 1993)

Rogers, Alexander and Henry Beveridge, trans. and ed., *The Tuzuk-i Jahangiri, or Memoirs of Jahangir*, 2 vols (Royal Asiatic Society, London, 1909–14)

Schimmel, Annemarie and Stuart Cary Welch, *Anvari's Divan: A Pocket Book for Akbar* (The Metropolitan Museum of Art, New York, 1983)

Sen, Geeti, *Paintings from the Akbar Nama: A Visual Chronicle of Mughal India* (Lustre Press Pvt Ltd, 1984)

Seyller, John, 'Model and copy: the illustration of three *Razmnama* manuscripts', *Archives of Asian Art*, vol. XXXVIII (1985), pp. 37–66

—'Scribal notes on Mughal manuscripts', *Artibus Asiae*, vol. XLVIII (1987), nos 3/4, pp. 247–77.

—'Codicological aspects of the Victoria and Albert Museum *Akbarnama* and their historical implications', *Art Journal*, vol. XLIX, no. 4 (1990), pp. 379–87

—'The inspection and valuation of manuscripts in the imperial Mughal Library', *Artibus Asiae*, vol. LVII, no. 3/4 (1997), pp. 243–349

Sherwani, H.K. and P. M. Joshi, *History of Medieval Deccan (1295–1724)*, vol. I (Government of Andhra Pradesh, Hyderabad, 1973)

Shukla, D.N., *Vastu-Sastra*, vol. II, *Hindu Canons of Iconography and Painting* (Munshiram Manoharlala Publishers Pvt Ltd, 1993)

Shyam, Radhey, *Life and Times of Malik Ambar* (Munshiram Manoharlal, Delhi, 1968)

Siddiqi, W.H., *Rampur Raza Library Monograph* (Rampur Raza Library, 1998)

Skelton, Robert, 'Two Mughal lion hunts', *Victoria and Albert Museum Yearbook* (1969), pp. 33–48

—'Mughal paintings from [a] Harivamsa manuscript', *Victoria and Albert Museum Yearbook*, vol. II (Phaidon, London, 1972), pp. 41–54

—'A decorative motif in Mughal art', in P. Pal, ed., *Aspects of Indian Art: Papers Presented in a Symposium at the Los Angeles Museum of Art, October, 1970* (E.J. Brill, Leiden, 1972), pp. 147–52, pls 85–91

Skelton, Robert, Andrew Topsfield, Susan Stronge and Rosemary Crill, eds, *Facets of Indian Art* (Victoria and Albert Museum, London, 1986), pp. 105–15

Smart, Ellen, 'Yet another illustrated Akbari *Baburnama* manuscript', in Skelton *et al.*, eds, pp. 105–15

Soudavar, Abolala, *Art of the Persian Courts: Selections from the Art and History Trust Collection* (Rizzoli, New York, 1992)

Staude, Wilhelm, 'Les artistes de la cour d'Akbar et les illustrations du Dastan-i-Amir Hamzah', *Arts Asiatiques*, vol. II (1955), no. 1, pp. 47–65; no. 2, pp. 83–111

Stchoukine, Ivan, 'Portraits moghols: deux darbar de Jahangir', *Revue des Arts Asiatiques*, vol. VI (1929–30), pp. 212–41

Thackston, Wheeler M., trans. and ed., *The Baburnama: Memoirs of Babur, Prince and Emperor* (Freer Gallery of Art, Washington DC, and Oxford University Press, New York and Oxford, 1996)

—(trans., ed. and annotator), *The Jahangirnama: Memoirs of Jahangir, Emperor of India* (Oxford University Press, New York, in association with the Freer Gallery of Art and the Arthur M. Sackler Gallery, Smithsonian Institution, Washington, DC, 1999)

Tyulyayev, S., ed., *Miniatyury rukopisi 'Babur-name'* (Gosudarstvennoe Izdatelstvo Izobrazitelnogo Iskusstva, Moscow, 1960)

Verma, Som Prakash, *Mughal Painters and Their Work: A Biographical Survey and Comprehensive Catalogue* (Centre of Advanced Study in History, Aligarh Muslim University, Oxford University Press, New Delhi, 1994)

—(ed.), *Flora and Fauna in Mughal Art* (Marg Publications, Mumbai, 1999)

—*Mughal Painter of Flora and Fauna: Ustad Mansur* (Abhinav Publications, New Delhi, 1999)

Walker, Daniel, *Flowers Underfoot: Indian Carpets of the Mughal Era* (The Metropolitan Museum of Art, New York, 1997)

Welch, Stuart Cary, Annemarie Schimmel, Marie L. Swietochowski, and Wheeler M. Thackston, *The Emperor's Album: Images of Mughal India* (The Metropolitan Museum of Art, New York, 1987)

Zebrowski, Mark, *Deccani Painting* (Sotheby Publications, University of California Press, 1983)

INDEX